W9-ACY-824

A Garland Series

OUTSTANDING DISSERTATIONS IN THE

FINE ARTS

The Early Sculpture
of
Bartolomeo Ammanati

Peter Kinney

Garland Publishing, Inc., New York & London

1976

Library of Congress Cataloging in Publication Data

Kinney, Peter.
 The early sculpture of Bartolomeo Ammanati.

 (Outstanding dissertations in the fine arts)
 Originally presented as the author's thesis, New York
University, 1974.
 1. Ammannati, Bartolommeo, 1511-1592. I. Title.
II. Series.
NB623.A46K56 1976 730'.92'4 75-23798
ISBN 0-8240-1993-8

THE EARLY SCULPTURE OF BARTOLOMEO AMMANATI

A Dissertation in the Department of History of Art
Submitted to the Faculty of the Graduate School
of Arts and Sciences in partial fulfillment of
the Requirements for the Degree of
Doctor of Philosophy at New York University

Peter Kinney
~~May,~~ 1974
June

PREFACE

It is my pleasure to take this opportunity to thank the many people whose thoughtful assistance made this dissertation possible. I am especially grateful to my advisor, Miss Olga Raggio, who supported my endeavors unfailingly, giving me many valuable suggestions, and whose careful reading of the text helped me to avoid many errors, and to Professor Ulrich Middeldorf in Florence who so generously put his inexhaustible knowledge of sixteenth-century sculpture at my disposal many times, and whose stimulating observations helped clarify a number of problems. I am indebted to Professor Kathleen Weil-Garris Posner for reading the text with great care, which helped me to avoid numerous blunders, and for giving me valuable suggestions which I hope shall bear fruit as my studies progress. In Padua, Dottoressa Irene Favaretto freely gave her time and resources to greatly facilitate my study of the Benavides projects, and generously made available to me a typescript of the seventeenth-century Inventory of the Benavides Museum. The assistance of Prof. Giovanni Gorini, Prof. Lucio Grossato and the late Giuseppe Fiocco aided my investigation of Ammanati's Paduan activity in many important ways. In Vicenza Prof. Renato Cevese and Prof. Giovanni Bandini provided much valuable help in matters concerning Ammanati's work for Girolamo Gualdo.

I am indebted to Prof. Giuseppe Arsento for permitting me to consult documents in the Archivio Communale of Carrara.

I bear a particularly large debt to Charles Davis of Florence, who with extraordinary generosity gave me many pieces of the Ammanati puzzle which he laboriously excavated, and who, in many conversations, helped

me fit them together. His assistance will be acknowledged in the
appropriate footnotes but the extent of his help is such that I may
have unwittingly adopted some of his discoveries early in my work
and, forgetting what they were, can no longer remember where to give
him all due credit. Of course, I alone bear the responsibility for
the text, which does not always correspond with his views.

I also wish to thank the directors and staff of the following
institutions who kindly indulged my many needs and requests: the
Archivio di Stato, the Biblioteca Riccardiana, the Gabinetto dei
Disegni degli Uffizi and the Kunsthistorisches Institut in Florence,
the Biblioteca Bertoliana in Vicenza, the Biblioteca del Seminario,
the Biblioteca Civica and the Museo Civico in Padua, the Fondazione
Cini, the Soprintendenza ai Monumenti, the Biblioteca Marciana and
Biblioteca Correr in Venice, and the Biblioteca Hertziana in Rome.

My wife Dale selflessly gave great amounts of her valuable time
to help me with translations and to discuss interpretive problems.
Her perceptive observations threw light on many difficult issues
and resolved many awkward passages in the text.

I am indebted to the Woodrow Wilson Foundation for a Dissertation
Fellowship in 1969-70, and to the National Gallery of Art for a Chester
Dale Fellowship for 1970-71 which allowed me to pursue research on
Ammanati in various parts of Italy. I also wish to express deep
gratitude to the Institute of Fine Arts and its Director, Craig Hugh
Smyth, for collective, financial and intellectual support in the years
leading up to the dissertation.

TABLE OF CONTENTS

Table of Contents (cont'd.)

LIST OF ILLUSTRATIONS

Fig. 206) As fig. 204, Wisdom.

Fig. 207) Ammanati, Tomb of Benavides. Eremitani, Padova. Photo Gab. Fotografico del Museo Civico di Padova #456.

Fig. 208) As fig. 205. Photo Gab. Fotografico del Museo Civico di Padova, #144.

Fig. 209) As fig. 204.

Fig. 210) As fig. 206.

Fig. 211) As fig. 205. Photo Museum #1699.

Fig. 212) As fig. 205. Photo Museum #2292.

Fig. 213) As fig. 206.

Fig. 214) As fig. 204.

Fig. 215) As fig. 207, Honor.

Fig. 216) As fig. 207, Fame.

Fig. 217) Idem.

Fig. 218) Omitted.

Fig. 219) As fig. 215.

Fig. 220) As fig. 215.

Fig. 221) As fig. 215.

Fig. 222) As fig.207, Immortality.

Fig. 223) Idem.

Fig. 224) As fig. 207, left youth.

Fig. 225) Idem, right youth.

Fig. 226) Idem. Photo Soprintendenza ai Monumenti, Venice.

Fig. 227) Idem.

Fig. 228) Idem, left youth. Photo author.

Fig. 229) Tomb of Benavides, relief left side, base.

PLATES

Chapter 1

APPRENTICESHIP WITH BANDINELLI ANU SANSOVINO

Until thirty-five years ago the early sculptural activity of
Bartolommeo Ammanati was so poorly known that Frederick Kriegbaum[1]
could state, without great exaggeration, that all of the sculptures
before the Paduan period were lost. This state of affairs was due largely
to art historical neglect, deriving on the one hand from the unpopularity
of the "Biancone" (which nearly became the sole and fatal yardstick of
the master), and on the other from the fact that the period labelled
"Mannerism" (roughly 1525-1585) fell into a limbo in the seventeenth
century from which it has been somewhat resuscitated only in the present
century, and particularly in recent years. The wayward fluctuations of
taste in art from Ammanati's day to ours are responsible for the fact
that his stature in modern eyes is certainly not as great as it was in
the eyes of his contemporaries. This essay will try to sharpen our focus
mainly on Ammanati's activity up to the Roman period, roughly the first
twenty years or so of his sculptural activity, with the hope of showing
that Ammanati's early work is far from having wholly disappeared. On
the contrary much can be learned of it, which will throw light on his
career as a whole.

The art historical neglect begins as early as Vasari,[2] whose few
sentences on Ammanati, containing a number of glaring errors, are appended

[1]. "Ein Verschollenes Brunnenwerk der Bartolomeo Ammanati's"
Mitteilungen der Kunsthistorisches Instituts in Florenz, III, 1929, 7.

[2]. Vasari, ed. G. Milanesi, Le Vite ... Milano 1824, VII, 227; and
Vasari (1550) ed. Ricci, 1854, Milano, IV, 788.

to the discussion of Jacopo Sansovino's pupils and scattered in the Lives of
his contemporaries. This is a pity, for Vasari knew Ammanati well and could
have informed in great detail about nearly all phases of Ammanati's activity.
Instead, he left the job to Borghini,[3] who wrote a very summary account and
was not able to avoid many errors, particularly as regards the pre-Roman
activity. Baldinucci's biography[4] elaborates on Borghini and Vasari, and
provides much additional information about the master's later career. But
many important gaps in the early activity left by Vasari and Borghini are
not filled in. And so it persists to the present day.[5]

3. R. Borghini, Il Risposo, Milano, 1807, III, 164 ff.

4. F. Baldinucci, Opera, Milano, 1811, VII, 393 ff.

5. The most important literature on Ammanati as a sculptor is:

 F. Kriegbaum, op. cit.

 A. M. Gabbrielli, "Su Bartolomeo Ammanati," Critica d'Arte, 1937, II,
89 ff.

 H. Keutner, "Die Bronzevenus der Bartolomeo Ammanati," Münchner
Jahrbuch der bildenden Kunst, 1963, 79 ff.

 O. Marisani, "Una Statua del Montorsoli e una dell'Ammanati a Napoli,"
Rivista d'Arte, XXIII, 1941, 82 ff.

 P. Sanpaolesi, "La vita vasariana del Sansovino e l'Ammanati," Studi
Vasariani, Firenze, 1950, 134 ff.

 A. Venturi, Storia dell'arte italiana, X, pt. II, Milano 1936, 346 ff.

 S. Bettini, "Note sui soggiorni veneti de Bartolomeo Ammanati," Le
Arti, III, 1940, 20 ff.

 M. G. Ciardi-Dupré, "La prima attività dell' Ammanati Scultore,"
Paragone, n. 135, 1961, 3 ff;"Bronzi di Bartolomeo Ammanati" and "Brevi
note sui bronzetti italiani del Rinascimento," Paragone, n. 151, 1962,
57 ff. and 64 ff.

 For the architecture see E. Vodez, "Studien zum architektonischen
Werke des Bartolomeo Ammanati," Mitteilungen des Kunsthistorischen In-
stituts in Florenz, VI, 1941, 1 ff. and M. Fossi, Bartolomeo Ammanati
architetto, n.d. (1968); Bartolomeo Ammanati, La Città Roma 1970.

 For further literature see Magni in Thieme - Becker Kunstlerlexikon,
and I. Bella - Barsoli in Dizionario biografici degli italiani, Roma,
1960, 798 ff.

The uncertainty begins with Ammanati's birth date. Baldinucci

says that Ammanati was born in 1511[6] "d'Antonio d'un altro Antonio che

si crede da Settignano."[7] The Jesuits, who were intimately involved

with Ammanati and to whom he left most of his worldly possessions when

he died, were under the impression that Ammanati was 82 when he died on

April 13, 1592, and so reads his tombstone in the Jesuit church of S.

[6] Ammanati's birth date is often cited as June 18, 1511. The
earliest mention of this date that I have found is Nagler's Kunster-
lexikon. I have checked Nagler's sources without success in an attempt
to locate the origin of this date, which would seem to have no reliable
old source.

[7] Op. cit, 393. Concerning the question of Ammanati's origins in
Florence or Settignano we may follow Vasari (1550) ed. Ricci, IV, 788:
"Settignano luogo vicino a Firenze due miglia. Alcuni altri lo tengono
(Ammanati) Fiorentino ma questo rilieva nulla, per essere si poco dis-
tanza da l'un luoga a 'altro."

However, Ammanati's connections with Settignano are substantiated
by certain mentions of scarpellini named Ammanati from Settignano which
are found in his papers, ASF, Gesuiti (G. XII), filza 1037 carta 50
and elsewhere, and by the fact that in paragraph 7 and 8 of his will
(of Gaye, Carteggio, 1940, III, p. 54 ff). Ammanati provides dowries
for several daughters of scarpellini from Settignano.

As yet nothing is known of Ammanati's family or background other
than the scraps of names and notes in Ammanati's papers and will.

The mention of scarpellini from Settignano may suggest a stone-
cutting milieu for Ammanati before apprenticing with Bandinelli at the
age of 12.

For those interested in probing the problem further the following
documents should be taken into account: 1) a rough draft of Ammanati's
will (ASF, G. XII, filza 1037, no. 242, c. 10 ff.) 2) Nota dlla
Antichicità degli Amanati et ... sig.re dlla citta di Firenze, ASF,
Gesuiti, XII, f. 1036, no. 240, C.1, in Ammanati's handwriting. 3) A
note of Poligrafo Gargani's in his notes preserved in the Bibl. Naz.
di Firenze, vol. 89, s.v. A: "Ammannati detto sculture, della famiglia
di un Dei del popolo di S. Maria a Pontanico nel contado fiorentino"

Giovannino in Florence.[8] If so, he would have been born in 1510. The
conflict probably arises from the fact that Ammanati himself apparently
had a cloudy memory of his own date of birth. A rough draft of his
last will and testament in his own handwriting dated 1580 says "per
gratia di dio sono oggi a questo di ani 69 in circa (emphasis mine) ..."
and further on, "...Ma da laura mia moglie .30. anni sono ch e' mia
consorte ..."[9] Ammanati was married to Laura on April 17, 1550 at the
Santa Casa in Loreto. If he were 69 in 1580 and had been married to
Laura for thirty years, he would have been born in 1511. If Ammanati
himself was uncertain about it, in lieu of a document such as a baptis-
mal record, we can be fairly certain only that Ammanati was probably born
sometime in the year 1511.

According to Baldinucci, Ammanati was left fatherless at the age of
12 and entered the shop of Bandinelli at about this time. "... Si
acconciò con Baccio Bandinelli celebre Scultore Fiorentino, e da lui
apprese i principi del disegno. Ma o fusse perchè Baccio suo Maestro
era di natura alquanto fantastica e tutta contraria a quella del gio-
vanetto, o per altra che se ne fosse la cagione, stato ch'ei fu alquanto
col Bandinello, avendo sentito, che Jacopo del Tatta Fiorentino (che
per essere stato discepolo dell'eccellentissimo Scultore e Architetto
Andrea Contucci del Monte a Sansovino, dicevasi Jacopo del Sansovino)

8. A letter of April 13, 1592 by P. N. Fabrini which says that
Ammanati died on that day "un suggetto di 82 anni" is published by
P. Pirri, "L'architetto Bartolomeo Ammanati e i Gesuiti" Archivum
Historicum Societatis IESU, XII, 1943, 5 ff. This letter explains
the date on the tombstone.

9. ASF, Gesuiti XII, fil. 1037, no. 242, c. 10.

stavasene operando in Venezia con fama di gran Maestro, subito lasciato

la scuola del Bandinello, e con essa anche la Città di Firenze, colà

sen'ando, accomodossi con lui, e in breve tempo nell'arte della Scultura

molto s'approfittò."[10]

Ammanati's presence in Bandinelli's shop is confirmed by

Bandinelli's Memoriale.[11] But it cannot be gathered from the Memoriale

how long Ammanati was there or what kind of work was he was engaged in.

Bandinelli's words are few. He singles out Ammanati together with

Vincenzo de' Rossi as later becoming his two most successful pupils.

Later on in the text he says that he sent the two of them together with

his son Clemente to study the works of Michelangelo.

If Ammanati apprenticed at the age of 12 as suggested by Baldinucci,

a likely time for him to have joined Bandinelli is sometime during the

period between early 1522 and the fall of 1523, when Bandinelli was in

Florence. In the years prior to the election of Hadrian VII (January 18,

1522) Bandinelli was employed by Cardinal Giulio de' Medici in Rome and

made for him the marble Orpheus now in the Palazzo Medici in Florence,

the Giganti in the garden of the Villa Madama, and he began the Laocoon.

Upon the election of Hadrian VII the Cardinal returned to Florence.

Bandinelli accompanied him and "s'intrateneva intorno agli studi del

disegno."[12] When Giulio de' Medici was elected Clement VII (November 19,

10. Op. Cit. 393.

11. A Colasanti, "Il memoriale di Baccio Bandinelli," Repertorium
für Kunstwissen-schaft, XXVIII, 1905, 434.

12. Vasari - Milanesi, op. cit, VI, 142 ff.

1523), Bandinelli returned to Rome and assisted in the decorations for
his coronation, which included statues and reliefs, and he completed the
Laocoon. The Pope then commissioned from Bandinelli a Martyrdom of St.
Lawrence which was engraved by Marcantonio. This design moved the Pope
so greatly that Bandinelli was made a cavalier di San Pietro. At this
point Bandinelli went back to Florence and painted a St. Jerome in the
Desert and a cartoon of the Deposition, and began work on the Hercules
and Cacus. The preparatory work included many drawings and models. The
block was about half-hewn when the Medici were expelled from Florence in
1527. At this juncture the block was taken from Bandinelli and given to
Michelangelo. Bandinelli, a Medici partisan and hence in danger, as he
himself confesses in the Memoriale,[13] fled from Florence, going to Lucca
and then to Rome where, when the danger had passed, he carried out further
work for the Pope. It is not known when Ammanati left Bandinelli.
Baldinucci says that Ammanati left Bandinelli's shop after Sansovino
"stavasene operando in Venezia con fama di gran Maestro," that is by
the fall of 1527.

We may suppose that Ammanati was with Bandinelli up to the
expulsion of the Medici, when the artistic climate of Florence was
disrupted by political turmoil, as well as by the plague, and Bandinelli's
future was momentarily clouded. In addition to assisting Bandinelli on
his projects of these years, Ammanati's early training must have included

13. A Colasanti, op. cit, 422, 426.

a two-year exposure to the antiquities of Rome. As we shall see
Bandinelli's style of these years, as well as his intense study of the
antique sculptures, made a lasting impression on the young Ammanati.

Ammanati probably spent much of his time drawing modelli by
Bandinelli and antiques, such as those visible in the engraving of
Bandinelli's "Academy" by Enea Vico and Agostino Veneziano and in his
self-portrait, engraved by Niccolo della Casa. Scores of drawings in
Bandinelli's style, executed by pupils and followers, reproducing male
nudes in various postures inspired by the antique and Michelangelo, are
preserved in many drawing collections. It is possible that a few drawings
by Ammanati may one day be excavated from the limbo of "school of
Bandinelli." The difficulties of isolating Ammanati's early drawing
style are due to the fact that until now, there were no signed or other-
wise verifiable drawings by Ammanati datable earlier than 1555. Now we
can safely attribute a drawing in Boston to Ammanati, which dates from
ca. 1535-36, and which is the cornerstone upon which further attributions
of early drawings must be based. It will be discussed in chapter IV.

Even before leaving Bandinelli, Ammanati already had another
exemplar: Michelangelo. Bandinelli says he had his pupils draw from
Michelangelo, following his own method of self-instruction. As a young
and ambitious artist, like many of his peers, Ammanati was eager to
absorb the lesson of the older and enormously famous master. Ammanati's
ardor for Michelangelo even went so far as to follow Bandinelli's model
one drastic step further: stealing Michelangelo's drawings. The incident

is related by Vasari,[14] who says that the drawings were stolen by
Ammanati and Nanni di Baccio Bigio from the house of Antonio Mini in
Florence when Giovanni Norchiati was canon of S. Lorenzo. The drawings
were returned and Michelangelo forgave them, being moved by their
passion for art. The theft must have occurred before Mini's departure
for France in November 1531.[15] Furthermore, we may with all probability
date the episode between 1525 (Bandinelli's return to Florence to begin
work on the Hercules and Cacus) and mid-1527 when Ammanati probably left
Florence for Venice.

We may suppose, then, that the turbulence in Florence in the
summer of 1527 was the moment when Ammanati chose to leave Bandinelli
and fleeing his native city along with others, he found a refuge in the
Veneto under the guidance of Jacopo Sansovino. Sansovino had left Rome
at the sack and is documented as present in Venice by August 5, 1527.[16]
By October of the same year he was already at work on a number of
commissions. According to Lorenzo Lotto he was living with Giovanni
Gaddi, "homo di gran reputatione, rico e gran banchieri in Roma, ..."
for whom he had built a palazzo in Rome, and he was making a figure of
Venus, to be cast in metal, and a "modello di certo pallacio ch'e per

14. Op. cit, VII, 227.

15. R. Wittkower, "Nanni di Baccio Bigio and Michelangelo,"
Festschrift Ulrich Middeldorf, Berlin, 1968, 248-9.

16. A letter of this date of Lorenzo Lotto's mentions Sansovino in
Venice, published by L. Chiodi, Lettere inedite di Lorenzo Lotto,
Bergamo 1962, #19.

un homo da ben rico."[17]

In 1527 Sansovino also executed the Nicolesa tomb in Verona, and in 1528 he was commissioned for a relief for the Santo in Padua, though this was not complete until 1557. From 1528 there are no dated sculptures preserved until the Arsenal Madonna of 1534. In the early years in Venice Sansovino was occupied much of the time with architectural projects including the completion of the Procuratie Vecchie, the restoration of the cupola of S. Marco, projects for the Scuola della Misericordia and the Palazzo Correr.

We can only guess as to how Ammanati spent his time in the late 1520's and early 1530's.[18] Borghini claims that in these years he became "valenthuomo nella scultura." Yet not a shred of documentation has come

17.
 Ibid., #27, 26, 25, 20.

18.
 P. Zampetti, Lorenzo Lotto, Il Libro di spese diverse, Venice-Rome, n.d. (1969), 275, n. 2 suggests that Ammanati might be identified with a sculptor cited in Lotto's August 5, 1527 letter (Chiodi #19) described by him as "giovine et molto valente, unico et solo discipulo di Michelagnolo, quale ha molto bene quelli andamenti del suo maestro." This sculptor knew Sansovino, was also an architect and was repeatedly highly recommended by Lotto to execute an untraced tabernacle in Bergamo. (Cf. letters Chiodi #19, 25, 26, 28) He is traceable in Lotto's letters from August 5 to October 19 of 1527.

 Could Ammanati pass as the one and only disciple of Michelangelo when his closest involvement with the master up to this point was probably stealing his drawings? A much more likely candidate, who fills the limited picture Lotto provides, is Montorsoli. He had worked in the Medici Chapel, was young, and practiced architecture at a later time. This is our first and only knowledge of his presence in Venice, however, as Vasari's biography of him omits mention of the trip, which was apparently brief.

to light concerning Ammanati's activity in the Veneto in this period.
Most of Sansovino's architectural commissions were in the initial
phases, probably still too early for decorative sculpture to be executed
for them. If Ammanati was still in the shop in 1530, we might expect
that he would be a candidate to execute one of the two marble statuettes
for the organ loft which Sansovino designed for S. Salvatore. Instead
the figures went to Cattaneo and Jacopo Colonna. The latter could never
be seriously entertained as an equal of Ammanati. Perhaps this is a
hint, if slight, that Ammanati was already doing independent work at
the age of 19. In fact, there is one work which in all probability
was executed in the Veneto before 1533: the Neptune in Padua.

Chapter 2

THE STROZZI NEPTUNE

A life-size stone Neptune (195 cm. high on a base of 11 cm.),
(figs. 1-7) which stands in a niche of the double-winged staircase
leading to the piano nobile of the Palazzo Strozzi in Padua, is
Ammanati's earliest preserved work. A film of stucco or plaster applied
at a later date, now greatly flaked away, has contributed to the statue's
rather good state of preservation. Seriously detrimental erosion of the
surface of the Neptune is only now just beginning. The only major
losses are the five fingers of the right hand above the knuckles, which
are restored. The figure's state of preservation may also be attributed
to the fact that it was probably always set in a niche. It was certainly
carved for one, even if not necessarily the one in which it now stands.
At the rear of the statue the hollowed head of the dolphin is visible
and the figure is less carefully carved, and nearly devoid of visual
interest.

The dolphin's head is hollow, and channels drilled into the
nostrils and eyes are for the purpose of throwing water into a pool.
There are no metal jets, nor is there evidence that the statue was ever
actually used as a fountain. But the option is there.

The figure was introduced to the literature in 1954 by the late
Giuseppe Fiocco, who suggested that it was a youthful work by Ammanati,

in fact executed "in quegli anni per la prima volta uscito dal nido."[1]

Fiocco believed that Ammanati executed the Neptune as well as the facade

and a new wing of the Palazzo for the Strozzi, an exiled Florentine

family who had lived in Padua for about a century before Ammanati

arrived. The problem with this suggestion is that the building cannot

be documented as possessed by the Strozzi until 1599. Nor is there a

single document which associates Ammanati's name with the Strozzi family

at any time. Therefore the attribution of the building and the statue

must rest on stylistic similarities with certain works.[2]

Though Fiocco did not elaborate on his reasons for attributing

the Neptune to Ammanati, beyond noting a formal resemblance to Bandi-

[1]. G. Fiocco, "La Casa di Palla Strozzi," Atti della Accademia
nazionale dei Lincei, 1954, CCCLI, Ser. VIII, vol. V, fasc. 7, 361 ff.

Fiocco's tentative attribution was followed by C. Semenzato,
"Alcune Opere della Raccolta Benavides al Liviano," Bollettino del Museo
Civico di Padova, XLV, 1956, 93, n. 2, and M. Checchi et al. Padova,
1961, 393.

[2]. I do not believe any part of the palazzo conforms either to
Ammanati's architecture or to sixteenth century styles. The palazzo
is not mentioned in the older guides of Padua by Rossetti (1780),
Brandolese (1795) or Moschini (1817). M. Fossi, Bartolomeo Ammanati
architetto, 1968, 195, rejects the attribution to Ammanati.

Since the present building is unlikely to have existed when the
statue was carved its present niche and pedestal are almost certainly
not its original setting. The figure appears somewhat pinched by the
niche.

As for the pedestal, the base overlaps by a centimeter on the right
side. In addition the base is chipped and has a hole at the right corner
which may be damage done when the statue was moved. The present pedestal
is markedly unornamental and could date much later than the statue.

nelli's work,[3] his assumption that it is an early work is undoubtedly correct. Fiocco implied that Ammanati executed it immediately after leaving "suoi concittadini." Actually the statue, which shows the influence of Sansovino, could only have been executed after a sojourn in Venice.

The Neptune rides the waves (these are actually carved in the base),[4] his majestic weatherbeaten face scanning the horizon. His elegant full beard cascades down his chest, and the locks are pushed back over his head, as if by a moisture-laden breeze. He grasps the dolphin's tail, and holds the truncated cylindrical shaft of a trident or sceptre in his right hand. The thick-limbed, paunchy physique is clearly reminiscent of Bandinelli's revival of the coarser side of late Hellenistic and Roman art, especially in the stucco giganti in garden of the Villa Madama, (figs. 8, 9) executed shortly before Ammanati entered his shop. However, the proportions are not whimsical for a figure of Neptune, who is often represented as a full-bodied male past his prime. His healthy girth and powerful legs endow him with

[3]. Fiocco, op. cit, 369, observed that the Neptune was "ancora legata al fare grasso di Baccio Bandinelli."

[4]. Charles Davis rightly observed a similar attention to detail in the treatment of the bases for the Juno and Fiorenza of the Pratolino Fountain, now in the Bargello, and for the Neptune Fountain in Florence. In the case of each, water playing over the bases would bring them even more to life.

strength and a commanding presence. The figure is an ancient concept
freely restudied in flesh and blood. Both Sansovino and Bandinelli
were inclined to the same practice.

Though indebted to Bandinelli in concept the Neptune's physique[5]
lacks Bandinelli's coarseness and emphatic articulation of muscle and
bone structure. He possesses an elegant head and ideality which is
foreign to Bandinelli's work, and has its roots in Jacopo Sansovino.
But there is still another crucial influence: Michelangelo. The strongly
marked dynamism of the figure, the pronounced circular rhythms, the
imbalance obtained by combining a rotational thrust of the shoulders
with a diagonal movement of the legs, run against the grain of the
classicistic styles of Sansovino and Bandinelli and are inspired
primarily by Michelangelo. The sharp twist of the shoulders and the
oblique movement compel the spectator to move around the figure but the
deep niche prevents him from grasping more than a small arc of views
(ca. 90°). Analogous features are pronounced in much of Michelangelo's
work.

A search for dynamic effects and imbalance links the Neptune with
the Pisa lunette (fig. 13) and the allegories of the Benavides Tomb
(figs. 215, 216). The flat-nosed head and the locks are close to the
Honor on the Benavides Tomb (fig. 219) and Ammanati's River Gods on

5. The 'meaty'-hipped male physique reappears in the Jupiter at Padua,
the River Gods in the Villa Giulia, and the Mars in the Uffizi.

the Library in Venice (fig. 126), though the Neptune's locks are far
more exuberantly lyrical. The Sannazzaro sculptures (figs. 37 ff.) and
the Leda (fig. 25) display a number of similarities to the Neptune: an
underlying debt to classical sculpture and Sansovino, warm silky sur-
faces, and a veiled face drawn toward a plane. The exuberant melodiousness
and thickness of the Neptune's locks, marked by carving which follows and
plays with long discrete strands is closest to the Leda and the Sannazzaro
sculpture. This manner of handling the hair does not reappear after the
Sannazzaro Tomb. These early works possess a sensuous naturalism and
clarity of detail, and warmth which is not yet affected by a greater
abstraction which sets in after the Sannazzaro Tomb and becomes in-
creasingly stronger. This is why the Neptune must date from Ammanati's
first Venetian period rather than the 40's.

In the Neptune we perceive the opening lines of a theme which
occupied Ammanati at various stages throughout his career: the inte-
gration of circular and forward momentum in a striding figure. The Fame
on the Benavides Tomb (fig. 216), the Apollo on the Benavides Arch (fig.
237, 240), the Justice in the del Monte chapel (fig. 246), the Mars in
the Uffizi all reflect Ammanati's persistent interest in the problem and
present different solutions. In the Neptune the stride is hesitant and
the inherent struggle between two conflicting forces seems to arrest the
figure in mid-step. In subsequent works the solution of the Neptune tends
to be reversed. Forward movement dominates the circular, and the circular
acts as a counterpoint which enriches the forward movement without
inhibiting its fluidity and strength.

Statues by Bandinelli are usually conceived in stationary poses
or taking timid steps, like the Orpheus. Those of Michelangelo are
invariably arrested by conflicting forces. It is Sansovino, with his
Bacchus in the Bargello (fig. 10) and the S. Jacopo in Rome (fig. 11),
who announces Ammanati's solution to the problem of a monumental
striding figure, and freshly revives the genre from antiquity. Sanso-
vino's Bacchus adheres to the serene balance and straight axis of
comfortable forward movement exhibited by ancient prototypes. The S.
Jacopo, marked by a rotation of the shoulders, is represented carefully
balanced and poised at the end of a stride, and his movement is ter-
minated. In the Neptune Ammanati greatly dynamizes Sansovino's solution
by drawing on Michelangelo. He employs a sharper rotational thrust,
an off-balance composition and oblique movement, and unlike the S.
Jacopo, the composition of the figure implies further movement. The
far more fluid and organic solution of the Fame and Apollo in Padua
imply a growth away from the influence of Michelangelo which is marked
in the Neptune's semi-arrested movement. This is another cogent
argument for the Neptune's early date.

In the Neptune Ammanati offers a solution to the problem of
integrating forward movement with circular rhythms which Sansovino and
Michelangelo suggested but never explored. Younger artists, such as
Tribolo and Giambologna, in addition to Ammanati, evolved varying
solutions to the problem. Tribolo carved a striding figure with pro-
nounced circular rhythms at a slightly earlier time: the angel for the
Duomo at Pisa of 1528. But it is not known that Ammanati had much
contact with Tribolo at this early period, and their solutions, adapted

to different locations and specifications, are quite different.
Tribolo's figure aimed at balanced fluidity of movement, like Sanso-
vino's <u>Bacchus</u>, but with the use of circular rhythms in the intent to
create a multiplicity of interesting views. At this early date
Ammanati demonstrates that he had appreciated something in Michelangelo
which neither of his teachers had grasped in quite the same way, and
reveals considerable boldness and imagination in integrating it with
other sources.

Chapter 3

THE PISA LUNETTE

"Tornatosene poi alla Patria, e datosi con ogni applicazione a studiare le statue di Michelagnolo Buonarroti, che sono nella Sagrestia nuova di S. Lorenzo, fece maggiori progressi, onde cominciò ad essere da molti adoperato. Le prime figure ch'egli facesse in Toscana, furono un Dio Padre con alcuni Angioli di mezzo rilievo, una Leda, che fu poi mandata al Duca d'Urbino, e tre statue quant'il naturale, che portate a Napoli servirono per ornare il Sepolcro del Sannazzaro celebre Poeta."[1] Thus according to Baldinucci, Ammanati's earliest works in marble were the Pisa lunette, a Leda and three statues for the Sannazzaro Tomb. Borghini[2] is explicit that the latter two projects were executed in Florence, and implies that the Pisa commission was executed elsewhere, probably at Pisa. To judge from style and circumstantial information, the three projects were probably executed following the sequence in which both Borghini and Baldinucci list them.

A lunette with "Dio Padre con alcuni Angioli," with figures slightly under life-size, occupies the upper portion of a tabernacle dedicated to the SS. Martiri, the fifth altar in the right aisle of the Duomo at Pisa[3] (fig. 12-15, 19, 20, 23). The lunette contains the only

1. Baldinucci, op. cit, 398.

2. Borghini, op. cit, 164.

3. The width of the lunette as reported in R. Papini ed., Catalogo delle cose d'arte e di antichità d'Italia: Pisa, 1922, vol. I, p. 54-55, is 2.31 meters.

major figural sculpture of the tabernacle, the other parts being

decorative panels of grotesque and floral motifs by Stagio Stagi.

Although the documents pertaining to the lunette do not mention

Ammanati's name,[4] the sculpture has been accepted by everyone in

modern times as his work on the strength of its citation by the two

earliest biographers. Their attribution is fully justified on stylistic

grounds.

The tabernacle was commissioned from Stagio Stagi on April 8,

1532 and the sculptural parts were probably finished by July 8, 1534

4. I. A. Supino ("Documenti su artisti pisani," Archivio storico
dell'arte, 1893, VI, 428) published the document by which the Opera
del Duomo commissioned the altar of the SS. Martiri from Stagi on April
8, 1533: chon una chasia da sepoltura in dela quale e'à a mettere e corpi
di St. Ghamaliene e Nichodere e Abibo, chon una nostra Donna di rilievo
e antri intagli rilevotti sichondo il modello e disegno c'à l'à fatto
di su mano, la quale de' chominciar per tutto el mese di Setembre prosimo
e finire in due anni sequente, de la quale gli abiamo a dare scudi
quattrocento d'oro larghi a paghare a' lavoranti sichondo si lavorerà
in detto lavoro, con patto, che quando sarà finito detta cappella e la
siisi stimata più che dito pregio, non debi avere più, e quando siisi
stimata manco, debi avere quel mancho che siisi stimato di detta somma ...
(Arch. del Capitolo, filza d. Ricordanze, p. 100, Aprile 8, 1533).

C. Aru ("Gli Stagi," L'Arte, 1909, 286; also in Tanfani, Notizie,
1897, 466) published the document of July 8, 1535 in which a payment was
made to Fancelli and others for an evaluation of the work: "Schudi
secento settanta di lire 7 per schudo e sono per valuta della cappella
di san Ghamaliello e Nicchodemo e Abiba posta in duomo a suo marmo e
fattura" (Debit. e credit. dell'opera del duomo, July 8, 1535, c. 20).
The words "posta in duomo" seem to indicate that the work was complete
and set up.

(both dates according to modern style)[5] when a payment was made for
an evaluation of the work done. The altar carries an inscription
dated January 1536,[6] but this probably records the official liturgical
dedication of the altar, or the date when it was set up, not necessarily
the completion of the sculptural activity. The contract of April 1532
stipulates for the lunette "una nostra Donna di rilievo." Sometime
later, we don't know why, this was changed to the present subject.

Stagio Stagi was at the time the Capomaestro of the Operai of
the Duomo. He was largely a carver of small scale decorative sculpture
and foliage, and was less successful when attempting large scale figures.
In 1529 and 1533 he asked two other Tuscans more versed in figural
sculpture, Tribolo and Silvio Cosini, to carve two angels, most probably
according to their own designs, for the balustrade of the choir.[7] Thus
it should not be surprising that another Tuscan was called in to help
with a major piece of figural sculpture, but we do not know under what

[5]. The dates April 8, 1533 and July 8, 1535 given in the documents
are according to the Pisan year which preceded the Florentine year and
most of the modern year, by one. L. A. Capelli, Cronologia e Calendario
perpetuo, Milano 1896, p. XIII, XVI. To syncronize these dates with
the rest of chronology we must subtract one year.

[6]. The inscription reads: "OPVS FACTVS AN SAL MDXXXVI MENSIS
IANNARII."

[7]. See Vasari ed. Club de Libro, Milano, V, 448; W. Aschoff, Nicolo
Tribolo, 1967, 31 ff., and Bacci, in Bolletino d'arte, 1917, 122 ff.

circumstances it was that Ammanati, who may have been in the Veneto until this moment, was requested to assist Stagi with the lunette.

God the Father hovers in a cloudy firmament, flanked on either side by little youthful angels. He holds an open book in His left hand (with the inscription, EGO SVM LVX MVNDI) and blesses with His right hand. Playful angels, some soaring and some walking on the clouds, clamber about Him. The two angels in the spandrels hold palm branches and lighted torches. The subject was not usual for lunette imagery before this time. Can we attribute its substitution here in place of the Madonna and child to Ammanati, Stagi or the clergy, to Venetian or Tuscan sources? Jacopo Sansovino employed it at a later date, in the lunette of a small bronze tabernacle in the Bargello (fig. 16). Tomaso da Lugano, inspired by Sansovino's composition, used it in a marble lunette of the approximate dimensions of the Pisan one (the St. Jerome altar in S. Salvatore, Venice (fig. 17)), also at a slightly later time.

The Pisa lunette contains very high relief, almost completely cut out from the background, as well as very subtle low relief passages, such as the two putti just to either side of God's head. God the Father is a powerful, broad-shouldered figure, with a mature head marked by irregular lumps and furrows, and a thick beard. His posture is curiously awkward. His right thigh appears too long and raised in an improbable position given His support. Moreover, His left arm appears to be disjointed from His frame and His movements, like those of the putti, are stiff and abrupt. A thrust of the shoulders gives Him vigor and throws Him off-balance. The whole relief, like the large figure itself, is over-balanced to the spectator's left, reminiscent of the Strozzi Neptune.

The differences between Ammanati's composition and those of
Sansovino and Tomaso da Lugano, mentioned above, help us perceive how
closely Ammanati's idiom is derived from Bandinelli and Michelangelo.
Sansovino's lunette represents God the Father as soaring head-first
obliquely down and out of the clouds, gliding with effortless control.
Ammanati's God, instead, is stationary and seated precariously on a
cloud. A thrust of the shoulders and the legs pulled under Him in the
opposite direction spin Him off-balance, and threaten to tumble Him out
of the relief altogether. The opposing movements of the legs and arms of
the putto at the far left dynamize the figure similarly. The ultimate
source for this type of torsion is Michelangelo,[7a] and it was employed by
Bandinelli on occasion. The angels in the spandrels and God the Father
nearly fill up the relief space and appear constricted by it, like
Bandinelli's reliefs on the Papal Tombs in S. Maria sopra Minerva (figs.
18, 21, 22). The somewhat coarse stockiness and stiffness of the figures --
figures in sharp movement, juxtaposed with little organic rhythm or
harmony -- are again reminiscent of the same Bandinelli reliefs, and of
the composition of the colossal Hercules and Cacus. Though the Minerva
Tomb reliefs, commissioned in 1536, cannot be the direct source for
Ammanati's relief style, the links between them probably s t e m
f r o m Ammanati's apprenticeship and reflect densely packed late antique
sarcophagi which both master and pupil no doubt studied in Tuscany and Rome.
The garments of God the Father and of the spandrel angels are copious; the
folds fluctuate nervously and prevent one from clearly grasping an idea
of the body beneath. The source of this drapery style is Jacopo Sansovino's
work of the early 1530's. In his only dated sculpture of this period,

[7a.] For example, the unfinished St. Matthew, the "heroic" slave in the
Louvre, and many of the prophets, sybils and ignudi on the Sistine ceiling.

the Arsenal <u>Madonna</u> (fig. 24), we find a preference for a drapery with copious narrow, shallow-grooved folds and complex linear movement which conceal the structure of the body below.

The flesh of the lunette figures is soft and velvety. Contours and details are blurred, and the forms seem to be saturated in a dense haze like figures in a painting by Lotto or Titian. The drill has gouged thin, deep grooves in the locks and the recesses of the drapery which help to set the whole sculpture flickering and vibrating. The profound sensitivity to atmosphere and light, the love of rippling, fluctuating movement of soft draperies and body surfaces, remain fundamental to much of Ammanati's later sculpture. In the case of the present work, in which the figures should be understood as apparitions emerging from the heavens, the saturated atmosphere makes the divine event seem all the more vivid and palpable. Ammanati's awareness of the potentialities of atmospheric effects must have been awakened by Venice, and in part by Sansovino, whose interest in such qualities is perceptible even as early as the relief of <u>Susannah and the Elders</u> in the Victoria and Albert Museum.

A certain awkwardness of proportions and movement among the figures in the lunette can perhaps be ascribed to haste, youth and inexperience in marble, rather than to the possibility of a model by Stagio Stagi. This awkwardness is conspicuous in the stunted arms of the putto at the far right, in the overly large head of the angel in the right spandrel, and in the unfinished area at the bottom of the left spandrel.

Borghini leaves no doubt that of the works which he mentions, the Pisa commission was Ammanati's first effort in marble. Marble has

properties different from stone which only substantial direct experience
with a hammer and chisel can teach. This may explain why the stone
Neptune, though executed earlier, exhibits greater technical confidence
than the lunette. Despite their differences both works display a
merging of diverse qualities found in the sculptures of Ammanati's
three mentors, and both exhibit a certain awkwardness which accompanies
youthful boldness. This would soon give way to the greater refinement
and harmoniousness which characterize Ammanati's subsequent work.

Chapter 4

THE LEDA

Sometime after July 8, 1534 Ammanati probably returned from Pisa
to Florenze where he would shortly begin work on his most prestigious
commission to date, the Sannazzaro sculptures. Probably in the inter-
vening time he carved "una Leda alta due braccia" of marble cited by
Borghini.[1] Hitherto Ammanati's Leda has generally been identified with
an inferior piece of carving in the Bargello (fig. 36), which copies
Michelangelo's cartoons of the subject of 1529 and which cannot be
associated with Ammanati on stylistic grounds. The fact that the
figure is not nearly two braccia in height should have eliminated it
from consideration long ago. A Leda of nearly this height exists in
the Victoria and Albert Museum in London, where it is currently attri-
buted to Vincenzo Danti[2] (figs. 25, 27, 28, 29, 33). The current
attribution of the Leda to Danti is due to the arguments of H. Keutner.[3]
However, Danti's figures, especially the late works with which Keutner
associates the Leda, such as the Salome of the Baptistry group, are
considerably more abstract, inflated, and attentenuated than the V and

[1] Borghini, op. cit, 164. Professor Ulrich Middeldorf connected
the passage in Borghini with the V and A Leda, and I am most grateful
to him for passing his observation on to me.

[2] J. Pope- Hennessey, Catalogue of the Italian Sculpture in the
Victoria and Albert Museum, Text I, vol. II, p. 457.

[3] H. Keutner, "The Palazzo Pitti Venus and other works by Vincenzo
Danti," Burlington Magazine, c, 1958, 431.

A _Leda_, and owe this to a great dependency on the vocabulary of
Michelangelo's late style. Danti's figures often have large swelling
bodies with tubular limbs capped by small attenuated heads, and possess
a remoteness of expression which is quite removed from the warmth and
sensuous naturalism of the _Leda_, whose compact, normatively proportioned
forms derive from Sansovino and Bandinelli rather than Michelangelo.

If the V and A _Leda_ cannot be by Danti could it be the lost _Leda_
cited by Borghini? The V and A _Leda_ is 138.40 cm. high (without the
base); this equals 2.26 Florentine _braccia_. A difference of one-
quarter _braccio_ need not be considered a significant one in Borghini's
context. The V and A _Leda_ is a little over one-half life size. She
raises her left hand above her head, holding her locks and a garment
which falls down behind her. Raising her right foot on a shell which
shields her coyly from the swan's advances, she places her right arm on
his neck and sways slightly toward him. The composition is inspired by
a Hellenistic Leda type of which the original design is attributed to
Timotheos. This ancient work is known in numerous copies. One example
is today in the Uffizi (fig. 30) and one was in the Villa Giulia in
Rome by the mid-sixteenth century.[4] The relationship between the V and
A piece and the antique is clearer in the preparatory sketch for it in
the Boston Museum of Fine Arts (figs. 26, 34, 35). The overall com-
position in the drawing is reminiscent of the antique, including the

4. See G. Mansuelli, _Galleria degli Uffizi, Le Sculture_, I, #34.

one raised leg and the one arm raised and holding drapery which falls

behind her and to the side. In both, the garment is drawn together

at one shoulder and covers one breast, and the head is inclined. The

connection with the antique may explain Ammanati's use of aquatic

imagery which, though in keeping with the fact that the swan is an

aquatic bird, is rather unusual for Renaissance iconography. At the

base of the antique statue there is a dolphin and a rocky promontory.

The Leda's contained form and the composition oriented frontally

along one forward axis are inspired by Bandinelli and the antique.

These features recall Bandinelli's statuettes of Leda and Cleopatra

in the Bargello (figs. 31, 32), which were probably executed in 1529

or 1530.[5] Bandinelli no doubt knew the Uffizi antique or one like it

and adapted it not only in the Bargello statuettes, but perhaps also

in an early drawing of Leda in the Uffizi which he elaborated in a

painting in the later teens.[6] The Bargello statuettes were executed

after Ammanati had left Bandinelli, but Bandinelli may well have known

the antique before 1520 and perhaps kept a model of it in his studio.

The hand of Bandinelli's Leda, delicately placed on the swan's

neck, the placement and size of the Swan, and the right leg, are reminis-

cent of the V and A Leda, and even more so of the Boston drawing.[7] But

5. Vasari — Milanesi, VI, 153.

6. For this project see Pouncey in Bolletino d'arte, 46, 1961, 323 ff.

7. The connection between Bandinelli's bronze Leda and the V and A
piece was already noted by Keutner, loc. cit, 431.

the proportions, raised left arm, and swaying movement of the London
sculpture recall the graceful lithe <u>Cleopatra</u>. The proportions and
left arm of the latter are closer to the Boston drawing, and illustrate
the connection with Bandinelli still more clearly. As in the case of
the Strozzi <u>Neptune</u> the young Ammanati was clearly guided to ancient
sculpture by Bandinelli, but he interpreted it quite differently and
more freely.[8] He invigorated the figure with a graceful upward spring.
The quality of the dance, of the <u>pas de deux</u>, is brilliantly captured.
The qualities of rhythm and of warm sensuousness are markedly analogous
to the <u>Apollo</u> and <u>Minerva</u> of the Sannazzaro Tomb. They derive not from
the cool neo-Romanism of Bandinelli, but from the warm-blooded classi-
cism of Sansovino. Evidence for Sansovino's interest in this sort of
movement are the three putti on a fountain base in the Bardini Museum
(Florence), the <u>Bacchus</u>, and the frieze of the Library in Venice.

We might draw attention to a certain fullness in the hips,
visible from the side and more apparent in the Boston drawing, which
is characteristic of much of Ammanati's work. The soft, damp, clinging
drapery and its unbroken sweep at the left side are analogous to the
<u>S. Nazaro</u> in Naples (fig. 67). The bunched drapery at the thigh and

[8] The bounding <u>Nymph with a Panther</u> in the Uffizi, a Roman copy of
a hellenistic work perhaps known to Vasari, (cf. Mansuelli, <u>op.cit</u>, I
#100) displays a preoccupation with movement analogous to Ammanati's
Leda though we can't be sure that this particular work inspired him.
Note however, the similarity of the sway to one side and one upraised
arm.

the garment peeling away from the leg were often used by Ammanati,
e.g., in the Minerva (fig. 48), the Nari Victory (fig. 112), and the
Victories at Venice (fig. 164) and Padova (fig. 244a). Similarities
with the angels in the spandrels at Pisa (figs. 19, 20) are noticeable
in the small mouth, shallow eyes, large ears, thick locks and braids
and delicately placed hands.

The drawing in Boston[9] carries a seventeenth-century attribution
which claims it is the work of "Juliani Dandi sculptoris de San
Gimignano.[10] Aside from another drawing in Frankfurt with a similar

9. The drawing was first connected with the London Leda by Pope -
Hennessey, op. cit, who suggested that it might be a preparatory study
for the sculpture.

10. Boston Museum #15.1247. 20.6 (8 3/8") x 30 cm. (11 3/4"), pen
on paper. Provenance, according to museum records: G. Vasari, J. P.
Mariette, Comte de Fries, Heseltine Coll, entered the museum in 1951.
The drawing has been torn, repaired and skillfully touched up, princi-
pally along the top, bottom and left margins including the cheek, and
right-hand fingers of the front view, raised arm of both side and front
views, the swan's wing and rock, and in the drapery of the Pietà. At
the middle of the upper edge there appears to have been some writing,
now no longer decipherable (erased?). The attribution to "Guliano
Dandi" is neatly printed on Mariette's blue mount with gold trim and
reads, in its entirety, as follows: JULIANI DANDI SCULPTORIS E SAN
GIMIGNANO Fuit olim G. Vasari, nunc J. P. Mariette, 1741. Another pen
drawing attributed to Dandi is owned by the Frankfurt Städelschen
Kunstinstitut. It contains sketches of three putti, two of whom hold
tablets. The inscription on the mount of this drawing reads: "Giuliano
Dandi Scultore da san Gimign°." It's apparent from the similar mounts
and inscription lettering that both drawings were mounted and attributed
by the same collector, J. P. Mariette. But what basis did Mariette have
for the attribution? Could the genitive Dandi indicate that Dando owned
the drawing? Or could the attribution go back to Vasari?

Vasari was not always careful about his attributions and his idea
of attribution was different from ours, as Middeldorf (Old Master
Drawings, June 1938, XIII, 10) has observed in an instance where he
labelled a drawing Ammanati. In any case, there is no writing on the
drawing itself which would suggest its author.

seventeenth century mount and attribution, nothing is known of this Giuliano
Dandi. The old attribution must be erroneous, for the drawing is certainly
by Ammanati. The drawing shows a profile study of the Leda without her garment
and the swan, and another frontal view of her clothed. Between these is a
small hand, probably a study for architectural ornament. At the bottom is a
study for a Pieta,[10a] and a larger sketch of the hand of the Virgin.

The two studies of the Leda are among the artists' earliest studies
for the marble, done when the sculptor was still grappling with formal
problems and was still dominated by the formal characteristics of his
two earlier sculptures. Very little is carried over into the marble from
the drawing unmodified. The shell is not yet articulated in the drawing,
the swan is smaller, its form more closed, and Leda's arms are closer to her
body. In the sculpture everything is open and expanding into space rather
than c o i l e d i n u p o n i t s e l f, a n d i t o f f e r s
a more striking silhouette. The difference in the left arm and the
head gives a whole new feeling to the statue. The ballet-like nimbleness

10. (cont'd.)
Mariette owned several drawings attributed to Dandi which came from
Vasari's collection. (See P. J. Marietti, Abecedario, II, 545, Archives
de l'art Francais, Paris, 1853-54, IV, II) of which only those in Boston
and Frankfurt are identifiable today. Mariette sees him as an imitator of
Michelangelo with a style like Bandinelli but with more lightness and grace.

This characterization fits the Boston drawing well enough as far as it
goes, and it is possible that other drawings by Ammanati are lurking under a
Dandi attribution. The Frankfurt drawing may be by Ammanati. If it is, it
certainly is a late sketch, datable after 1555. The drawing has points of
similarity with Ammanati's later sketches in the Uffizi and Riccardiana
sketchbook. The body and head type may be compared to the "Genio dei Medici"
in the Pitti Gallery and to the putti of the Neptune fountain.

10a. Is the Pieta a sketch for a sculpture? The relaxed, slumping body
of Christ and the diagonal sweep of drapery may echo Michelangelo's Pieta
in St. Peter's. The sketch needs further study and comparison to drawings
by Michelangelo and Bandinelli.

and the delicate upward flow are hardly emerging in the drawing. Instead of letting the drapery at the right carry the upward sweep, in the sculpture the body speaks for itself. A spiralling rhythm and a composition over-balanced to the left side, found in the drawing and also in his two earlier sculptures, have been eliminated. The statue is more slender and the transition between the waist and the hips is more fluid and harmonious. What is impetuous and clumsy in the drawing is more controlled and refined in the marble. The stiffness, angularity and imbalance of the Pisan figures, still evident in the drawing, have been eradicated.

The study from the right side shows the figure without her tunic (which is additional proof that the drawing is not a copy after the marble), and shows the sculptor studying the relationship of the members and the structure of the whole. The figure is not built up by the action of light and shade, though the surrounding atmosphere is rendered by parallel hatchings which enclose parts of the figure. This suggests the sensibility of a sculptor who is aware of atmospheric nuances.

While the drawing clearly displays an awareness of the limits imposed by a marble block, the sculpture has an unconstrained movement and expansiveness which attempt to conceal them.

Aside from the subject matter and general outlines, an emphasis on relief-like silhouette and atmospheric nuances are preserved in the sculpture. The fact that the statue is left unfinished (in the swan, the left calf, areas of the hands and shoulders, and back) (fig. 29) suggests that Ammanati's ideas were still undergoing modification even as the statue was nearing completion. The back is only roughly

blocked out, which might also suggest that the figure was intended
for a niche. In any case, the figure is intended to be seen from a
narrow arc of frontal viewpoints, like the Strozzi Neptune. It may
also be that the statue's existing state of execution reflects the
problems of incomplete vs. complete which Michelangelo had posed in
the Medici Chapel. These problems may have been interpreted by the
young sculptor as licensing the option of leaving the figure in its
present state. Certainly the unfinished areas do not inhibit communi-
cation of expressive or formal values, any more than in the case of
Michelangelo's Allegories.

The differences between the Boston drawing and the sculpture
in the V and A point up a considerable modification of aims between
the earliest works and those immediately following. This is part of
the process whereby the sculptor gradually sheds aspects of the styles
of Bandinelli and Michelangelo which were not congenial to his own
sensibility.

The drawing exhibits connections with Bandinelli's graphic style
in the shading by means of vigorous hatching and cross-hatching, but
it lacks Bandinelli's controlled regularity which gives a crystalline
volumetric clarity. Short irregular flicks and squiggles, whose
vibrations break up the plastic volume, are used to construct the
figures. In places such as the hair and drapery, they are the graphic
counterpart of the drill which creates the flickering of light and
shade in the Pisan figures. The choice of studying the figure from
pure frontal and lateral views and the emphasis on relief effect reflect
a classicistic bias which runs through the drawing of Bandinelli.

Did the Duke of Urbino commission the <u>Leda</u>? Neither Borghini
nor Baldinucci suggest it. Borghini says "si trova oggi in mano del
Duca d'Urbino." Perhaps, however, as Baldinucci suggests, the work
was bought by the Duke shortly after it was executed, and it may thus
have been, in part, the reason why shortly after completing the
Sannazzaro commission, Ammanati entered the Duke's services.

Chapter 5

THE SANNAZZARO TOMB

Probably sometime in the latter part of 1536 or the first half
of 1537 Ammanati received the commission to execute "tre statue
quant'il natural, che portate a Napoli servirono per ornare il sepolcro
del Sannazzaro celebre Poeta."[1] These are two over-life-size seated
statues of Apollo (158 cm. high) and Minerva (153 cm.) (figs. 37 ff.
and 46 ff.) on the Tomb and one approximately life-size statue of
S. Nazaro (figs. 67 ff.) (165 cm. high), Sannazzaro's name saint, in
the choir of S. Maria del Parto in Naples. The commission probably
came from Montorsoli, who was charged by the executors of Sannazzaro's
will with the execution of the Tomb. Vasari gives an ample discussion
of the Tomb in the Life of Montorsoli, but he curiously omits any mention
of Ammanati's name. This lapse is responsible for the oversight of
Ammanati's share of the work which persisted until 1937, when Anna
Maria Gabbrielli[2] called attention to the passage in Borghini which
mentions Ammanati's three statues, and rightly recognized the Apollo
and Minerva as works by Ammanati. Slightly later (1941) this was sup-
plemented by Morisani,[3] who noted that the S. Nazaro should also be

1. Vasari – Milanesi, VI, 637 f.

2. Op. cit.

3. Op. cit.

acknowledged as Ammanati's. Finally, Maria Ciardi – Dupré[4] recognized Ammanati's hand in the two putti on the base of the monument.

According to Vasari, Montorsoli received the commission in Naples following his work for the apparato erected for the entry of Charles V into Florence on April 28, 1536. Montorsoli carried forward the project in three cities (Naples, Carrara, Genoa) over a period of four years. The allegorical relief, the last of the three pieces he carved, was executed in Genoa and he left this city to set up the Tomb, it appears, after July 1540.[5]

If Montorsoli did not originally envisage Ammanati's participation, he probably did after he returned to Florence when the Turks attacked Puglia (at the end of July, 1537),[6] whereupon he immediately got himself distracted from the task at hand and was obliged to finish the S. Cosimo for the Medici Chapel and to execute a marble Hercules and Antaeus for Castello.

Ammanati's presence in Florence shortly after the entry of Margaret of Austria to wed Alessandro de' Medici (June 15, 1536) is

4. "Prima attività," p. 9.

5. According to Vasari Montorsoli left Genoa for Naples after executing a statue of St. John the Evangelist which can be dated July 1540 (Vasari, ed. Club del Libro, VI, 485 n. 3 and C. Manara, Le Opere di Giovanni Angelo Montorsoli a Genova, Genova 1959, 41), and is thought to have returned before 1543.

6. L. v. Pastor, Storia dei Papi, Roma, 1904, V, 177, n. 5 and 6.

mentioned by Vasari. It was soon after this event that Battista Franco
met Ammanati while studying the New Sacristy and Ammanati "tirò in case
Battista ed il (Bartolomeo) Genga da Urbino, e di compagnia vissero
alcune tempo insieme, e attesero con molto frutto agli studi dell'arte."[7]
The fruit of this study of the New Sacristy would be realized in
Ammanati's share of the Sannazzaro Tomb.

Ammanati's work for the court of Urbino probably took him to
Urbino and Pesaro by the summer of 1538 at the latest. Is it possible
that his share of the Sannazzaro commission was complete by this time?
To execute three statues of high quality, two of them well over life
size, and the two putti, perhaps in a year and a half is a remarkable
achievement, and consistent with our knowledge of Ammanati's working
capacity. We know that the Tomb in Padova, which carries eight stone
statues, was executed within a year's time. The colossal Hercules was
probably executed within a year, and the Nari Tomb seems to have been
carved in about a year and a half. However, their execution could con-
ceivably have been delayed until as late as 1540.

Sannazzaro died on August 6, 1530 and left the greater part of
his worldly possessions to the Servite Order.[8] This included his Villa
at Mergellina on the fringe of Naples and the small church of S. Maria

7. Vasari - Milanesi, VI, 572.

8. Sannazzaro's will and an instrument of December 25, 1529 by which
he left his estate and the church of Santa Maria del Parto to the
Servite brothers are published in F. Colangelo, Vita di Giacomo
Sannazzaro, Naples, 1819, 201 ff. The most relevant parts for us are
pp. 216-219 and 259.

del Parto which he had begun on its grounds. It is not known who designed this church. It was begun sometime before 1524,when a wooden Nativity group by Giovanni da Nola was installed in the lower church,[9] and it is mentioned as incomplete when Sannazzaro died. In his will Sannazzaro stipulated that 2000 ducati be used to finish the church and to erect a tomb for himself.[10]

The church as it stands today carries the impression of being a large mortuary chapel. It is a small Latin cross-shaped structure of three bays and a choir, with a vaulted tomb chamber attached to the apse and connected with it by a doorway behind the high altar. The Tomb occupies the rear wall of the chamber facing east. Its total width is 333 cm., its height 304 cm. It consists of a large base with putti carrying a memorial inscription by Pietro Bembo which celebrates Sannazzaro's proximity to Virgil in art and death.[11] The base suggests a sarcophagus, raised on legs and decorated with putti and fruit swags. Above the sarcophagus is a marble bust of the poet, who turns in the direction of the window in the left wall, the strongest source of light

[9.] See B. Croce, "La Tomba di Jacopo Sannazzaro e la Chiesa di S. Maria del Parto," Napoli Nobilissima, I, 1892, 73, n. 2, n. 4.

[10.] Colangelo, op. cit., 239.

[11.] The inscription: DA SACRO CINERI FLORES / HIC ILLE MARONI / SINCERVS MVSA PROXIMVS. VT TVMVLO / VIX. AN. LXXII OBIIT MDXXX.

The Tomb of Virgil was located near Naples. Cf. G. C. Capaccio, La Vera Antichità di Pozzuolo, Rome 1652, 9 ff.

in the room.[12] Under the sarcophagus is an allegorical relief. Both
the bust and the relief are by Montorsoli (figs. 62-63 and 57-58, 60-61).
Flanking the sarcophagus are the seated figures of Apollo and Minerva,
the divine wellsprings and protectors of Sannazzaro's art. Though the
presence of Apollo and Minerva on the Tomb is thoroughly appropriate to
a poet, use of such figures in a monument with no Christian imagery was
a bold and innovative creation at the time, especially such a figure as
the nearly nude Apollo. Later in the century, or in the early years
of the sixteenth century, the pronounced classical flavor of it proved too
disturbing and Ammanati's figures were spared the fate of the Nari Tomb
only by submitting to a Christianization. Ammanati's seated figures were
inscribed with the names of David and Judith, according to a tradition,
to avoid having them confiscated on grounds of heresy by a Spanish
governor of Naples.[13] Perhaps for the same reason, the side walls
of the chamber were later frescoed with Old Testament narration.[14]

12. That Montorsoli's bust acquired considerable repute is testified
by Lomazzo's citation of it (Trattato dell'arte della pittura, Milan,
1584, II, 371) as an exceptional example of the expression of prudence.

13. It is not known when the renaming took place, but certainly after
P. De Stefano's guide book (Descritione dei luoghi sacri della città di
Napoli, Napoli, 1560, 265) and Tobias Fendt's engraving of the Tomb in
1574 (Monumenta Supulcrorum ..., 1574 #11). C. Celano, Notizie del
bello ... Città di Napoli, 1724, III, giornata IX, 63.

14. Cf. Croce, Op. cit, 69 ff. for a discussion of the frescoes. A
drawing in the ASF, Convento 119, vol. 1273, #113 contains sketches which
may be studies for the frescoes in the Tomb chapel. This needs further
study, however. Perhaps the tabernacle above the high altar, though late,
reflects an earlier de-secularization idea. Without it, people in the
nave could have seen the bust of the poet above and behind the altar (!)
in the adjoining chamber if the open doorway were not screened off by a
curtain. As it is, the Tabernacle provides a central devotional focus
which Montorsoli apparently did not plan for. See a discussion of a
drawing for the choir further on.

Apparently it was not sufficient that the Tomb was connected to a church
which Sannazzaro erected at his own expense and gave to the Servite Order,
or that he named it after his De partu verginis, an epic glorifying the
Virgin, however classicizing its flavor.

Figures of Apollo and Minerva may have been planned for the Medici
Chapel. However, secular and pagan glorification in a religious context
was often confined to the ideational and planning stage rather than the
final execution, as the Tomb of Julius II demonstrates.

Within the Medici Chapel, the Madonna and two saints were the focus
of the ensemble. In the case of the Sannazzaro Tomb however, originally
no Christian subject matter was placed in the Tomb Chapel proper. Vasari
relates that the statues of San Nazaro and San Jacopo originally were
within the Tomb chamber but, as we shall see, he is mistaken. These are
today, and always were, in niches flanking the high altar. The S. Jacopo
is the work of Montorsoli, and between them the saints spell out the name
of the poet (figs. 64-66).

The question of the iconography of the Tomb needs further investigation,
especially the possible role of neo-platonic philosophy in Sannazzaro's
thought, and the allegorical implications of the antique subject matter.
For the Renaissance humanist, are not Apollo and Minerva the classical
analogues of Christ and Mary? The advent of the Counter-Reformation brought
about the decay of humanism, leaving the two figures exposed to puritanical
Christian orthodoxy, which necessitated the change of their names and the
addition of the frescoes, perhaps another gesture of purification.

Vasari, who presumably got his information from Montorsoli, says that
the Brothers awarded 1000 scudi for the Tomb. A sum of 1000 ducati is
allotted for the Tomb in the first testament of December 25, 1529. In
the final one of August 18, 1530 the sum 2000 was stipulated for both the

Tomb and the completion of the church.[15] One can suppose that 1000 was
used for the completion of the church, presumably carried out between 1530
and 1536. The six-year delay between Sannazzaro's death and the commission
of the Tomb is explained by the fact that the testament provides that the
2000 _ducati_ were to accrue from an annual sum of 400. Thus five years
would have to pass before the full amount for the Tomb would have been
available. It should be borne in mind that the 1000 _scudi_ allocated for
the completion of the church might have included payment for the completion
of the choir and the statues of S. Nazaro and S. Jacopo, as these figures
are not part of the Tomb proper. Currently there is a mistaken assumption,
originating with Vasari,[16] that the two statues originally stood in niches
in the side walls of the tomb chamber. It is believed that if Vasari was
correct, the renovation of the church in the seventeenth century must have
included a transferral of the statues from a previous location i n t h e
tomb chamber to the current one in the choir. Actually the present
arrangement is the original one. A drawing in Florence, either by

15.
 The document published in Colangelo, op. cit., 217: vole che li Frati
del dicto Monasterio e suo Erede, et Successore sia tenuti complire, et
accapare dicta Cappella et Cantaro secondo lo disegno con la spesa de mille
docati, li quali habiano ad pigliare da li trecento docati restano al suo
erede de la dicta summa annuatim sino che serà fornito al dicto Cantaro,
et Cappella, ... The August 18, 1530 will is published also in Colangelo,
239: Vole che de li fructi predicti, et non de la proprietà de esse se ne
habiano ad pigliare dui milia ducati in cinque anni ad ragione de' ducati
quattrocento lo anno, Tanto per lo complemento de la dicta Ecclesia, et
fabrica de Essa quanto per lo Cantaro et Cappelle se haverà da fare dereto
lo altare Magiore de la dicta Ecclesia, dove se haverà da ponere lo Corpo
del dicto Testatore faciendo esso Cantaro, et Cappella come li infrascritti
Signori exequtori vorrano. I am at a loss to explain why Sannazzaro's
final will (August 18, 1530) is later than his death (August 6, 1530).
"Cantaro" is a type of vase. It had a variety of extended meanings,
including,in this instance, funerary urn. Cf. F. Cabrol, Dictionnaire
d'archéologie chrétienne et de Liturgie, II Paris, 1910, s.v. canthare.

16. Vasari - Milanesi, VI, 642.

M o n t o r s o l i or a copy after him shows an advanced project for

the choir of the church (fig. 56 ᴧ).[17] Despite modifications which took

place between the drawing and the final execution, it shows the two

17.
The drawing is preserved among the Servite records in the ASF,
Convento 119, vol. 1273, #113. 27 1/2 x 21 cm., lead and ink on paper.
At the top there is an inscription, probably by a later cataloguing
hand: "disegno della tribune della chiesa di Mergolino di Napoli, dovera
il sepolcro famoso del Sannazzaro."

Among the major differences between the drawing and the existing
choir are:

1) The doorway to the Tomb chamber at the center of the drawing
is rectangular instead of a round-headed arch which breaks the cornice
above it.

2) The four-step platform below the altar in the drawing was
eliminated. The altar in the drawing provides an idea of what the
original altar looked like. The present altar was introduced in the
seventeenth century, and the tabernacle above it containing a modern
statue of the Madonna could be a very recent addition.

3) Details of the ornament of the cornices and separating strips
of the ceiling are not yet present in the drawing. The present ornament
is consistent with Montorsoli's vocabulary as we know it in S. Matteo in
Genoa.

It is not known how complete the church and the chapel were when
Montorsoli entered the picture. The cracking of plaster presently
observable above the Tomb indicates that a window corresponding to
those in the side walls once existed and was later filled in. In addition,
it is likely that a wide shallow niche like those of the side walls below
the windows also once existed in the rear wall. This is suggested by the
difference in substance and density of the wall area between the wall at
the corners and that behind the Tomb. The likely explanation of this is
that the Tomb chapel was already built with the side and back walls equal
in articulation and Montorsoli, wishing to build a Tomb which rose higher
than the niche, filled in both niches . By filling in the window above
he may also have blocked a source of light and glare which would have
interfered with grasping the Tomb, especially its upper parts. Apparently
then, Montorsoli's role in the architecture of the church was confined
to the above and the design of the surface articulation of the choir.
The stucco decoration in the transept chapels and elsewhere in the church
is by a different, apparently seventeenth century hand. On architectural
drawings by Montorsoli, see E. Battisti in Arte Lombarda, X, 1965, 143.

niches which today contain the statues of the saints, and which must
have been originally intended for them. There are no niches provided
for them in the Tomb chapel, and it is difficult to imagine how they would
have been placed there satisfactorily. Vasari thus confused his
information in saying that the two statues in niches were in the tomb
chamber rather than in the choir. He also gives several erroneous
measurements for the figures; e.g., he claims that the size of the
allegorical relief is 2 1/2 x 2 1/2 braccia (146 cm.), whereas actually
it is 88 x 78 cm. For the size of the seated figures he was off by
more than a braccio in the same direction (158 and 153 cm. vs. Vasari's
4 braccia or 224 cm.).

In the December 1529 testament Sannazzaro states that the church
and Tomb ("cantaro") are to be executed "secondo lo disegno."[18] But
what and whose design? No record of it survives, and it is not clear
whether the Tomb, the church or both are meant. In the later testament
of August 1530 Sannazzaro adds that the church and Tomb are to be carried
out "come li infrascritti signori exequtori vorranno." The foundations
and main outlines of the church had already been laid down by 1529.
By "secondo lo disegno" Sannazzaro probably meant to indicate that this
basic plan should not be changed. But what of the Tomb itself? Some,
including Croce,[19] believed that Sannazzaro actually provided a visual

18. Colangelo, op. cit, 217. See note 15.

19. Op. cit.

design. There is little to support such a view. Vasari adds that
Montorsoli and other artists submitted models of the Tomb. Moreover
the Tomb shows nothing in common with Neapolitan tomb sculpture of the
time but does reflect progressive tomb design in Rome and Florence.
It is likely that Sannazzaro indicated some idea of the subject matter
he wished for it, and even its placement. But the architectural and
sculptural articulation was probably left to the artists, subject to
the approval of the executors of the will, as is suggested by the phrase
"come li ... exequtori vorranno."

The design of the Tomb reflects Andrea Sansovino's Sforza and
Rovere Tombs in S. Maria del Popolo in Rome, but even more closely
resembles the scheme of an unexecuted project of Andrea's for the Tomb
of Leo X, recorded in a drawing in the Victoria and Albert Museum
(fig. 55).[20] This shows two seated Virtues flanking a raised sarco-
phagus. As in Montorsoli's design, the seated figures are independent
of containing niches or other architectural elements. However the latter
feature probably reflects Michelangelo's 1505 project for the Tomb
of Julius II.

A drawing by Montorsoli in the Uffizi (14526 - F) (fig. 56)shows
sketches of masks, cornucopiae and a standing figure. It is possible
that these are scraps of his initial ideas for decorative elements of

[20]. Cf. U. Middeldorf, "Two Sansovino Drawings," Burlington Magazine
1934, p. 160.

the Tomb and for the S. Jacopo.[21] But since the objects in the drawing
cannot be certainly identified with any element in the finished tomb,
nothing can be said of the development of his ideas.

Since Sannazzaro probably selected the imagery of his tomb he
no doubt chose the theme for the beguiling allegorical relief, one of
Montorsoli's most handsome creations (fig. 57). The relief has defied
all attempts to precisely identify its subject. It has no apparent
connection with the epitaph provided by Bembo. One aspect of its
meaning is clear enough and was known to Vasari: "fauni, satiri,
ninfe, et altre figure, che suonano e cantano nella maniera che ha
scritto nella sua dottissima Arcadia di versi pastorali quell'uomo
eccellentissimo."[22] Vasari was unsure what was represented (though
this may be due to a memory lapse), as has been everyone since. Only
Pan and Neptune are beyond doubt identifiable by their attributes.
The figure at the extreme right has been consistently misidentified
as Marsyas. He is a creature with a faun's face and fishtail-legs

21. Cf. P. Barocchi et al., Mostra di disegno dei fondatori dell'
Accademia delle arti del disegno, Uffizi, Gabinetto dei disegni,
1963 #22 (Uffizi 14526 F).

22. Vasari - Milanesi, VI, 642. For the various opinions on the
subject matter of the relief see J. Pope - Hennessey, High Renaissance
and Baroque Sculpture, London, 1963, I, 56; S. Bottari, "Giovanni
Angelo Montorsoli a Messina," L'Arte, 1928, 235; B. De Domenici,
Vite dei pittori ... napoletani, 1843, II, 156; W. Rolfs, Neapel,
II, Leipzig, 1905, 139; Croce, op. cit, with earlier guide literature;
D. Maria Avoloi, Il cicerone istructo del deposito di Sannazzaro,
1817, Bibl. Naz. Nap. ms. XIV, E. 38.

bound to a tree. Marsyas is never represented with fishtails. The
female (not Apollo, as is sometimes suggested) who plays a lyre is
probably a Muse. The female between Pan and Neptune holds a feathered
lance. She appears to be a consort of Neptune and therefore may be
Thetis. But no one, including myself, has come up with a classical
or Renaissance text which fits the action. It seems clear that a
contest between sacred and profane music is intended, though not the
orthodox one of Marsyas and Apollo or Pan and Apollo. The theme may
just be an invention of Sannazzaro's. Pan's spirit is central to
Sannazzaro's early pastoral verse. Three figures -- Neptune, his
consort, and the curious sea creature at the right -- might be warranted
by the proximity of Mergellina to the coastline as well as by the fact
that Sannazzaro's later pastoral verses, the Pescatorie, are set at the
seashore. The introduction of the Muse, and hence the rivalry between
sacred and profane, is probably a delicate allusion to the dual and
opposing natures of Sannazzaro's poetic achievement: the light, pastoral
works which he wrote late as well as early in his life, and the major
epic work which occupied much of his later years, the De Partu Verginis
which solemnly glorifies the Virgin. In any event, it seems likely that
the theme of the "scherzo," if it is one, is attributable to Sannazzaro
rather than to Montorsoli.

Since Montorsoli no doubt provided the executors with a model of
the Tomb, what role did he have in the design of Ammanati's figures?
Perhaps he provided Ammanati with initial sketches or bozzetti which
helped establish the main outlines of the figures. Since both artists

had been deeply immersed in the Chapel and influenced by Michelangelo per-
haps it is fruitless to debate who is responsible for the close rela-
tionship of the Apollo and Minerva to the M e d i c i e f f i g i e s.
However, the completed figures hardly reflect Montorsoli's personality.
One need only compare Montorsoli's own work on the same project or the
work in Genoa to guage that Ammanati had a free hand in the final design
and execution of all his work in Naples.

The Apollo and Minerva are among Ammanati's most exalted creations
conceptually and technically. It is easy to understand why no critic
has ever had anything but words of praise for them, no matter what
sculptor was believed to have carved them. The figures are overflowing
with movement and life. Minerva turns toward the poet and seems about
to spring up to acclaim or defend him. Apollo appears to be waiting
for a divine signal to begin a chant and bow his viola da gamba.
They are imbued with alert serenity and self-assured calm, and they
embody a lofty ideal of classical grace and perfection which is a
direct outgrowth of Jacopo Sansovino's sculpture. The flesh is warm
and soft, the skin as smooth and moist as a petal, the marble caressed
to a high degree of translucency.

As has often been noted, many similarities are evident between
these figures and Michelangelo's effigies in the Medici Chapel: the
poses, the attenuated proportions (e.g., the long necks), as well as
details of costume. The large helmet which throws a shadow over
Minerva's face is inspired by the Lorenzo, while the cuirass, treated
like an epidermis, and the loving attention given to vivid masks,
recall the Giuliano (fig. 46a). Drapery is more controlled and

subordinated to corporeality than in the lunette in Pisa. This is
reminiscent of the Leda and also derives from Michelangelo. The pose
of Apollo may echo an early study for the effigy of Giuliano in the
nude, later rejected, by Michelangelo. Michelangelo's study may be
recorded with some accuracy in drawings by Tintoretto in Oxford.[23]
Where the Giuliano is arrested by a clash of opposing movements,
Ammanati's figures seem to be palpable apparitions frozen by a camera
shutter. This quality, as well as the obsession with forward and up-
ward spring, with grace and fluidity, are present in the V and A Leda.
The differences between the Boston drawing and the marble Leda are not
unlike those between the Giuliano and the Minerva: the spiralling of
Michelangelo's form is somewhat opened, the coiling released, and the
sculptor employs a more balanced, frontal compositional scheme inspired
by the classicism of Bandinelli and Sansovino. The figures are a
sophisticated adaptation of Michelangelesque formal vocabulary into a
lyrical idiom wholly diverse from Michelangelo's. They are rather
the spiritual descendants of Sansovino.

The S. Nazaro (fig. 67) is more classically proportioned than
the two seated figures, conforming more to the canons of Sansovino
and Bandinelli. But the creamy, velvety surfaces, and the commanding
serenity and aloofness are much in the same spirit. The head is broad

23. Illustrated in D. v.Hadeln, Zeichnungen des Tintoretto, Berlin,
1922, pl. 7. The possibility of a connection with Michelangelo's
earlier studies for the Giuliano was noted by Weinberger, Michelangelo
the Sculptor, 1968, 345 n. 115.

and squarish, reminiscent of Bandinelli's types. But the powerful
neck, the veiled eyes, the thick, sharply curling locks, the mouth
and nose are much inspired by the Giuliano de' Medici (fig. 72).
The contrapposto is a modified reversal of J. Sansovino's S. Jacopo
in Florence (fig. 74), a statue which Ammanati openly admired in his
letter to the Accademia del Disegno. Weihrauch[24] has called attention
to the distinctiveness of the contrapposto of Sansovino's statue, in
which the shoulder above the weight-bearing leg rotates forward rather
than backward and the head turns in the direction of the forward-
rotated shoulder. This coils the standing figure like a spring and
is in violation of the classical canon of contrapposto employed in
ancient times and in the Quattrocento. The creator and developer of
coiling movement in sculpture was Michelangelo and, in formulating
the contrapposto of his S. Jacopo, Sansovino was no doubt influenced
by the master's work, perhaps by his unfinished St. Matthew. Ammanàti
takes up Jacopo's idea, but he creates a more powerful figure with a
higher degree of tension, despite its smaller dimensions. He does
this by using a figure with a broader, more compact physique and by
clarifying the structural members of the body, so that the energy
obtained from the figural torsion is not lost in an abundance of
drapery with occasional independent life. Ammanati clarifies the
position of the legs and rectifies the instability and slight Gothic
sway of Sansovino's statue by making the drapery conform more to the

24. H. W. Weihrauch, Jacopo Sansovino, Strassburg 1935, 10.

body beneath and by eliminating the broad sweeps of drapery which mask
the distribution of weight in the legs. These changes reflect the more
architectonic and powerful sculptures of Michelangelo and Bandinelli, as
well as Sansovino's later work.

Ammanati also executed the two delightful putti which support the
inscription on the base of the Tomb (figs. 77-78). Their locks are
quite similar to those of S. Nazaro, and their buoyancy and surface
are like the two statues above them.

The three Sannazzaro statues show that Ammanati made a profound
study of Michelangelo's Medici Chapel, but at the same time his roots
in Sansovino's art grow stronger, and actually come to outweigh
Michelangelo's influence even more than before. Michelangelo's influence
is more markedly tempered by Bandinelli's and Sansovino's classicistic
styles than it was in the Neptune, the Pisa lunette and the Boston
drawing. As already announced in the Leda, A m m a n a t i h a s
shed Bandinelli's coarser side and demonstrated himself capable of
utilizing compositional modes alien to his own earliest works and the
compositional principles of the Medici Chapel. But the shift visible
in these two projects was not irreversible, as the allegories of the
Benavides Tomb demonstrate. Ammanati's sensibility synthesizes as it
explores, tests, shifts direction, and develops stylistic options
congenial to the sculptor at a given moment and suitable for a specific
subject for a specific location, rather than following a rigid linear
development.

Chapter 6

AMMANATI'S WORKS FOR THE COURT OF URBINO

Following the Sannazzaro commission, Borghini says, Ammanati
"trasferitosi poscia ad Urbino, diede principio a una sepoltura, e
lavoro molte istorie di stucco; ma in questo tempo morendo il Duca,
egli se ne tornò a Firenze."[1] Vasari mentions the Tomb in his Life of
Girolamo Genga: "Fu similmente per suo (Genga's) disegno e opera fatta
da B. Ammanati fiorentino scultore, allora molto giovane, la sepoltura
del duca Francesco Maria in Santa Chiara d'Urbino, che, per cosa sem-
plice e di poca spesa, riuscì molto bella."[2]

On the strength of the Borghini it is often thought that the Tomb
of Francesco Maria I was executed shortly before the Duke's death in
October 1538.[3] However, it should be observed that Borghini only says
that the Tomb was begun("diede principio") at this time.

The entire Dukedom was thrown into uncertainty and momentary
panic by the unexpected death of Francesco Maria and work on the Villa
Imperiale stopped at this time. Genga and assistants turned to the
construction of funerary decorations. A contemporary account of the
funeral tells us that it was conducted in the Duomo of Urbino and that

1. Op. cit, .164.

2. Vasari - Milanesi, VI, 321.

3. E.g., Pope - Hennessey, op. cit.

the Duke was laid to rest in S. Chiara, but there is no mention of a
Tomb monument.[4] This suggests that no tomb for him existed when he
died. In this light "diede principio" might suggest no more than
drawings, or perhaps a model existed when the Duke died. In fact
Vasari, in the 1550 edition,[5] says that the tomb was carried out by
Guidobaldo II, Francesco Maria's heir, after the death of the latter.
But when? During the initial years of his reign Guidobaldo used his
resources to secure his military and political power.[6] Under him work
never resumed at its former pace at the Imperiale. Thus it seems
unlikely that Ammanati executed it between the October 1538 and the
fall of 1539, the onset of work for the Nari Tomb. Ammanati's activity
in late 1542 and 1543 is unaccounted for and there is reason to believe

[4] Anonymous, "Le Memorie del Duca Francescomaria ..., n.d.,
Vatican Cod. Urb. 997 p. 576-600. Though undated, the manuscript
goes into detail that would seemingly be available only from eye-
written accounts of the funeral.

 cf. also Marco Guazzo, Cronica, Venice, 1553, 411 r.

[5] Vasari (1550) - ed. Ricci, IV, 788: "dopo la morte del predetto
duca (Francesco Maria I), il suo figliuolo Guidobaldo facessi fare
per ordine pure di Geralamo Genga, la sepoltura di marmo che è volle
fare a suo padre, da Bartolomeo Ammanati da Settignano".

This hitherto unnoticed passage was kindly brought to my attention
by Charles Davis.

[6] W. Dennistown, Memoirs of the Dukes of Urbino, III, 400.
G. B. Bellucci (Diario Autobiografico (1535-41), ed. P. Egidi, Napoli,
1907, 107) mentions that in December 1538 "l'signor ducha per respette
de la guerra aveva fatto lascare la fabrica de lo Imperiale."

that he executed the Tomb at this time.

For one, Vasari in his life of Genga[7] associates the tomb's execution with Battista Franco's frescoes for the choir of the Duomo of Urbino. They were nearly complete by August of 1546[8] and may have been begun as much as two or three years earlier. Secondly, Ammanati was involved with another commission for Guidobaldo which had reached the execution stage by the summer of 1544. We suspect that this project provides the terminus ante quem for the Tomb, for why would he embark on it if the Tomb was not finished?

The information about the latter commission is derived from a recently discovered document in the Carrara archives[9] which states that the Duke of Urbino was attempting to ship, for Ammanati's use,

[7] Vasari – Milanesi, VI, 320 ff.

[8] cf. G. Gronau, Documenti Artistici Urbinati, Firenze, 1936, p. 147, doc. #CLXXXV.

[9] The document is published in full in Appendix I, doc. 1. The gist of it is that Michael Ferrari (the Duke's agent probably) had contracted for the shipping of the marble, with three other men, in June. Since it was not done in June the said three absolved him and his heirs from the cost because they still intended to ship the marble to Messina.

The document was unearthed by Christiane Klapish – Zuber (Maitre du Marbre Carrare, Paris, 1969, 210, n. 134) who also gives references to documents concerning Ammanati on March 10, and July 11 and 31. However, there are no documents of these dates.

I would like to express my gratitude to Dott. Giuseppe Arsento, Direttore of the Archivio Communale at Massa for his kindness in taking the trouble to allow me to consult the documents, to Mr. John Monfasani for transcribing the text, and to Charles Davis for alerting me to the notice in Mlle. Klapish – Zuber's book.

three blocks of marble from Carrara to Messina. The document does not reveal the purpose for which the blocks were to be used, nor does it imply Ammanati's presence in Carrara at the time or earlier. It does say that the shipment was delayed (it's not known how long) by the presence of the Turkish fleet in the Mediterranean. Presumably, the marble was to be later shipped from Messina to Pesaro, and then perhaps overland to Urbino.

However, Ammanati must have abandoned the project, temporarily or permanently, for the more attractive offers of Benavides. For the colossal Hercules in Padua was begun sometime in 1544 and carried out in the brief span of only a year.

The question might arise as to whether the three marble blocks were destined for the Tomb. The only description of it is Vasari's, who says "per cosa semplice e di poca spesa, riuscì molto bella." This sounds somewhat more modest than three marble blocks. And if these were to be carved into figures, as seems likely, would Vasari have omitted mention of them if they formed part of the Tomb?[9a]

Today a wall tomb for the Duke exists in S. Chiara, which is sometimes believed to be the work of Genga and Ammanati.[10] It consists

[9a]. There is a sketch for a Pieta on the drawing in Boston (fig. 35). Could this be a study for one of Ammanati's lost works for Urbino, for the Tomb or the project involving three marble blocks?

We should recall that Bandini's family Tomb which replaced Ammanati's (see below, p. 57b) included the Pieta today in the Oratorio della Grotta.

This possibility, which needs further investigation, is seductive because the sketch is together with that for the Leda, which might possibly have been commissioned by the Duke. If the sketch does reflect Ammanati's intentions for the Tomb then the preparatory stages of planning for it must have begun earlier than I have suggested, before the Duke's death, and as early as perhaps 1535-36 when Ammanati and Genga were closely associated.

[10]. Most recently, G. Marchini, "Il problema dell'Imperiale," Commentari, XXI, 1970, 66 ff.

of a simply framed memorial inscription[10a] flanked by two small marble
tondi (ca. 30 cm. in diameter), devoid of frame or enclosing features,
representing on the left a portrait of the Duke in profile, and on the
right his coat of arms (figs. 80a, 81, 84, 86, 87, 88).

As a whole, the elements are arranged in a very plain and modest
manner, hardly worthy of Vasari's praise "molto bella." Would the
services of Genga have amounted to this?

The frame of the inscription agrees in style with the current
decor of the building, but the building has not been sufficiently
scrutinized to be able to establish with certainty either its date,
author, or the sequence of execution of its parts. Wholly or in part
it has been claimed for Francesco di Giorgio, Genga, Ammanati, and an
anonymous seventeenth-century architect. Nor is this similarity much
help in itself, as the frame is simple enough to have been made to
conform to a pre-existing scheme without difficulty.

10a. The inscription says that Leonora, Francesco Maria's consort,
had the tomb erected. It may be that she persuaded Guidobaldo to
follow through with the project. It reads:

Francesco Mariae Duci, amplissime belli pacisque
Muneribus perfuncto, dum paternas urbes, per vim
Ter ablatas, ter per virtutem recipit, et receptis
Aequissimo moderatur; dum a pontificibus, a Florentinis,
A Venetis exercitibus praeficitur; deinceps et gerendi
In turcas belli; dum princeps et administrator
Assumitur, sed ante diem sublato, leonora uxor
Fidissima et optima meritissimo posuit, et sibi.

The most plausible thesis of the current Tomb's origin was put
forth by P. Rotondi.[11] He suggested that the current monument was
actually erected when the church was renovated in the second quarter
of the seventeenth century, using Genga's inscription but sculptures
by Bandini carved in the 1580's. A notice of 1587 informs us that Duke
Francesco Maria II acquired "pietre" for a tomb of Francesco Maria I.
Why would he do so when there already existed a tomb of this Duke? The
only hint lies in the inscription below Bandini's Pietà in the Oratorio
della Grotta, which suggests that Francesco Maria II planned a family
mausoleum for himself and his ancestors. Apparently he intended to
commission it from Giovanni Bandini in the 1580's. The same project
may be referred to in a letter of the Duke's of January 1582 to Bandini
mentioning "figure grandi et piccole di marmo et anco di getto." Until
recently, nothing further was known of the project and Rotondi supposed
that Bandini's Tomb was either aborted after he had executed the two
tondi and the Pietà or destroyed at a later date. But recently Pinelli
and Rossi unearthed a new piece of documentation which supports Rotondi's
thesis, that: "Francesco Maria I fu seppellito pomposamente nella chiesa
di Sta. Chiara, dove Francesco Maria II, suo Nepote fece fabricare un
bellissimo sepolcro di marmo che poi fu rimosso stante le proibizioni

11. P. Rotondi, "Contributi all' attività urbinate di Giovanni
Bandini detto dell'Opera," Urbinum, XVII, 1942, 8 ff.

che vennero di non potersi tener tali sepolcri in mezzo della chiesa."[12]
This document enables us to establish that Francesco Maria II's Tomb
project for his people was in fact carried out, presumably by Bandini,
and in all probability contained the figures of bronze and marble
mentioned in the Duke's letter of 1582. The text does not refer to
the Tomb as a family mausoleum, though it may have been, as is suggested
by its size and placement. What became of the earlier Tomb? Perhaps
it had to be removed even before Francesco Maria II could occupy it.
This is suggested by a letter of the Duke's of December 1627 which
mentions plans for a complete remodelling of the church.[13]

Perhaps the remodelling was partly or wholly occasioned by the
removal of the Tomb, since only a few years later, by 1631, the
concluding year of Bonamini's chronicle[14] and t h e y e a r o f the

[12.] Text by the seventeenth-century chronicler Bonamini, published in
A. Pinelli and O. Rossi, Genga Architetto. n.d. (1971), 290. Ms. Bibl.
Oliveriana, Pesaro, vol. 54, t.3, c. 64.

Unfortunately, I have not been able to locate an example of
C. Leonardi, "Il sepolcro di Francesco Maria II della Rovere ultimo
duca di Urbino" Deputazione di storia patria per le Marche, Atti e
Memorie, ser. 8, IV, 1964-5, 99 ff.

[13.] Cited by Rotondi, loc. cit, 12, and its most important parts
published by the same author in Studi Urbinati Artistici, Urbino 1949,
128, n. 53.

[14.] Bonamini's account explains why the remains of the members of the
ducal family who presently have wall tombs in the church were found in
broken, piled up caskets under the floor of the church when the pavement
was restored in 1872. This discovery is related in P. and E. Gherardi,
Guida di Urbino, Urbino, 1890, 56.

Duke's death, the <u>Tomb</u> was gone. If in fact, as Rotondi suggested, at
the time of this remodelling, the two tondi were taken from their original
context and inserted in the wall, we should be able to associate them
stylistically with Bandini. And indeed we can, as Rotondi himself has
shown.

Both tondi have at the periphery a slightly sunken lip which might
be a framing device, but which might have also functioned to hold them
within a larger architectural framework, such as might have been en-
visioned by Bandini for the family mausoleum. Notable similarities
are observable with Bandini's work, especially with the bronze bust of
Francesco Maria I which he executed for the Duke's grandson, now in the
Uffizi and with the marble statue of the same Duke in the <u>cortile</u> of
the Palazzo Ducale in Venice (fig. 89). All three show a crisp and
precise delineation of the features of the head, a dry and cool clarity
and organization of the locks in small, thick tufts deriving directly
from the later classicistic style of Bandinelli. The disparity between
Ammanati's work and the tondi is pointed up by comparing the relief
portraits on the balustrade of the del Monte Chapel in S. Pietro in
Montorio (Rome) (figs. 82, 83, 89). The portraits, in somewhat lower
relief than the tondi, have a translucent, buttery texture and glow
from within. The whole surface fluctuates and eddies like an image
seen beneath a pool or water. A similar handling of form is not lacking
in the head of Mario Nari, which is nearer in date to Ammanati's Urbino
activity.

Another important difference between the works is the manner in
which the eye is treated. In the del Monte reliefs the eye is pulled

toward the back of the head, and seen almost in flattened three-quarter view, while the Urbino head is represented in precise profile with an unflattering bag below the eye (not found in Ammanati's heads) and an eyebrow formed of a smooth geometrical arc reminiscent of other of Bandini's heads. The vocabulary of the Urbino relief has notable similarities with Bandini's Christ in the Oratorio della Grotta (fig. 87) executed contemporaneously, and with later figures for the choir of the Duomo (fig. 85).

The barrenness of the frame of the Urbino tondo is apparent when compared with that in Rome which lends support to the notion that it was lifted from a larger context. Notable also is the striking difference in the way in which the bust proper relates to its frame. Ammanati's Rome relief precariously balances itself against the side and bottom as if a fragment severed arbitrarily from a larger whole. Bandini's head by contrast is suspended, formally independent of it. The impression that the head is a fragment of a larger portrait is suggested even more strongly in the female relief head (fig. 82), where it appears as if we are looking through a window at the head of an entire figure whose shoulder is pressed against it.[14a] In the Urbino relief by contrast, the lower edge is smoothly and decoratively shaped into a wave form, which leaves the impression of a complete unit, and hangs suspended, formally independent of its lip.

14a. Cf. Irving Lavin's study of this feature in Renaissance portraiture in Art Quarterly, V. XXXIII, Fall 1970, 207 ff.

Thus we have little choice but to agree with Rotondi that
Francesco Maria I's original Tomb by Genga and Ammanati is lost, except
perhaps for the inscription, and that the current sculpture of the Tomb
is Bandini's work of the 1580's lifted from a larger Tomb which once
stood in the center of the church and set into the wall in the second
quarter of the seventeenth century by an anonymous hand.

What of the "molte istorie di stucco" cited by the two biographers?
Borghini's words suggest that Ammanati's work consisted of narrative
reliefs set in quadri, such as those executed later by Federico Brandani
for Duke Guidobaldo in the Ducal Palaces in Urbino and Pesaro.

Borghini would lead us to think that Ammanati's stuccos were
executed in Urbino. If Ammanati did work in Urbino, the most likely
place would have been the Ducal Palace. However, Bernardino Baldi's
1581 description of this Palace,[15] which is quite thorough, says that
Francesco Maria had very little decorative work carried out there, and
no stucco work can be associated with his reign. The only major piece

15. B. Baldi, Descrizione del Palazzo Ducale di Urbino, 1587, 89 ff.

of work which the Duke ordered was the construction of the coridoi
pensile, which is now destroyed. However, Baldi notes that Guidobaldo
II ordered stucco decorations for a number of rooms. These, which still
exist, are by F. Bandani and date from the second half of the sixteenth
century.

It is well known that the focus of Francesco Maria's artistic
interests was the Villa Imperiale at Pesaro, enlarged and remodeled by
Girolamo Genga. The decoration of the interior of the villa consisted
primarily of paintings by Bronzino and others. But Vasari[16] and
documents[17] mention that some stucco was also executed, of which only
scraps remain today on the piano secondo.[18] These consist of square
quadri composed of classicizing decorative motifs enclosing a sunken por-
tion containing an oval.[19] No figural work now survives among them, though
Borghini suggests that at one time there may have been some. The anti-
quicizing flavor of the remaining stucco including the use of the oval
form is reminiscent of the architectonic stucco work which Ammanati did
for the grotta of the Villa Giulia. The vault of the grotto also consists
of recessed stucco quadri, composed of classicistic mouldings and decora-
tive motifs. For the grotta however, birds and other decorative motifs
occupy the central recessed areas. This suggests that Ammanati may
indeed be responsible for the surviving stucco work at the Imperiale.

16. Vasari' - Milanesi, VI, 320.

17. G. Gronau op. cit, 140 # CLXVI, letter of April 29, 1538: "... in
le stantie tuta via si lavora, benchè in li lavori di stucho et pictura
non si pò molto correre."

18. Cf. Pinelli and Rossi, op. cit, 194, and B. Patzak, Die Villa
Imperiale in Pesaro, Leipzig, 1908, 98-100.

19. Illustrated in Patzak, op. cit, 100.

The decoration of the Imperiale was not entirely complete when work there was totally halted by the unexpected death of the Duke. What stuccoes were carried out were already in a bad state of repair in 1627, according to an inventory of the Villa of this date.[20] If any survived the seventeenth century, a coup de grace was perhaps delivered by a shelling which the building received during the Second World War, which extensively damaged Genga's wing.[21]

To sum up what we know of Ammanati's Urbino activity, it seems that initially Ammanati was perhaps introduced to the artistic projects sponsored by the court by G. Genga. Genga and Ammanati must have known each other at least as early as mid-1536, when Ammanati took Genga's son Bartolomeo under his wing in Florence. Perhaps as a return favor Genga was instrumental in the Duke's acquisition of Ammanati's Leda and provided Ammanati with work at the Imperiale as the building became ready for embellishment, sometime between 1536 and October 1538. In these years Ammanati may well have been active in an architectural capacity as well, though none of the recent Urbinate attributions to him has been convincingly demonstrated.[22] It seems fairly certain that Ammanati was executing stucco quadri, now mostly lost, at the

[20]. The inventory published in Gronau, op. cit, 145 #CLXXVIII: "nel 2° piano sono n. 15. stanze ornate parte con stucchi quali patono notabilmente dal umido, piccole similmente da non potervi accomodare un letto." The same in Pinelli-Rossi, 278.

[21]. cf. Pinelli-Rossi, op. cit, 274.

[22]. cf. G. Marchini, op. cit.

Imperiale from the early part of 1538 until October of the same year.

Our examination of Ammanati's activities in Venice and Padua allow for a return to Urbino in late 1542 or 1543, and it is likely that he executed the Ducal Tomb at this time. Ammanati was probably involved in a commission subsequent to the Ducal Tomb, but it's not certain that he was active at the court after 1544.[23]

23. A. E. Brinckman (Barocksculptur, Berlin, 1917, 107) attributes to Ammanati a stucco head of a youth formerly in the Lanz Collection, Amsterdam, whereabouts now unknown. This head is said to have come from Urbino, but its provenance can apparently not be documented before the nineteenth century. In the Lanz Collection, until Brinckman's attribution it was called School of Michelangelo (personal communication Mr. G. B. Lanz). Prince Erkinger - Schwarzenberg has observed that the head is a copy of the so-called Antinous Grimani in Venice (personal communication). Judging from photos, the head seems to have nothing which would justify an attribution to Ammanati. Renaissance copies of the Antinous are numerous. Cf. M. Wegner, "Antikenfälschung der Renaissance," Bericht über den IV intern. Kongreß für Archäologie, Berlin 1939, 147.

I am very grateful for the assistance of Mr. Lanz and Professor Erkinger - Schwarzenberg in this problem.

M. Weinberger (Gazette des Beaux-Arts, May 1945, 257 ff.) attributed a bronze bust of Galli in the Frick Collection to Ammanati. However, a more sensible attribution to Federico Brandani has been proposed by Pope - Hennessey, Italian Sculpture in the Frick Collection, V. III, N.Y. 1971, p. 228.

Chapter 7

THE NARI TOMB

While continuing to maintain contact with the court of Urbino,
Ammanati probably returned to Florence after the death of Duke
Francesco Maria. Ammanati's activity between November 1538 and
October 1539 is not known. Analogies between aspects of Tribolo's
grotto at Castello and Ammanati's later fountain in Vicenza suggest that
Ammanati might have spent sometime during this period working with
Tribolo (see Chapter 9, part VII). The next major commission of which
we have a record is the Tomb of Mario Nari, once in the SS. Annunziata
in Florence, which was given to Ammanati sometime after October 18, 1539.
"...Fece quella sepoltura di marmo, che doveva andare nella Nunziata,
di Mario Neri Romano, che combatte con Francesco Musi, in cui egli
avea fatto la Vittoria, che avea fatto un prigione, due fanciulli, e
la statua di Mario sopra la cassa; ma quest'opera (perchè fu stimata
incerta da qual parte fosse la Vittoria, e perchè non fu l'Ammannato
in ciò molto favorito dal Bandinello) non si scoperse altramente, e le
statue furon trasportate in varj luoghi, ed i due fanciulli di marmo
sono oggi, rappresentando due agnoli, dinanzi all'altar maggiore nella
chiesa de' Servi. Per questa cagione rimanendo mal soddisfatto
l'Ammannato, se ne andò a Vinegia..."[1] The Tomb was dismantled in the
later sixteenth century and only the effigy of Nari and the Victory group

[1]. Borghini, op. cit, 165.

survive, today preserved in the Bargello (figs. 90 ff. and 103 ff.).
The lost parts include the casket and two youths (<u>Fanciulli</u>) and
whatever other decorative embellishments there may have been. The
Victory group (200 x 100 cm.) in the Bargello fits Borghini's des-
scription. The effigy (160 x 66 cm.) is identifiable with Nari on the
basis of style and because of the soldier's dress.[2] The two youths
were given wings and used as angels flanking the high altar of the SS.
Annunziata for a little over a century. Today the only visual record
of them, and it is an impoverished and unreliable one, is a drawing of
the high altar area of 1675[3] (figs. 95, 96). It shows them standing
on low columns holding candelabra. The one on the left appears to stand
in a gentle contrapposto, holding a candelabrum in a raised right hand.
The figure on the right holds up a candelabrum with the left hand.

[2] Not identified with Nari in the <u>Catalogo del Reale Museo Nationale
di Firenze, Roma</u> 1898 #2 (as Tuscan sixteenth century). Perhaps
Venturi, <u>op. cit</u>, X, II 350 first made the correct identification.

[3] ASF, convento 119, vol. 1273, #26. To my knowledge the last
mention of the two figures is in D. Moreni, <u>Descrizione della chiesa
SS. Annunziata di Firenze</u>, Firenze, 1791, 60: al di sopra del con-
vento rimane la Libreria nel di cui vestibolo sono due statuette di
marmo, lavoro dell'Ammannato, le quali poco fa erano dell' uno e
dall' altro fianco del presbiterio della chiesa, fatte già per il
sepolcro del sopranmunciato Mario Nari Romano.

We know that originally they were nude and lacked wings.[4] Perhaps
they were mourning geniuses flanking Nari's sarcophagus.

Hitherto, nothing was known of the date or the circumstances sur-
rounding the commission of the Tomb other than what can be gathered
from Borghini and Baldinucci,[5] namely that it was executed sometime after
the death of Francesco Maria and left incomplete (and believed never set
up) when Ammanati left Florence for Venice sometime in the early 1540's.
Nothing is known of Nari's adversary, Francesco Musi. The Nari were a
noble family of Rome who had a chapel in S. Maria sopra Minerva.[6] But
who was Mario, why was he entombed in Florence, and why was he deemed
worthy of one of the largest funerary monuments undertaken in Florence
in the first half of the sixteenth century? These questions cannot be

[4] F. del Migliore, _Firenze città nobilissimi illustrata_, Firenze,
1684, 277: (the high altar) offervisi in altre, due Fanciulli ignudi
di marmo, in atto di Regger certi Viticci, collocati sopra due sopr' a
pilastri, dall'uno, dall'altro lato del presbiterio scolpiti dall-
Ammannato, per parte d'ornamento d'un sepolcro del'Nari ..."

What is implied by "Viticci," literally 'tendrils', is unknown to
me.

Cf. also G. Richa, _Notizie istoriche delle chiese fiorentine_, VIII,
1759, 39: "offervinse a' viticci due fanciulli di marmo."

Wings are not visible in the drawing but are mentioned by an
anonymous editor of Bakdinucci, _Notizie_, Firenze, 1796, VI, 8, n.1: In
fatti hanno le ale posticce.

Baldinucci (1681) _op. cit_, VII, 401, notes that the youths (trans-
formed into angels), held candelabra and that "a cagione di non so qual
disegnato nuovo acconcime, sono stati tolti di detto luogo." Del
Migliore's note (1694) must then predate Baldinucci, though published
slightly later.

[5] Cf. Pope - Hennessey, _High Renaissance and Baroque Sculpture_, 1970,
London, III, 373.

[6] D. Ameyden, _La Storia delle Famiglie Romane_ ..., Roma, II, n.d.,
108-9.

fully answered, but some helpful hints are provided by documents newly

unearthed by me. These mention him as "cortigiano del duca," and state

that he was provisionally buried in the dei Cresci Chapel in the

Annunziata on October 18, 1539.[7] Since, as we shall see, he died in a

duel and his death therefore could not have been foreseen, this date must

be the terminus post quem for the commission of his Tomb. The expense of

his burial was rather large in comparison to others of the same period

held in the Annunziata, and the Chapter ("Capitolo") of the church was

present at the funeral. The Chapter was an important decision-making

body made up of the high-ranking monks of the church, and their presence

at the funeral signifies that the deceased was of some importance.

The documents mention that "sua havarono facto un sepulcro di maro."

"Sua" probably indicates Mario's relatives. The documents further specify

that "sua" wished to have the Tomb placed in the chapel of S. Niccolo,

which is the first on the right as one enters the church, and permission

for this was obtained from the Brothers of the Annunziata. Their

permission was dependent upon the approval of Cosimo d e M e d i c i

and the d e l P a l a g i o f a m i l y, who were the patrons of the chapel.

7. ASF, Convento 34, Partiti 1538-50, c. 90: "A di 18 (October 1539)
le(h)anno a un morto solnne(.) tutto lo capitolo nostro a un cortigano
del Duca ciamato mario Romano sebe (si ebbe) de cera menuta libre otto
e tre torche che per sorho libre venti cavatene laquarta che restoranno
libre euiennici (= quindici) lib. 15."

For the provisional burial see n. 6.

The placement of the tomb in S. Niccolo was decided by a vote of the
Brothers on August 30, 1542,[8] and the wording of the document indicates
that the Tomb must have been completed by this date. We have no reason
to believe that the Brothers' decision was not carried out shortly after
the vote. Vasari confirms that by 1550 the Tomb was set up in the chapel,
though not unveiled.[9] Given that Mario was buried in a church which was
tacitly Medici property, Cosimo would have had to approve or authorize
each of the steps leading to the erection of the Tomb. He probably
arranged with the del Palagio family to have the Tomb set up in their
chapel as the 1542 document hints, and may even have played a role in
directing the commission to Ammanati. Perhaps Nari's death was a result
of the rebellions which clouded Cosimo's reign in 1539, and the duke
wished to insure that his services were not forgotten.[10]

8. ASF, Convento 34, Partiti 1538-50, p. 80 "A di 30 di detto
(agosto 1542) Sepolcro della cappella di S. Nicolo."

A donato e presente del con.te dodici proposa al padre priore
qualmente gia presso che dua anni in circha era stato un deposito
dom. mario romano nella cappella dei cresci lora e sua havarono facto
un sepolcro di marmo et desideravano di metterlo nella cappella di S.
Nicolo se le loro p. (padroni) si contentarono (.) tutti furono contenti
se sua excellentia et padroni della cappella erano contenti (.) cosi si
messe al partito fu vinto per favi neri undici et una biancha."

9. Vasari (1550) - Ricci, IV, 788: "le sculture del quale sono oggi
coperte in Fiorenza nella Nunziata a la cappella di San Niccolo, in
una sepoltura di marmo."

10. Alf. Reumont, Tavole di cronologia e storia fiorentina, 1841, s.v.
1539.

It is clear that Nari was a "soldato morto in duello."[11] Dueling
was frowned on by the Church, and Pope Julius II issued a bull in 1509
forbidding the erection of funerary monuments in churches to those who
died in duels.[12] Perhaps Mario's ignominious end was something of an
embarrassment to his family, as it later proved to be for Cosimo
himself, and they preferred that he be honored in Florence rather than
in the family chapel in Rome. The violation of the bull explains why
the Tomb was apparently never unveiled. Already in 1550 it is covered,
if it was ever uncovered at all. Again in 1567[13] it is mentioned as
covered, before being dismantled permanently by 1581.[14]

A letter of 1559 and a text of 1565 indicate that the Tomb was
set up against the right wall of the chapel,[15] where nothing impeded

11. F. Bocchi, Sopra l'Imagine Miracolosa della SS. Annunziata,
Firenze, 1592, 86.

12. F. L. del Migliore, Firenze Città Nobilissima Illustrata, 1684,
294.

13. See note 16.

14. Borghini, loc. cit.

15. Torelli's letter (G. Gaye, Carteggio, III, 14, #XVII): "... il
sepolchro di quel soldato che morì in duello, che è a man dritta
appunto allo altar dell'annunziata." The altar mentioned here must
be that of the miraculous painting of the Annunciation enshrined by
Michelozzo's tabernacle on the inside wall of the church. This wall
is contiguous with the wall against which Nari's tomb was set, at the
other side of the church. Cf. Bocchi, op. cit., 86: "Perquesto acceso
di santo affetto nel volger gli occhi a quella parte del muro, che e
verso mezzo giorno, che con quello e unito, dove è la santissima
Nunziata, gli venne veduto un sepolcro di marmo bianco, in cui era un
corpo di certo soldato morto in Duello."

its erection except for Trecento frescoes representing the story of S. Niccolo by Taddeo Gaddi.[16] The left wall was and still is occupied by the double tomb of Tommaso and Guido del Palagio of the fourteenth century. From its position the Victory would have addressed the entrance of the chapel and, more importantly, the miraculous painting of the Annunciation on the inside face of the rear wall of the nave. The present decoration of the chapel, which dates from 1627, erased all traces of the Tomb, including perhaps a niche which may have contained the Victory group.

The Tomb enjoyed considerable repute in the sixteenth century on aesthetic grounds despite its moral offensiveness. This is apparent from its appearance in a dialogue written by Cosimo Bartoli, Florentine humanist and letterato, published in 1567:[17]

Messer Vincenzo Martelli ... havete voi per sorte veduto nella
 Nunziata la sepoltura di quel gentil-
 huomo Romano che si chaimava Mario Nari,
 fatta da quel nostro Giovane Fiorentino,
 che ei si chiamano Bartolomeo smannati.

16.
 See W. and E. Paatz, Die Kirchen von Florenz, I, 1940, 99.

17.
 Cos. Bartoli, Ragionamenti accademici ... sopra alcuni luoghi
dificili di Danti, Venice, 1567, p. 19a. Charles Davis most kindly
brought this notice to my attention, in addition to the Mancini article
mentioned in note 22.

 Cf. also Bocchi, Le Belleze di Firenze, Firenze, 1591: "... i due
Angeli di marmo carrarese ... sono di Bartolomeo Ammanati; i quali
per l'industria mirabile, che in essi si scorge, sono da gli artifici
tenuto in pregio, e come chiede la ragione, oltremodo ammirati. Et
di vero molto sono simili al vivo, et quasi di carne palesano una rara
intelligenza di artifizio et mirabile."

Messer Angelo della Stufa: Non ha ho veduta.

Messer Vincenzo: Di grazia cercate di vederla, et ancor
che ella stia coperta, se voi vi andate
un giorno a qualche hora che non vi sia
molta gente, quei frati ve la scoprirrano.
Et vedrete una opera che voi ne resterete
stupefatto, et che cio sia il vero diman-
datene Messer Cosimo.

Messer Cosimo Bartoli: Certo ella è delle belle cose, che a me
paia che si siano fatte in questa città
da quindici ò venti anni in qua..."

The Tomb was removed from the chapel by 1584, the date of
Borghini's Riposo. Apparently the violation of the papal bull, from
which Cosimo averted his eyes in 1542, proved to be its undoing. Bocchi
clearly alludes to this in 1565: "perche non giudicava (Cosimo), che
vicino al santo muro della Madonna havesse luogo cosa troppo dissimile
verso di se da tanta santità, biasimò molto il fatto, commise à chi
era presente, come poi si fece, che si desse buon ordine alla bisogna.[18]
Ironically it was Cosimo himself who had it removed. The smoldering
controversy surrounding the tomb was stirred up in 1559 when Lelio
Torelli, a respected advisor of Cosimo's,[19] having been prodded by Ban-
dinelli, wrote to Cosimo saying that it was appalling that a tomb of a
man of "peccato enorme" should be near the sacred relic of the church
and advised that it be moved to allow Bandinelli to set up his own tomb
in its place.[20]

18. Bocchi, op. cit, 86.

19. On Torelli, cf. B. Varchi (Storia Fiorentina, ed. Milanesi, 1858,
III, 222). He had a "grandissimo nome d'esser non solamente buon
dottore, ma giusto."

20. Gaye, Carteggio, III, 14, #XVII.

At this time the Council of Trent was in full swing, and cries were
rising everywhere for more obedience to Church regulations. Bandinelli
shrewdly saw an opportune moment to harass a rival, and stirred up a
controversy which, to judge from Bocchi, was something of an embarrass-
ment by 1565.

Bocchi mentions that the Prince of Bavaria accompanied Cosimo
to the Annunziata when he recognized the impropriety of the Tomb.
Vasari mentions that the Prince of Bavaria was present in Florence
for the marriage of Francesco de' Medici in 1565.[21] Thus probably
shortly after the marriage the Tomb was dismantled.[22] The Victory
group was moved to the large cloister on the left flank of the church
and provided with a chalice with an inscription identifying it as
Faith with a figure of a vanquished world at her feet (haec est
Victoria / quae vincit mundum / fedes nostra[23]). She was flanked by
paintings of the other two theological virtues, Charity and Hope, by
Cecco Bravo. This transformation would surely have warmed the hearts
of Counter-Reformation Inquisitors. Later the statue found its way
into the Giardino dei Semplici and from there into the Bargello. It
is not known where the effigy was brought after being moved from the

[21] Vasari - Milanesi, VIII, 571.

[22] Bartoli's "Ragionamenti," though published two years later than
1565 may have been written somewhat earlier. Cf. G. Mancini, "Cosimo
Bartoli," Archivio Storico Italiano, Ser. 6, 76, V. 2, 1918, 119 ff.

[23] The transformation had taken place by 1684. Cf. F. L. del
Migliore, op. cit, 294.

church, but it has suffered a great deal from rough handling and from exposure to the elements.

Borghini's mention of Bandinelli's harassment of the project probably refers to his machinations in 1559. However, there is reason to think that trouble may have been brewing even before the Tomb was set up. Judging from other circumstantial evidence, to be discussed in chapter VIII, it appears that Ammanati left his native city for Venice by late 1540 or early 1541. If the Tomb was finished when he left Florence, why was it not set up until a year later? Sometime in the late 1530's Bandinelli tired of his work on the Papal tombs in S. Maria sopra Minerva. Vasari relates how he returned to Florence and by industriousness and self-promotion managed to muscle the commission of the Giovanni de' Medici monument from Tribolo by May 26, 1540.[24] After January of 1540 he was in Florence working on this project. Probably at this moment he was very much alarmed that a skilled former pupil was already well advanced with a project overseen by Cosimo, the size and expense of which could approach the Giovanni de' Medici Tomb. Doubtless he viewed Ammanati, after Tribolo, as the most dangerous threat to his domination of the sculptural scene in Florence. Whatever problems he may have raised for Ammanati, he was effective in securing his own pre-eminence at the court and in postponing Ammanati's until a much later date.

24. Vasari - Milanesi, VII, 167, n. 168.

Borghini's words that the <u>Tomb</u> "doveva andare" in the Annunziata might suggest to the uninformed that the Tomb was never set up. In this way he preserves a more favorable and pious historical image of Cosimo than is actually the case. Another phrase of Borghini's is somewhat puzzling: "ma fra 'l non sapersi di certo da qual parte fosse la vittoria" This might suggest that both men died in the duel. However, given Borghini's historical editing, it is likely that he invented this excuse to help justify the history of the Tomb without raising the real issue of the Bull. Borghini is careful to avoid the word duel in his text. However, Bocchi and Torelli's letter make it clear that Nari died in a duel. Given Borghini's unreliability, we can't be certain that Musi also was killed.

If the <u>Victory</u> group is viewed as reflecting the fatal duel, it hardly seems appropriate. Rather it is a symbol of victoriousness in multiple aspects: on the historical level, as the triumphs and exploits of Nari's career as Cosimo's warrior. On the allegorical level the group must be viewed in the light of Christian and neo-platonic notions of psychomachia, the struggle between virtue and vice within the soul of every man, which determines the future of his soul as well as terrestial fame. On this level, beyond signifying the victory of the soul over death, the redemption brought about by Christ, it no doubt implies the triumph of Virtue within the soul of Nari, all of which insure him lasting glory, a triumph over time.[24a] Victory groups in funerary

24a. The psychomachia was embodied more explicitly later in Vincenzo Danti's <u>Triumph of Virtue over Vice</u> in the Bargello, which is formally dependent on Ammanati's group, and no doubt was implicit in Michelangelo's <u>Victory</u> in the Palazzo Vecchio.

I am greatly indebted to Prof. Kathleen Weil-Garris Posner for calling my attention to the possible psychomachic implications of

contexts were licensed by antiquity and examples were known to the
Renaissance (fig. 100). The foremost example is the Pisa battle
sarcophagus, which was copied by Bertoldo. At either end of it are
winged Victories standing on the shoulders of bound, crouching captives.[25]
Another source for funerary Victory groups could be Etruscan sarcophagi,
many of which contain representations of winged deities with captives at
their feet (fig. 101). Originally these figures may not have signified
military or spiritual triumph, but they were infused with such a meaning
during the Renaissance. The Renaissance mind probably would have connected
them with the Victories on Roman sarcophagi and triumphal arches.

24a. (cont'd.)
 Ammanati's group, the whole question of which needs further study.
She also suggested that the fallen figure under the Victory may represent
Nari's lower self. The defeated figure has remarkably individualized
facial features that we don't usually encounter in representation of
abstract personifications (e.g. the Victory herself or Bandinelli's Cacus).
Both the effigy and the defeated have a trimmed moustache and beard, the
wide, full lips, similar chins, nose and curly hair. The slightly blockier
and coarser face and physique of the defeated reflect a lower status. In
this light it is interesting that the position of the arms of the defeated
are reminiscent of Bandinelli's Cacus, also a symbol of vice and impurity.
However, the figure need not carry Nari's features in order to convey the
idea of a personal identification with Nari. In fact, by leaving the
physical resemblance in some doubt, Ammanati suggests the personal level
while at the same time preserving a more universal level of interpretation.
We should note that, as the group once stood in the chapel the defeated seems
to make a pained appeal for mercy toward the spectator entering the chapel
and the sacred shrine in the Annunziata; while the Victory, impassive,
immutable and self-assured in triumph, also turns slightly toward us, with
mouth slightly parted, as if asking us to witness the event.

25.
 Note also a Roman biographical sarcophagus at the Medici Villa
at Poggio a Caiano with Victories and prisoners behind a seated general
(fig. 100).

Michelangelo planned <u>Victory</u> groups for the early projects of the Tomb of Julius II and he seems to have been the first to envisage monumental psychomachic groups of this kind in a Christian funerary context. But in the case of the <u>Nari</u> Tomb, its large scale, and appearance in a monument probably devoid of more explicit Christian imagery, within a church, was certainly a novelty for its time.

On top of the fact that a tomb of any sort was prohibited for Nari, Ammanati created a monument within a church with more explicitly pagan associations than anything Florence had seen up to this time. Moreover, the monument was placed in proximity to a sacred relic, and even addressed it. For clerical authorities the secular and pagan associations were apparently too strong to endure without taking some action. Thus a compromise was reached whereby it was set up but not unveiled. With the rise of the Counter Reformation, these licenses, exacerbated by Bandinelli, became unacceptable and proved to be the tomb's undoing.

The form of the <u>Tomb</u> - a reclining effigy flanked by genii below a standing group probably in a niche, is reminiscent of the individual <u>Tombs</u> in the del Monte Chapel. This form seems to have been an unprecedented design in 1540, and may have been suggested to Ammanati by

Michelangelo's 1513 project for the Julius Tomb, where the Madonna
and Child stand in a niche above a reclining effigy of the Pope.

Nari's effigy wears a soldier's costume "all'antica" -- cuirass,
tunic, and sandals - and a drawn scabbard lies under his left hand,
which holds a cloth.[26] The pose suggests a soldier fallen in battle,
nobly and gracefully expiring.

Ammanati's composition should be viewed from approximately eye
level, as in fig. 92. This angle, which may be the originally
intended one,[27] brings out the strength and prowess of the legs and
torso. The effigy is of a type i n s p i r e d b y E t r u s c a n
sarcophagus lids which represent the deceased in a reclining position,
propped on one arm. In Italy it was revived in the Renaissance by Andrea
Sansovino, who employed it in the Sforza and Rovere Tombs in S. Maria

26. The fingers of the right hand (which in the original touched
the leg) and pieces of the right foot, were added in the nineteenth
century.

27. We can only guess as to the tomb's original appearance against
the right wall of the S. Niccolo Chapel. The body of the sarcophagus
does not survive. I would suppose that the effigy was raised on a base
to the height of four to five feet. This base probably had flanking
elements upon which the two youths, or geniuses, stood on either side
of the effigy. Behind and above, probably in a shallow niche excavated
from the wall, stood the Victory group. If a niche was not made, the
ensemble would probably have projected too far into the central space
of the chapel, engulfing the area before the altar. A drawing by
Ammanati for an unidentified tomb project in the Riccardiana sketch-
book may be compared (M. Fossi, La Città, f. 92 v). Here a large base
supports a sarcophagus flanked by mourning male nude youths with wings.

A reclining effigy flanked by two youths was a popular type in
Florentine tomb sculpture (cf. Sansovino's Nicholese Tomb in S.
Anastasio, Verona), though the idea of a single group above the effigy
was new. It derives from a simplification of the traditional place-
ment of the Madonna flanked by two saints above an effigy. Cf. E.
Panofsky, "The Neoplatonic Movement and Michelangelo," Studies in
Iconology, Harper Torchbooks, N.Y. 1962, 171 ff. fig. 133 (Santarello
Tomb by Nino Pisano).

del Popolo (fig. 94). [27a] These effigies, which are in a state of utter
rest, impress us as inert bodies which are artificially propped up.
The type was transformed by Jacopo Sansovino in his effigy of
Cardinal S. Angelo in S. Marcello in Rome (fig. 93). Here the figure
is more erect and there is a tension and potential movement in the
arms and legs. He seems above all a fully alive figure, who is lightly
dozing or in a restless sleep. The Nari effigy is conceptually akin
to this one, but filled with more energy and strength, as befits a
valorous soldier. Later, in the del Monte effigy (fig. 265),
Ammanati arrived at a solution closely akin to the Etruscan arche-
type: the figures are fully alive, and represented reclining in a
state of calm relaxation.

The highly idealized nature of Nari's head (figs. 98-99), and
the coiling locks, are inspired by Michelangelo's Giuliano de Medici.
For the figure as a whole Ammanati preferred to follow the example of
the antique. The pose is open and planar, devoid of Michelangelesque
gyrations. The velvety surface and the soft moist locks, where well
preserved, glow and shimmer as if washed by a wave, and recall the
Pisan lunette. The gaze of the Victory is remote and dream-like,
carrying a muted smile, gently hinting serenity and a sense of satis-
faction with her station. The prisoner is heavy, broad, and his
unhappy, anxious features are coarse, though not to the extent of his
ancient prototype. His face seems highly individualized,
but it is unlikely he is a portrait, however idealized, of Francesco

[27a]. Cf. E. Panofsky, Tomb Sculpture, 82 b.

Musi.[28]

The similarity of Ammanati's <u>Victory</u> group to Michelangelo's projected <u>Victory</u> groups for the Tomb of Julius II has been noted by Weinberger and de Tolnay.[29] Our knowledge of Michelangelo's groups is derived from two drawings which show two of these groups in the niches of one of the short sides of the Tomb of the 1505 and 1513 projects[30] (figs. 102, 104, 105, 107-9). The height of these figures is stipulated in the 1513 contract to be one <u>palmo</u> greater than life-size. Weinberger observed that Ammanati's group is about this height.[31]

However, it is debatable to what degree the two drawings accurately reflect Michelangelo's design, and there are notable differences between Ammanati's group and the two groups represented in the drawings. Hence, Weinberger goes too far in asserting that Ammanati's group is a faithful copy of a design by Michelangelo. It should be observed that the drawings in question, in Berlin and in the Uffizi, though presumably copies of the same original project (at least in the representation of the <u>lower story</u> of the <u>Tomb</u>), differ slightly from one another in almost every feature. This raises questions about the degree with which the drawings accurately reflect the original.

[28]. Cinelli (in his edition of Bocci, <u>Le Belleze di Firenze</u>,1677, 465:"un prigione ritratto d'un vinto") is the only writer to suggest this. Cf. n. 24a.

[29]. C. de Tolnay, <u>Michelangelo</u>, IV, 1954, 60, 92, 112. M. Weinberger, <u>Michelangelo the Sculptor</u>, I, New York, 1967, 135, 161-166.

[30]. The drawings are illustrated in Tolnay, <u>op. cit</u>, IV, fig. 96 and fig. 97.

[31]. <u>Op. cit</u>, 161.

Though the statuary in the drawings is undoubtedly Michelangelesque
in general appearance, some features, such as the fluttering, billowing
drapery, seem wholly unlike Michelangelo in character. Weinberger
assumes that Ammanati copied small clay _modelli_ of the figures which
Michelangelo made for the model mentioned in the contract of May 1513.
However, the contract cites only a wooden model of the architectural
parts, and does not at any point specify _bozzetti_ of the figural parts.[32]
Perhaps to supplement the model Michelangelo supplied the executors with
only drawings of the figural parts.

There are several notable differences between Ammanati's group
and those in the Berlin and Uffizi drawings. Firstly Ammanati's
Victory has no wings. Secondly she originally held something in her
right hand, perhaps a bronze or wooden lance which has been lost. In
the drawings the groups hold no attributes. Ammanati's _Victory_ is more
slender and attenuated, and her drapery is less billowing. The
Victories in the drawing stand on both feet and step forward in more
or less three-quarter view poses. Ammanati's _Victory_ balances herself
on one foot and is completely frontal. Ammanati's figure is a good
deal more coiled up than those in the drawings, probably to
accommodate itself to a niche with a smaller platform extending before
it. Since Weinberger unwisely assumed that Ammanati was little more

[32] Published in G. Milanesi, _Le Lettere di Michelangelo Buonarotti_,
Florence, 1875, 636 ff.

than a diligent copyist , he is led into the trap of suggesting
that Ammanati's group copies - indeed verifies the existence of - a
presumed bozzetto prepared for the modified July 1513 project which
specifies smaller dimensions (hence smaller niches) for the short
face.

Nonetheless, it is undoubtedly true that Ammanati knew Michelan-
gelo's Victory groups in some form, and Weinberger is correct in
suggesting that he would have had ample opportunity to see Michelan-
gelo's studies when at Urbino in 1538. The project would have been
fresh in his mind when, slightly later, he undertook the Nari Tomb
commission. Ammanati must have found it challenging to execute in full
scale a variation on a theme which Michelangelo had carried probably
no further than a sketch or rough bozzetto, of which we have a vague
idea preserved in the drawings in Berlin and Florence. This frame of
mind probably also explains why Ammanati took up Michelangelo's early
aborted idea rather than follow the master's later solution, the
Victory group in the Palazzo Vecchio. As we have observed, the same
selectivity may have occurred when Ammanati designed the Apollo in
Naples.

The composition of the Victory contains none of the spiraling
movement or tension which we associate with Michelangelo; it is frontal
and the prisoner crouches in a relaxed manner, without sharp movement
or strongly projecting and receding members. The flesh of both figures

is soft and mellifluous. The surface is everywhere irregular and silky, unlike Michelangelo's taut surfaces of the Medici allegories which reveal strength and tension and bodily structure. However, Ammanati's further study of Michelangelo is revealed principally in three other aspects: in the swelling and attenuated proportions, in the emphasis on plastic volume at the expense of drapery play, and lastly in the heightened abstraction of the surface. The latter is apparent especially in the veiled and remote expression of the Victory, which foreshadows the Benavides Tomb figures and the Buoncampagni Allegories. In this, Ammanati's debt is again to the Medici Chapel, and Michelangelo's works nearer in date to 1539. Like Michelangelo, Ammanati left unfinished areas, such as the right ear of the prisoner (fig. 118). Overall, the handling of the marble is looser and broader than in the Sannazzaro sculptures. The highly polished surface and attention to minutiae of the latter is absent, and Sansovinesque classicism is more heavily overshadowed by a Michelangelesque abstraction and formal type.

The heightened abstraction of Michelangelo's sculptures of the Medici Chapel and later endow his figures with an aloofness and distance, which is a kind of magnified classicizing veil (fig. 121). Ammanati's sculptures up to this point had another kind of veil, a translucent, vaporous one. In the Nari sculptures we find both qualities present -- a caressing liquid haze the density of which is increased by a Michelangelesque veil of abstraction.

Ammanati's continuing and deepening study of Michelangelo's work should be viewed not only in the light of the enormous influence the

master had on Ammanati's generation of artists, but also of the
growing taste for copies and imitations of Michelangelo's work on
the part of collectors and patrons who could not hope to acquire
originals. About this trend Vasari gives much information scattered
in the Vite. Among others, Venusti made miniature copies of
Michelangelo's painting, Pontormo colored some of his cartoons, Tribolo
executed reduced copies of the Medici Allegories, and Pierino da Vinci
copied several of his designs and executed a one-half life-size copy
of the Moses. Certainly, Ammanati's passion for Michelangelo meant
that he also, in the course of his self-education, copied the master's
drawings and sculptures. But to copy for the sake of expanding one's
formal horizons and to use verbatim the master's ideas in a major
commission are quite distinct activities. Ammanati never indulged in
the latter as far as we know, though Weinberger would lead us to think
that he was not above it. This idea, which clung to Ammanati with the
Leda in the Bargello, can now be abandoned for once and for all.
Ammanati in fact was on the whole a good deal more independent of
Michelangelo's art than a number of his contemporaries, including his
friend and collaborator Battista Franco. Sansovino's critical stance
viv-à-vis Michelangelo must have had an important effect on the young
Ammanati. After his training with Sansovino, Ammanati always trans-
formed even those features which he most admired in Michelangelo's art,
and viewed Michelangelo as only one among several valid artistic
guideposts.

Chapter 8

THE SECOND SOJOURN IN VENICE

"... Quest'accidente di non essersi potuta quell'opera scoprire
(the Nari Tomb), apportò a Bartolommeo tanto disgusto, che immanti-
nente lasciò la Patria, ed a Venezia di nuovo se n'andò. In quella
nobilissima città scolpì la figura d'un Nettuno in pietra d'Istria,
che fu posto sopra la Piazza di S. Marco. Quindi andatosene a Padova,
lavorò per Maestro Marco da Mantova, celebre Medico..."[1]

We don't know when Ammanati left Florence to enter the service
of Jacopo Sansovino in Venice. The work of carving the four marble
sculptures for the Nari Tomb could have been done within a year to
judge from Ammanati's optimum working capacity, which we have discussed
earlier. Since the Nari commission perhaps came in November, 1539,
one would not expect Ammanati to have been present in Venice until
towards the end of 1540 or the spring of 1541.

Jacopo Sansovino made a brief trip to Florence in October, 1540
and perhaps, as has been suggested,[2] he offered Ammanati work at this

[1] Baldinucci, op. cit, 399-400; Borghini, op. cit, 165.

[2] A letter of Giovanni Urtada from Venice of October 31, 1540
mentions that Sansovino is coming to Florence. ASF, Archivio Medici,
Spogli inediti Milanesi, f. 347, c. 305, cited by Ciardi-Dupre, "Prima
Attività," 27, n. 21.

Vasari (ed. Club del Libro, VII, 408), mentions that Sansovino
came to Florence "per suoi negozii..."

time. Lorenzo Lotto's account book mentions Ammanati in Venice in
January and April of 1541 or 1542. This is the earliest document
which certifies his presence in the city. The account book mentions
that when in Venice Lotto paid one "Meo scultore fiorentino lavora
con il Sansovino, protto de San Marco."[3] Meo was Ammanati's nickname.
Aretino in his letter of May, 1545 addresses him as "Meo scultore."

Ammanati arranged to have a putto in relief and a pair of hands
sent from Florence, for which Lotto paid him altogether one gold
scudo, 6 lire and 16 soldi. We know nothing more of these sculptures.
The hands suggest that the two items might have served as models for
Lotto's paintings. It is not even certain that the cited works are
by Ammanati.

The date of the notice is problematical.[4] One of the notices is
of January, the other two April, but the year has been left out.
Lotto's account book is not systematically chronological in its listing
of data. However, the three notices fall on two pages with notices

3.
 See Chapter IX, pt. IV, n. 1.

4.
 P. Zampetti, ed., Lorenzo Lotto, Il Libro di spese diverse, Venice-
Rome, n.d. (1969), 132: "In Venetia /adi ... zenar, die dar Meo
scultore fiorentino lavora con il Sansovino, protto de San Marco,
lire 3. quale / detti per parte a farmi venir de Firenze un puttino
de relevo et un par de mane L 3 s
 Adì ... April, die dar Meo scultor per resto de la conduta del
putino de Firenze scuti uno/d'oro L 6 s 16
 Et adì ... Aprile, die haver Meo scultor havi da lui per
consignato el putino in Firenze / et dato in mane del mio agente in
Venetia misser Bortolamio Carpan gioilier trevisano, qual lui ricevete
in nome mia."

dating between the end of January 1540 and September 1542. The
notices in all probability fall at some time within these limits.
The first two entries mentioning Ammanati, of January and April,
follow two notices dated September 1541 and July 1541 and are followed
by a notice of January 1540. Therefore a date in 1541 would be most
likely, but 1542 is also a possibility.[5]

Borghini mentions only one of Ammanati's sculptures in Venice,
a Neptune for the balustrade of Sansovino's Library, which is lost.
"(Ammanati) se ne andò a Vinegia, dove fece un Nettuno di pietra
Striana, alto quattro braccia, che si vede sulla piazza di S. Marco."[6]
Pietra d'Istria is the stone of which all the decorative sculpture
for the Library was carved. The other figures executed for the balu-
strade were about life-size (5.5 feet or 1.65 m.), to judge from two
figures once on the face of the campanile, and now in the cortile of
the Correr Library, which are 1.72 and 1.77 m. high. Thus Borghini's
"quattro braccia" is probably an overestimation, and three Florentine
braccia (1.63 m.) is probably closer to the truth. In the 1740's the

[5] Zampetti, though he does not give his reasons, believes the
notices are of 1540.

[6] Borghini, loc. cit. The Neptune is mentioned by Fr. Sansovino,
Venetia città nobilissima et singolare, ed. D. Martinioni, Venice,
1663, 310, as life-size (tutto tondo grande al naturale) and as
"sul cantonale verso il campanile ... presso all'obelisco"

statue fell from its pedestal at the corner of the Library nearest

the campanile, facing the Palazzo Ducale, and was destroyed.[7] Its post

remained empty until the Library was restored after being damaged by

the collapse of the campanile in 1902, when it was filled with an

Apollo by Urbano Bortotti. The Neptune was the first of thirty

statues to be executed for the pedestals of the balustrade, and the

only one which was executed during Sansovino's lifetime. The remainder

were made after 1588 when Vincenzo Scamozzi executed arches 17-21 on

the facade and the three arches facing the wharf.[8]

Despite the omissions by his biographers, we know that Ammanati

executed other sculptures for the Library. Francesco Sansovino says:

"Ne gli angoli de i volti, le figure de i vecchi con vasi versanti

acqua, sono significativi di fiume. Et nelle chiavi che serrano i

volti nel mezzo, sono teste di huomini, di donne, e di Lioni inter-

zate, le quali tutte furono scolpite dal Danese Cattaneo, da Pietro

da Salo, da Bartolomeo Ammanati, & da diversi altri nobili & lau-

dati scultori."[9] Temanza follows Sansovino and includes the name of

7. G. Lorenzetti, "La Libreria Sansoviniana," Part II, Accademie e Biblioteche d'Italia, III, part II, 1929-30, 31, n. 2: "Nel 174... cadde la statua di Nettuno dell'Ammanati, durante una delle consuete feste del Giovedi Grasso" (from a note of the Notatori Gradenigo, Biblioteca Correr, vol. V, c. 49).

8. Lorenzetti, op. cit, 46 ff. Cf. N. Ivanoff, "Il coronamento statuario della Marciana," Ateneo Veneto, Jan-June, 1964, 101 ff, and "La Libreria Marciana, Arte e Iconologia," Saggi e Memorie di Storia dell'arte, 6, 1968, 40.

9. Francesco Sansovino, Venetia citta nobilissima et singolare ..., ed. D. Martinioni, Venice, 1663, 310.

Vittoria with the three given by Sansovino.[10] Vasari adds Girolamo
Lombardo to the roster, and supports Sansovino's mention of Cattaneo
and Pietro da Salo, but omits all mention of Ammanati's role in the
Library decoration.[11]

Construction of the new Library according to Jacopo Sansovino's
model began on March 6, 1537.[12] But already in 1536 buildings were
being demolished to make way for it. The intrados of the third arch
on the campanile face, nearest to the Procuratie Nuove, carries a
date of 1538. In 1539 documents mention work being carried out on
the corner ("chantanal"). A letter of 1540 by Pietro Aretino
mentions "two treasures" in Piazza San Marco, the church and Sansovino's
Library, but the Library was at that time visible only "in segreto,"
which probably indicates that the structure was concealed by scaf-
folding. The first phase of construction, which included four arches
of the main facade, was near completion toward the latter part of
1544, as in August of this year the building was complete enough to
rent out the shops under the arcade, and by November authorization
was given by the procurators to demolish another section of buildings
which impeded construction toward the wharf.

It can be gathered from the documents that the main thrust of the
construction began at the campanile face and proceeded toward the wharf.

10. T. Temanza, Vita di Giacomo Sansovino, Venice, 1752, 34.

11. Vasari-Milanesi, VI, 541 ff.

12. Lorenzetti, op. cit, part II, 35 ff.

Although the face toward the campanile was probably being built in all parts simultaneously, the part nearest the Procuratie Nuove was probably completed before the corner. Then once the structural members of the campanile face were substantially built, work could proceed toward the wharf, and work on the vault could begin. If work was done on the corner in 1539, probably the campanile face was completed by 1540, and the subsequent four arches along the piazzetta were executed roughly between 1540 and 1544. However, the roof of this section was not yet covered when "la parte verso la Panataria" collapsed on December 18, 1545.[13] We shall come back to the question of the damages a little later.

Ivanoff[14] has found documentation which shows that the decorative sculpture was not part of the structural members of the building and could have been attached to it at any time after the building was erected. Thus the dates which we have for the construction of the Library can serve as no more than a very rough guideline for the chronology of the sculpture. However, the building would look oddly barren without its decorative sculpture, and one imagines that an attempt was made to have the spandrel decorations ready for each section as the construction proceeded.

The sculptures in the spandrels and keystones, g r e a t l y

13. Ibid, 38-39.

14. N. Ivanoff in Saggi e Memorie di Storia dell'arte, 6, 1968, 50.

esteemed in their own day,[15] have not received the attention they
deserve. Sanpaolesi,[16] and then Ivanoff[17] have recently made attempts
to sort the figures according to hands, and Ivanoff has also investi-
gated and clarified the meaning of some of the figures represented.
Sanpaolesi in 1951 was the first scholar since Francesco Sansovino
to examine Ammanati's share. While generally pointing in the right
direction he erred in attributing to Ammanati a large number of figures
by other hands. A few of these misattributions were subsequently
corrected by Ivanoff, but Ammanati's contribution to the Library still
remains unclear.

Sanpaolesi was largely correct in suggesting that Ammanati was
responsible for the River Gods and Victories on the short side facing
the campanile. In fact, Ammanati's entire contribution, as far as it

15.
 Fr. Sansovino, Delle Cose notabili che sono in Venetia, Venice,
1561, 23r: V. Avanti che fosse quel cantonale (corner of the Library),
corsero parecchi anni, nel qual tempo molti credettero che si dovessi
restar senza fare altro, e molti proposero diversi partiti: final-
mente fu fatta questa impresa che voi vedete. F. Mi piacciono assai
questi fiumi negli angoli dell'ordine Dorico; e quelle vittorie la
su alto, negli angoli dell'ordine Ionico.

16.
 P. Sanpaolesi, "La vita vasariana del Sansovino e l'Ammanati,"
Studi Vasariani, Firenze, 1950, 134 ff.

17.
 N. Ivanoff, Saggi e Memorie Op. cit, 1968, 50 ff. and
"Ignote primizie veneziane di Alessandro Vittoria," Emporium, June,
1961, 243 ff.

is preserved, is found on this side. Here Ammanati executed six
River Gods, the "Victories" and the head of Phanes, all carved in
pietra d'Istria. In addition, he probably carved four other spandrel
figures for the piano primo which were lost in the 1545 collapse.

Ammanati's River Gods, which occupy the three arches of the lower
story, are bearded mature male nudes,[18] (figs. 121-4). Four of them
hold vases spilling water in one arm, and a folded cloth in the other.
The remaining two hold cornucopiae rather than vases, and a cloth.
The figures place their feet on a small sphere at the bottom of the
spandrel,[19] and prop themselves against their vases and the side of
the spandrel. As decorative sculpture, they harmonize well with
Sansovino's building. Even though the figures are carved in high
relief, and in several areas are cut fully in the round, they neither
attempt to explode their confines nor exhibit violent movement which
would disrupt the spectator's grasp of the entire building.
(Ammanati's ability to make his figures seem at ease within their

[18]. At present the spandrel figures are receiving a terrible, and
perhaps fatal, beating from industrial pollution and thousands of
pigeons which roost, defecate and procreate on them. The acids from
these sources is rotting the stone and several of the heads of the
River Gods on the Campanile face will soon break off unless something
is done.

[19]. The supporting sphere may have been borrowed from the Arch of
Titus in Rome where a similar object supports the Victories in the
spandrels. It appears to have been a sphere but today the objects
are badly eroded, making certain identification difficult.

constricted space is pointed up by a glance at the River Gods in the
spandrels of the Procuratie Nuove, executed 75 to 100 years later.)

At the same time, each figure wears well if the spectator chooses
to focus on it. Each has a unique personality and differs from his
neighbors in subtle and interesting ways. Some gaze dreamily off into
space, eternally imperturbable; others have a slight frown and a
pensive cast to their features, and are more restless and sinuous in
movement. To facilitate comparisons I will label the six River Gods
A-F beginning from the corner and continuing towards the Procuratie
Nuove. The postures and physiques of River Gods A (figs. 125-8) and
B (figs. 129-132) are reminiscent of the effigy of Mario Nari. They
lean on one hip and arm, while the other arm rests on one thigh. The
legs are slightly bent at the knees, and (in the case of River God A)
the head and shoulders are drawn together. The physiques are full-
bodied and strong-limbed. The muscles of the torsos and legs are
tense and contracted yet mellifluized into a gentle undulating.

Similarities to the Nari Prigione and the Immortality of the
Benavides Tomb are apparent, moreover, in the broad heads and the
compactness of the bodies, as well as in an expression of languishing
calm. Their beards, composed of large strands curling sharply at the
ends, are reminiscent of the Strozzi Neptune and the Honor on the
Eremitani Tomb (fig. 219).

River Gods C (figs. 133-136) and D (figs. 137-140) are smaller
and more slender than A and B, and their poses are more sinuous and
complex. Their shoulders and knees project more sharply from the

background and display a coiling movement which Ammanati learned in Michelangelo's Medici Chapel, especially from the Dawn and the Day. Yet, very unlike Michelangelo's figures, the River Gods are almost delicate in proportions, psychologically composed, and physically comfortable in their spandrel space.

River Gods E (figs. 141-144) and F (figs. 145-148) have compositional qualities found in both the other pairs, but are more attenuated than the other four. They are more full-bodied than C and D, yet not quite so massive as A and B. They have something of the sinuous movement of C and D. More than the others, they remind us of the attenuated sinuosity of Vittoria's River Gods carved for the main facade about a decade later.

The considerable diversity which Ammanati was capable of, as well as the kind of astonishing atmospheric effects the master could achieve, can be nicely pointed up by focusing for a moment on the heads of River Gods A (fig. 126) and C (fig. 134). The former has a massive, powerful head with limpid features, sharply incised eyes and wrinkles in his brow. The latter is thin, frail, dreamy, and his features are rendered in a far more loose and imprecise manner. His head is wrapped in a dense haze, like a figure in the background of a painting by Titian. The freedom of handling is reminiscent of a wax bozzetto, and indeed Ammanati's stuccoforte modello of Sapienza in Padua (fig. 212) exhibits precisely analogous qualities.

On the piano primo (figs. 149-152) Ammanati is responsible for four of the six figures, those in arches 2 and 3 (figs. 153-167) (here

labelled A-D counting as with the River Gods). The Victories (A and
C) (figs. 153-155, 160-162) in the left spandrels of these arches are
nearly reversed replicas of those on the right sides. They exhibit
a more wooden and superficial carving, simplified drapery patterns
and slight changes in posture which clearly suggest the intervention
of an assistant closely following Ammanati's model, or perhaps later
copies replacing figures by Ammanati which might have been destroyed
in the collapse of 1545.

The four figures hold open books in one hand and drapery in the
other. Like the River Gods below, they plant their feet on spheres,
and display a comfortable and harmonious integration with their
spandrel space. Though carved nearly in the round in several areas,
they tend to cling more tightly to the background of the spandrels
than the River Gods. Victory B (figs. 156-159) is rather slender
and attenuated, reminiscent of River Gods E and F. Her firm, well-
endowed body snugly clothed in thin clinging drapery, and the manner
in which the dress peels away from the arms and legs is similar above
all to the V and A Leda, but also is reminiscent of the Minerva in
Naples and the Fame at Padua. Her lithe graceful movements are
thoroughly characteristic of the same sculptures. Similarities to
the Victories in the spandrels of the triumphal arch at Padua are
evident in the relation of the figure to its space, the support of
the figure at the base of the spandrel, the graceful rhythm, bending
knees, and drapery at the ankles.

The faces of both Victories B and D, composed of veiled, shallow-

set eyes, slender nose, small mouth and dimpled chin, are very close
to the bozzetto of Sapienza, the female figure at Padua and the Leda.
The coiffures have the freely articulated rippling of which Ammanati
was fond, and used in the Nari Victory and repeatedly in the sculp-
tures at Padua. The drill is extensively used, as in the River Gods,
to render an intense atmospheric vibration, which in the case of
Victory B is astonishingly similar to the effect of the Padua
bozzetto.

Victory D (figs. 163-167) is broadly proportioned, and reminiscent
of the canon of River Gods A and B and the seated allegories of the
Padua Tomb. The drapery bunched at the shoulder evokes the Nari
Victory, and the faceted swirls at her feet recall the Victories at
Padua.

The only other certain figural work executed by Ammanati for
the Library is the elegant head of Phanes (figs. 173-174). The aloof
classical severity of her face is fitting to her function as a key-
stone, for it emulates the impassive heads used for such purposes in
antiquity. Her locks are similar to River Gods A and B and to the
Honor of the Eremitani Tomb, and the broad, full-jowled head with wide-set
eyes is reminiscent of the Fame, the Immortality and the two ephebes
in the Eremitani (figs. 222 ff).

We will recall that the campanile face was the first to be built,
probably by sometime in 1540, while the arches along the piazzetta
followed roughly in the period 1540-44. Therefore the campanile face
would have been the first part ready for its sculptural complement,

and perhaps the first to be unveiled. When Sansovino went briefly to Florence in the fall of 1540 he probably persuaded Ammanati to execute the choicest pieces for the campanile face, and the Neptune. If Ammanati executed any of the less important sculpture for the frieze or the intradosses it does not survive.

We don't know why Sansovino went to Florence, otherwise than to attend to his personal affairs. Conceivably, he could have gone, among other reasons, to enlist help in executing the decorative sculpture. The job was a big one, and if very little had been done before Ammanati's arrival in the spring of 1541, as we suppose to be the case, we can well imagine a certain degree of apprehension on Sansovino's part in contemplating the enormity of the sculptural task which he had set for himself.

Ammanati was probably in Venice for at least two years, but there are no documents which suggest a sequence for the execution of his works, or how long it took to carve the Library sculptures. If we assume that Ammanati was working diligently, and if we apply the yardstick of the Benavides and Nari Tombs, the six River Gods, two Victories and the Neptune could have been executed easily within a year or a year-and-a-half, even if we include two or three figures on the piano primo which may have been destroyed.

It should be borne in mind that all of Ammanati's figures were intended for one face and their diversity is meant to entertain the eye of the passing stroller with a pleasing variety. Doubtless they were all conceived and substantially designed at the same moment with

an eye for neighboring figures to the sides and above. For example,
it is no accident that the two pairs of River Gods which offer the
greatest formal contrasts are juxtaposed in arches 1 and 2, or that
analogous formal comparisons exist between River Gods E and F and
the two Victories above them: restlessness and slenderness are
juxtaposed to full-bodied heaviness and greater stability. In this
light, the question of the sequence of execution loses some of its
importance. Moreover, he may have worked on several figures simul-
taneously. Nevertheless, one could postulate that generally
Ammanati worked from River Gods A to F and did the Victories later.
The order of the latter is more open to debate, because of the fact
that visually the optimum location on this level is the third arch
rather than the first and because Ammanati executed only two of the
six figures here today. At ground level, on the other hand, the arch
nearest the corner is the prime location of the face, as it is the most
conspicuous. It therefore might be the first to have received its
figures. The River Gods of this arch, of the six, are the closest
formally to the Nari sculptures, and on stylistic grounds it is plau-
sible that these two represent Ammanati's first efforts.

It is possible, I believe, to detect a certain growth in
Ammanati's ability to felicitously integrate his figures with their
spandrel space. River Gods A and B seem slightly stiff alongside
River Gods E and F and the four Victories above. The movements of
the latter react to and play off the slippery curving shape of the
archivolt itself; and their greater restlessness is more suited to

the inherent instability of their support.

It is difficult to ascertain the role played by the model -- whatever it was[20] -- which Sansovino provided the artists who were to carve the decorative sculpture. Certainly it must have established the attributes and set other formal limits for the sculptures. The enormous formal diversity of all the figures indicates that the master allowed his artists considerable freedom in interpreting it. None of the sculptures are so Sansovinesque that one would think of seeing behind them a specific model by Sansovino. Even the integration of the figures with the spandrel space displayed by Ammanati's figures cannot be totally attributed to the model, because it also varies considerably from master to master among the sculptures carved within Sansovino's lifetime.

In Ammanati's sculpture as a whole, Sansovino's influence seems to have freshly tempered the heavy, swelling Michelangelesque forms of the Nari Victory and the Apollo and Minerva. But do his works exhibit Sansovinesque characteristics which are different from those already mastered by Ammanati before his return to Venice in 1541? If so, it is difficult to isolate them. The relation between Sansovino

20. Lorenzetti, loc. cit., suggested that a terracotta model of a river god in the Berl collection served as the model for the spandrel figures. However, this figure does not conform to the shape of the spandrel spaces of the Library. It is stylistically akin to Sansovino's four bronze Evangelists for the balustrade of San Marco and the Colossi for the staircase of the Palazzo Ducale, as noted by Planiscig (Venezianisches Bildhauer, Wien, 1921, 369-372) and probably dates from the late 40's and 50's.

and Ammanati at this point is one of independent masters rather than
of master to pupil, and while a mutual exchange of ideas can be taken
for granted when artists work in such close proximity, both were
moving along separate, though related paths.

Michelangelo's influence can be felt in the sinuosity and the
attenuation of several of the figures. But simultaneously Ammanati's
figures display significant analogies with the profound Sansovinism
of his earliest works. Clearly the forms of Sansovino and Michelangelo
were not mutually exclusive in his mind, nor were they adopted without
profound modifications. From Sansovino Ammanati acquired a certain
ambivalence toward, and independence from, Michelangelo's art; in
Michelangelo he found a means of expanding and transforming Sansovino's
rigidly classicizing formal vocabulary. While Ammanati exhibits a
growing formal diversity in figure types and composition which reflects
an exploratory mind always seeking new solutions to sculptural problems,
his temperament remains constantly lyrical and harmonious.

We have had occasion to mention the atmospheric qualities in
Ammanati's sculpture which are a marked feat of his earliest work,
the Pisa lunette. In subsequent works and especially those deeply
influenced by Michelangelo, this factor is somewhat toned down. But
it acquires new dimensions in the spandrel figures. This is an oppor-
tune moment to examine its sources in greater detail.

Ammanati's contact with painters is documented in the cases of
Lotto and Franco, and he probably had opportunity to know what Titian

and many others were doing. However, Ammanati's knowledge of painting
does not in itself serve to fully explain what is usually called a
"pictorial" or painterly quality in his work. In Florence the domains
of painter and sculptor were often not clearly distinct. Intense
pursuit of effects more commonly dealt with by painters -- illusion-
istic, optical and atmospheric -- are crucial problems in Florentine
sculpture as early as Ghiberti and Donatello, and are very much pur-
sued by later sculptors, e.g., Desiderio and Agostino di Duccio. One
of the major figures to carry this tradition into the sixteenth
century is none other than Ammanati's teacher, Sansovino. This is
apparent in the early relief of Susannah and the Elders in the V and
A, the terracotta relief of the Madonna and Saints in Berlin, and the
reliefs for the tribune of S. Marco. But Ammanati develops atmospheric
and chiaroscuro effects further than Jacopo ever did in stone or
bronze statuary. Certainly the shimmering light of the canals and
the palpable moisture of the Serenissima had a profound effect on the
young Ammanati, both as a pupil of Sansovino and now ten years later.
Unlike Sansovino, who came to Venice as a mature artist, Ammanati had
a deep exposure to Venice while still young and impressionable. The
"unfinished" sculptures in the Medici Chapel probably also had a role
as catalyst in liberating Ammanati from the bonds of orthodox con-
vention and spurring him toward quite different explorations for
pictorial effects, hints of which we already noted in the Nari sculp-
tures. Another factor should not be overlooked: the inherent
characteristics of pietra d'Istria. Its grain is not as fine as

marble's and it does not lend itself as well to fine detail or polish. Ammanati has exploited the stone to achieve an effect which is inherently well suited to it.

Ammanati's exploration of light and atmosphere points ultimately to the Juno and the Fiorenza for the Palazzo Vecchio fountain, figures which seem dissolved by a flickering light and a moisture-laden breeze. Atmospheric and chiaroscuro effects similar to those of the spandrel figures, partly indebted to Ammanati, were pursued later by Vittoria and Girolamo Campagna.

Ammanati's oscillation in his use of bozzetto-like forms is apparent in the River Gods. This reflects, apart from an oscillation in taste, the inherent conflict between the styles of his teachers -- the limpid and clearly articulated forms of Bandinelli and Michelangelo on the one hand, and the atmospheric forms of Sansovino and Venice on the other. The oscillation is apparent already in the different handling of the heads of the Leda and the God Father at Pisa, and between the Sannazzaro allegories and the Nari sculptures.

Interestingly, the collaboration of the two artists coincided with a more profound stylistic change for Sansovino than for Ammanati. In the years between the two sets of tribune reliefs Sansovino moved away from the fragility and fifteenth-century-orientated formal vocabulary of the '30's toward a more heroic and monumental idiom. The figures in the first three tribune reliefs, of 1537 (fig. 252), seem frail and delicate beside the massive and powerful figures of the second set (fig. 251), cast in December 1542. The figures of the first set are smothered in webs of densely faceted drapery which have

a considerable independent life of their own. In the second set the figures are larger and fewer, and the drapery organically follows the body below, and faceting is minimal.

The full-bodied figures of Ammanati's River Gods (especially A, B, E, F), and the relation of body to drapery in his Victories on the piano primo, are fundamentally analogous to Sansovino's second tribune rather than the earlier one. The same analogies hold also for Ammanati's earlier works markedly influenced by Michelangelo, e.g., the Minerva in Naples and the Nari sculptures. Ammanati was trained in Sansovino's style of the first tribune reliefs (as the Pisa lunette demonstrates), which he modified by the study of Michelangelo and Bandinelli. He brought this new style to Venice in 1541, when Sansovino seems to have been practicing in substantially the same style as he was when Ammanati left him some eight years earlier. Sansovino executed the second set of tribune reliefs between March 1541 and December 1542, at the time when Ammanati was elaborating his ideas for the spandrel figures. While Ammanati was probably not the only influence on Sansovino, he was, of the several Tuscans who came from Florence to Venice in the late '30's and early '40's with the most advanced notions of style, the one who was in a position to be more influential than the others.[21]

If Ammanati planned and balanced the figures of five of the six

[21]. Cf. J. Schultz, Venetian Painted Ceilings of the Renaissance, Berkeley 1968, 9 ff.

arches of the facade one might wonder why the two figures of the first
arch on the piano primo (figs. 169, 170) are not his. One suspects
that he planned the sculptures of all six arches as a unity, and it is
rather a visual surprise to find that these first two figures do not
remotely resemble the other five pairs on the facade. They lack the
sphere on which to support themselves, and since their feet are raised
above the lower edge of the relief, they dangle oddly, like weightless
puppets. By contrast, in Ammanati's figures one is always aware of a
sensitivity to the balancing of natural forces, of mass, and its
support. The bodies of the first two figures are more inflated and
inert, and their draperies run more flaccidly in simpler rhythms.
They run swiftly forward which seems to violate the confines of the
spandrel, and is out of keeping with the relative composure and sta-
bility of all of Ammanati's figures. Their movement and drapery
patterns are reminiscent of certain Victories of the piazzetta face
(figs. 171-172). The most probable solution is that they are replace-
ments for figures which were lost in the collapse of 1545 and carved
without attempting to preserve Ammanati's design.

What of the two replicas of Ammanati's figures in spandrels two
and three? Are they contemporary with Ammanati's work on the facade?

We do not know a great deal about exactly what was damaged when
the Library collapsed in December 1545. Contemporary writings and
documents give imprecise, brief and contradictory reports about the
damage.[22] To judge from the most reliable reports, recorded in the

22. Lorenzetti, op. cit, 39 ff.

archive of the Procuratorie de Supra,[23] it is clear that the vaults collapsed, part of the walls fell in, and some unspecified pieces of figural sculpture were destroyed, including at least part of the frieze. We learn of the damage to the figures from a record dated February, 1545 of Sansovino's obligation to rebuild the Library at his own expense of 1000 ducati. Included in this statement is the requirement that Sansovino remake "li figure frisi (i.e., fregi) et altro che fussero rotti et spezato il non possa metter quelle in opera: ma farli da novo." Sansovino rebuilt the damaged section of the Library in eleven months, between the collapse and November 1546, and in the process changed the roofing from a barrel vault to a flat wood-beamed ceiling. The Library was examined by "Zoro Io. Antonio Proto" and "maistro Bernardin Proto ali Provedadori de comun," and their report of November 28, 1546 stated that the building was satisfactorily repaired and that "le piere vive esser bone et ben squarizate et ben intagliate con le sue figure benissimo lavorade."

It will be recalled that the Library, according to the documents, collapsed "a la parte verso la Panateria."[24] All evidence suggests localizing the area traditionally called the "panateria" in the space

23. Archivio di Stato di Venezia, Procuratorie de Supra, busta 68. "Fabrica reparata dal Sansovino 1545." Published in Laura Pittoni, Jacopo Sansovino Scultore, Venice, 1909, 172-178.

24. Ibid, 178.

between the campanile facade and the Library,[25] but one would think
that when early writers say "verso la Panateria" they could mean a
section of the piazzetta facade near the campanile or the campanile
face itself. The documents are simply not explicit enough in them-
selves to pinpoint the areas of damage. But some circumstantial
evidence is contained in the sculpture. The presence of four figures
not by Ammanati in the spandrels otherwise allotted to him suggests
that the campanile face indeed suffered some damage in 1545.

Several figures have been cracked and broken in places, but
admirably repaired. The left leg of River God A is cracked above
the knee. The right wrist of River God E appears to be cracked. The
Victories are damaged a bit more severely. Victory A had her left
elbow severed, B had both elbows cracked, Victory C's wing was broken,
and the spandrel behind her has been repaired. All of the figures
have suffered abrasions and gouges in the surface, especially Vic-
tories B and D.

It is very difficult, if not impossible, to isolate the damage
suffered by the figures when the campanile collapsed in 1902, caving
in arches two and three.[26] Whatever damage was done cannot be distin-

25.
 Lorenzetti, op. cit, 36.

26.
 The 1902 campanile crollo collapsed part of the piano primo,
knocking out all but the first and sixth spandrels facing the campanile
and buried, but did not cave in, those of the pianterreno. A truly
remarkable and painstaking restoration effort managed to salvage most
of the pieces and repair the figures. The River Gods miraculously
escaped pulverization, probably thanks to the projecting cornice
above them. See photographs of the damage in G. Mariacher, Il
Campanile di San Marco, 1912-62, n.d. (1962), photos 8, 12 ff. and
Comune di Venezia, ed. Il Campanile di San Marco riedificato, n.d.,
37, 71, photos 134, 164, 177.

guished from that which the figures might have suffered in 1545 until they
c a n be brought under closer scrutiny. Their extremely dirty surface,
pigeon dung, and inaccessibility hamper investigation of questions of
style and repairs. However, one thing is certain: despite repairs
and minor replacements, all of the figures date from no later than
the mid-sixteenth century. Even the two Victories which are replicas
of Ammanati's have fractures, which indicate that they are not wholly
replacements carved in 1902.

It is very difficult to choose a period of execution between
1541-43 and 1545-46 for the two replicas. They follow Ammanati's
figures opposite them with the barest of modifications. If Ammanati
was present when they were executed it seems unlikely that he would
have permitted this kind of unimaginative work. If they followed
an original model by Ammanati, we would expect a design differing
somewhat from the other figure in the same arch, notwithstanding a
lower quality of execution. Therefore the replicas, like the two
Victories of the first arch, are also likely to be replacements for
two figures by Ammanati, executed in 1546 after he had already left
Sansovino's shop. But the two groups are not by the same hand. Pro-
bably Ammanati's original figures were severely damaged and as the
document of January, 1546 stipulates, rather than patch them up
Sansovino was required to "farle da novo." In conclusion, we can
tentatively hypothesize that at least the three arches of the piano

primo of the campanile facade wholly or in part collapsed in 1545.[27]

Why did the sculptural plum fall to Ammanati rather than to Sansovino's other assistants, such as Cattaneo, Tiziano Minio or Girolamo Lombardo? These sculptors may have been still occupied with the reliefs for the Loggetta, but one suspects that other factors were more important. Ammanati was a more experienced sculptor than any of these three, and had earned a considerable reputation by the time of the Nari commission. Sansovino obviously knew Ammanati well, and knew his conscientiousness and considerable capacity for work. Because of the enormity of the task at hand, these factors were no doubt important. Cattaneo was a somewhat intractable personality, and had a reputation for working slowly.[28] From Ammanati Sansovino could confidently expect, and did receive, a goodly number of high-quality figures which, being the first to be unveiled, could be expected to make a favorable impression on the Procurators.[29]

27. This agrees in large part with Ivanoff, Saggi e Memorie, 1968, 52, who believes that the piano primo toward the piazza collapsed in 1545 destroying the frieze with putti.

28. L. Planiscig, op. cit, 418.

29. A. Callegari ("Il Palazzo Garzoni a Ponte Casale," Dedalo, Feb., 1926, 588) attributed to Ammanati stucco (not bronze) a group of Pluto and Cerberus above a fireplace in the Villa Garzoni (now Stechini) at Ponte Casale. This was accepted by Venturi (Storia, X, II, 371, fig. 310) and S. Bettini, "Noti sui soggiorni veneti di Bartolomeo Ammanati," Le Arti, III, 1940, 20.

However, I am convinced that this work was done by the young Vittoria in the later '40's just before emerging as an independent artist in the stuccos at Palazzo Thiene at Vicenza. The openness and

29. (Cont!d.)

the fluidity of the poses, the penetrating observations of bone and
muscle structure, the sharp oscillation between projecting and receding
parts of the anatomy, the deeply recessed eyes and undercut locks, the
attenuated, slender proportions, the liquid flow of the locks and
torsos - all this is characteristic of the young Vittoria, more
attuned to the naturalism of Sansovino and the elegance of Parmigianin-
esque forms at this early time. Ammanati's figures in the '40's are
far more abstract, psychologically aloof, compact, broader and
heavier than this. The handling of the head, the attenuated elegance
and naturalism are also close to the River Gods on the Library which
have been convincingly attributed to Vittoria by Ivanoff, Emporium,
op. cit.

Venturi (loc. cit), followed by Bettini (loc. cit.) also attri-
buted the two male caryatids flanking the fireplace below the Pluto
group to Ammanati. Though perhaps executed with the aid of assistants,
these are clearly designed by Sansovino, and I fail to detect any sign
of Ammanati's participation. These two figures, together with the
other two brilliant female caryatids in another room of the villa
surely must be those meant by Vasari when he speaks of "quattro figure
bellissime del Sansovino" at the villa.

The villa was constructed by Sansovino, probably in the 1540's
(see L. Puppi, "La Villa Garzoni a Pontecasale di Jacopo Sansovino,"
Prospettive, IX, Oct. 1961, 56 and B. Rupprecht, "Die Villa Garzoni
des Jacopo Sansovino," Mitteilungen des Kunsthistorischen Instituts in
Florenz, II, 1963, 24).

By the time the decoration of the villa got under way, perhaps
by the mid or later '40's, Ammanati was already very busy with the
Benavides commissions.

Callegari (loc. cit, 588) also attributed to Ammanati a bronze
statuette of a nude male youth once at the villa and now at the
Metropolitan Museum in New York. This attribution was accepted by
Gabbrielli (op. cit, 1937, 90) and Bettini (loc. cit, 20) and H.
Weirauch, Europaeische Bronzestatuetten, Braunschweig, 1967, 189,
though not by Ciardi - Dupre (op. cit, 1962, 57, n. 1). This figure
possesses a powerful masculinity and torsion, an athleticism and coiled
tension unknown in Ammanati's oeuvre. It has closer analogies with
works by Giambologna and his following, especially Adrian de Vries,
at their most Michelangelesque moments. A fine replica is in
Braunschweig, Herzog Anton-Ulrich Museum. The source for the pose of
the figure may be a hellenistic torso of a satyr in the Uffizi, pro-
bably known to Ghiberti.

29. (Cont'd.)

Gabbrielli (loc. cit, 90), followed by Bettini (loc. cit)
attributed a bronze statuette of a satyr in the Castiglione collec-
tion to Ammanati, and observed analogies between it and the
Metropolitan bronze. Planiscig, in his catalogue of this collection
(Catalogo dei Bronzi, 1923, p. 15) attributed this piece, more
accurately, to Giambologna.

Ciardi - Dupre ("Bronzi di Bartolomeo Ammanati," op. cit, 57-59)
attributes two bronze statuettes of Mars and Neptune in the Detroit
Institute of Arts to Ammanati. However, the slender ankles and wide
torsos of these figures, characterized by tense, knotted musculature,
are analogous to Cattaneo's Risen Christ on the Fregoso Tomb in
Verona, and the male figures in the bronze reliefs of the Loredan
Tomb in SS. Giovanni and Paolo in Venice. We may follow Pope -
Hennessey (Essays on Italian Sculpture, London, 1968, n. 108) who
favors an attribution to Cattaneo.

I see no reason why a bronze portrait of Lazzaro Bonamico in
the Museo Civico in Bassano should be given to Ammanati rather than
Cattaneo, as Ciardi - Dupre (loc. cit.) has suggested.

A terracotta relief of the Madonna and Child occasionally cited
as a Venetian work by Ammanati has been shown to be a work by
Francesco da San Gallo by Heikamp, "Ein Madonnenrelief von Francesco
da San Gallo," Berliner Museen, berichte, N.F. VIII, Nov. 1958, 34 ff.

Chapter 9

AMMANATI'S ACTIVITY IN PADOVA AND VICENZA: 1544-48

Part I: Chronological Introduction

If Ammanati worked as rapidly as he frequently did, his share of
the Library sculptures could have been completed by mid-1542 or easily
by the end of this year. Ammanati is documented in Padua and Vicenza
intermittently from 1544 to October 1548. Where was he in 1543? As
discussed earlier, it is likely that after completing his work for
the Library he returned to Urbino to execute the Tomb of Francesco
Maria and had another commission given to him by the Duke of Urbino,
later lost or aborted, which took him to Carrara to select three blocks
of marble. By sometime early in 1544, however, Ammanati was in Padova
working on the colossal Hercules.

A letter of April 16, 1545 mentions that "il Colosso a que tempi
era fatto;" this is its terminus ante quem.[1] According to Benavides,
who had it erected, Ammanati executed it "aetatis suae... anno 33," or
in the year 1544-45.[2] Since Ammanati's birthday is not known with
certainty, the dating must be somewhat flexible. Benavides implies
that Ammanati executed the twenty-three-foot high figure in just one
year. Even granting that the figure is hewn from eight pieces of stone
rather than one, and that it is local stone, not marble, the achievement
once again demonstrates Ammanati's astonishing capacity for work.

[1] See Appendix 1, doc. 2.

[2] Marco Mantua - Benavides, Enchiridii Rerum Singularium, Patavii,
1553, 238.

In 1545 and 1546 Ammanati was moving back and forth between
Padova and Vicenza at intervals, and in fact carried forward at
least one phase of his work for Girolamo Gualdo simultaneously with
his work for Benavides. The cities are separated by roughly 30
kilometers and it was probably no more than a few hours or a morning
by horseback. According to Girolamo Gualdo's letter to Benavides of
August 26, 1545 (Doc. 4), Ammanati had already executed a fountain in
the Giardino Gualdo by this time. Only the sculptural decoration was
incomplete. However, Ammanati was in Vicenza as early as April 21,
1545, whence he brings greetings to Benavides from Francesco Maria
Machiavelli (Doc. 3). What he was doing in Vicenza at this moment
is not known, but his presence there probably indicates that Ammanati
was already at work on the Gualdo fountain. Moreover, it's not un-
thinkable that he may have designed the Casa dal Toso in Vicenza and
the Villino Barbaran in Nanto, near Vicenza, at this time.

The Benavides Tomb was begun soon after May of 1545 -- the date
of Aretino's letter mentioning the model. The figural sculpture may
have been substantially complete by February of 1546, when Ammanati's
notebook records payments to a mason for helping him erect the archi-
tectural framework of the Tomb in the Eremitani Church. These payments
run through April and the Tomb was dedicated in May of the same year.

Ammanati also was active building stage sets for Giovannandrea
dell'Anguallara in July of 1545 and from February to April of 1546.

Of the three fountains which Ammanati built for Gualdo, two
carried dates of 1546. In all probability Ammanati completed his

work in the Giardino after the Benavides Tomb was finished, between May and the end of 1546.

The triumphal arch in the cortile of the Palazzo Benavides was probably conceived by Benavides to commemorate two major honors which he received in 1545. Thus its terminus post quem is this year. The arch and the Palazzo Benavides itself were probably nearing completion by August 1547. This is suggested by a letter of Luca Martini's to Ammanati of August 27, 1547 (Doc. 5) from which it can be gathered that Ammanati is looking for work in Florence.

No document lends support to the hypothesis that Ammanati executed the Palazzo Benavides itself. A letter of Beaziano's of November 20, 1546 mentions Benavides' "casa bella e magnifica."[3] The Palazzo, if not complete by this time, certainly was by September 20, 1547 when a letter mentions that the Palazzo is built.[4] Thus, the construction of the triumphal arch coincides roughly with the completion of the Palazzo. This is to be expected, since one side

[3] Letter of Agostino Beaziano with a poem eulogizing the Tomb in the Eremitani, Seminario Cod. 609, 6, #296. Published in part by G. Rossetti, Descrizione delle pitture, sculture, ed architettura di Padova, Padova, 1780, 160. From 1528 to 1540 Benavides lived in Via Urbano (B. Candida, I calchi rinascimentali dell' Museo Archeologico dell' Universita di Padova, Padova, 1967, 16). Presumably, the Palazzo was built in greater part before 1540, which excludes Ammanati's involvement in its basic design.

[4] See doc. 6.

The most complete testimony of Ammanati's work for Benavides by Benavides himself is his letter of 1549 to Altoviti (Doc. 12). Here he mentions the Colossus, Tomb, and arch, but not the Palazzo. If Ammanati significantly contributed to its building, it is doubtful that Benavides would have omitted mention of it. The attribution is rejected by Fossi, Bartolomeo Ammanati architetto. Cf. W. Arslan,

of the arch abuts the end of the major wing of the Palazzo and
together with it forms one continuous wall of the garden behind
the Palazzo and cortile.

Luca Martini's letter to Ammanati of August 27, 1547, in reply to
Ammanati, clearly suggests, as we said, that the sculptor was looking
for work in Florence at this time. What he was doing in the year
between the date of Martini's letter and October, 1548 is unknown.
Several possibilities suggest themselves: 1) he returned to Urbino to
take up work on the project connected with the three blocks in Carrara;
2) he attended to the architectural projects in Vicenza mentioned
above;[5] 3) he executed some smaller works in terracotta, now lost,
for Benavides' garden and study.

4. (cont'd.)

"Di alcune architetture toscane a Padova," Miscellanea di Storia dell'
arte in onore di I. B. Supino, Firenze, 1933, 503. The Palazzo was
renovated in the eighteenth century, but this and other additions
have never been clarified. Certain minor differences between the
vocabulary of the cortile and that of the facade might suggest
Ammanati's collaboration on the former. These differences include:
1) the addition of a string course linking the pilaster bases and
window frames of the piano primo, eliminating the clashing of these
members in the facade; 2) the addition of another string course on
the piano primo where the arches spring, having a similar effect to
that above; 3) eliminating the raised moulding of the pilasters of
the facade, a classicizing improvement by Renaissance standards.

The vocabulary overall appears too provincial and Quattrocentesque
to be by Ammanati. But could Ammanati have suggested to the unknown
architect the more sophisticated integration and harmonizing effects
visible in the cortile? It is entirely possible, since Ammanati was
probably in Padova before the cortile facade went up, and would have
wanted the best environment for his sculpture that was feasible.

There is a clear break in building phases on the left wing of
the cortile where the gutter pipe descends. This appears to be much
later (renovation?) than the sixteenth-century parts.

5. The affinity of the Villa Barbaran in Nanto to Ammanati's
architecture was noted by R. Cevese, Le Ville Vicentine, Treviso

Ammanati left Padova for Rome shortly after October 16, 1548

and arrived in the Eternal City about one month later, by November

17 -- not in 1550 as erroneously stated by Vasari, followed by

Baldinucci and widely repeated ever since.

5 (Cont'd.)

1953, 51. Ammanatesque features have been noted regarding the
Casa dal Toso in Vicenza also (see F. Barbiere et al., Guida di
Vicenza, Vicenza, 1956,.

Neither building has been closely studied. The Villa Barbaran
is disintegrating rapidly. The sensitive organization of the facade
of the little Casa dal Toso, and the type of stucco classical
mouldings articulating the vault of the pianterreno, with ovals
predominating, could suggest a design by Ammanati, or at least his
influence.

The fragility and organization of the classical vocabulary of
both buildings recall the Villa Giulia, grotta as well as nymphaeum,
and the Benavides Tomb.

Part II: The Works for Benavides: Introduction

Marco Mantova Benavides, the son of Pietro Mantova Benavides, a doctor of some repute, was born in 1489.[1] He studied Latin and Greek, then Law, at Padova University. He took his degree in 1510 when twenty-two years old. In 1515 he was given a chair at the University of Padova, and remained a professor there until he retired. For fifty years he taught civil, pontifical, canon and criminal law. He also found time to serve as ambassador to Venice in 1545-46 and to advise princes, Popes and dukes on legal matters, among them the Duke of Montefeltro Federico II, the Duke of Ferrara Ercole II, Cosimo de' Medici, Guidobaldo of Urbino, Charles V and Ferdinand II, Paul II, and Pius IV. He was knighted three times, by Charles V in 1545, by Ferdinand II in 1561, and by Pius IV in 1564. The King of Portugal offered him 1000 scudi to serve at his court in 1546,[2] and Paul II called him to serve as Auditor of the Sacra Rota.

But he was more than one of the most famous jurists of his time in all of Europe. He was a man of vast erudition, astonishingly well versed in Greek and Latin literature. He published over 45 books, including a large number of encyclopedic tomes on problems of jurisprudence, as well as smaller works which ranged over such fields as

[1] On Benavides, see A. Valsecchi, Elogio di Marco Mantova Benavides, Padova, 1839, with earlier bibliography.

[2] Letter of Diego Clazevedo from Rome, Oct. 16, 1546; Seminario Cod. 609, #77. See also #222.

poetry, literary criticism, the novella, dialogues, biography,
history, diplomacy, emblem books and hieroglyphics.[3] Doni, in a
letter of 1550, remarked on Benavides' "tante infinite virtù di
Nobilità, di dottrina, di splendore, di cortesia, e di magnanimità
nate in voi, e sparse, e seminate, sopra li letterati, sopra gli
scoltori, Pittori, e sopra tutte le sorte di virtuosi."[4] His circle
of acquaintances ranged widely among the most renowned letterati,
antiquarians, artists and musicians of his time. Ghillini noted
that "sua casa era il teatro delle muse e della musica insieme, dove
concorrevano quasi tutti i virtuosi della patria; insomma, fu egli
un chiaro specchio d'ogni honorato operazione, un vero esempio di
gentilezza e cortesia, et una bella idea di perfetto letterato."[5]

Benavides' taste in art was as catholic as his interests outside
the visual arts. Ammanati, in his letter describing the Villa Giulia,

[3.] The most complete, though not exhaustive bibliography of
Benavides' writings is in G. Vedova, Biografia di scrittori padovani,
Padova, 1831-32, I, 573 ff. Cf. also N. C. Papadopoli, Historia
Gymnasii Patavini ..., Venice, 1726, I, 256.

Of the works which might prove useful to iconographers a short
study of hieroglyphs (Zographia, sive Hieroglyphica, Patavii, 1566)
and a modest emblem book (Locutati opusculi ..., 1580) are noteworthy.
Copies of both are in the Bibl. Correr.

[4.] Letter of A. F. Doni ("Doni Fiorentino") to Benavides of Feb. 7,
1550. Ms. in the Seminario, Padova, Cod. 619, #18.

[5.] G. Ghilini, Teatro d'huomini letterati, Venetia, 1647, I, 161-62.

notes Benavides'passion for art: "conoscendo il bellissimo animo
Vostro, eccellentissimo messer Marco, dilettarsi di vedere ed inten-
dere cose nuove e virtuose."[6] He had dealings with many of the well-
known antiquarians and artists of his day, including Valerio Belli,
Giovanni Cavino, Vittoria, Giuseppe Salviati, Domenico Campagnola,
Guariento, and perhaps Titian and Tintoretto. He lavished most of
his attention on Domenico Campagnola, Ammanati, and his famous museum.
When inventoried in 1695 the museum contained well over 376 objects,
the majority of which were collected before Benavides died in 1592.[7]
It is reported that Francis I wanted to buy the entire collection.[8]
It contained a variety of Greek and Roman marbles and vases, urns,
medals and coins; gesso casts of ancient portraits, casts of ancient
and modern sculpture, as well as original sculptures, paintings,

[6]. Published in G. Balestra, La Fontana Pubblica di Giulio III e
il Palazzo di Pio IV sulla via Flaminia, Rome, 1911, 65.

[7]. This inventory was compiled by Marco's nephew Andrea Benavides
in 1659. Ms., Biblioteca Civica, Padova, #5018.

I am deeply grateful to Professor Luigi Polacco and Dottoressa
Irene Favoretto of the University of Padova for allowing me to
freely consult their typescript of the manuscript.

That the vast collection formed by Marco was partly broken up
before the inventory was taken is known from an evaluation of some
things in it of December 13, 1652, made by Gian Pietro Benavides and
Andrea Benavides, heirs of Marco, in preparation for a division of the
collection between the two. The document was published by F. Cessi,
"Luca Ferrari da Reggio stimatore dei beni d'arte di casa Mantova,"
Padova, IX, 1963, n. 78, 11-12.

[8]. Ant. Riccoboni, Oratio in obitu M. Mantuae Benavidii, Patavia,
1582, n. p.

drawings, and prints by artists of Benavides' own day. Today a
small fragment of his museum is preserved in the Museo Archeologico
dell' Università di Padova, including two works by Ammanati, the
stuccoforte model of Sapienza and a small terracotta head (figs. 261-
262).[9]

9. For the Sapienza see p. 135, n. 2; 147 f.; for the terracotta
head see p. 162, n. 12.
On the collection see the studies by Luigi Polacco, "Il Museo
di Marco Mantova Benavides e la sua formazione," Arte in Europa,
Scritti di Storia dell'arte in onore di Edoardo Arslan, 1967, I,
665 ff; "Il Museo di scienze archeologiche e d'arte dell' Università
di Padova. I. Storia e Ordinamento," Atti dell'Istituto Veneto di
Scienza, lettere, ed arte, 1966-67, CXXV, 421 ff; and by Bianca
Candida, I calchi rinascimentali nell'Museo di Archeologia e di Storia
d'arte dell'Università di Padova, Padova, 1967, and Irene Favoretto,
in Musei e gallerie d'Italia, 14, 1969, 16 ff, and a review of
Candida's book by N. Dacos, in Archeologia Classica, XXI, fasc. I,
1969, 101 ff. Benavides' correspondence, as far as I know it, is
preserved in:

1) Marco Mantova Benavides, Di lettere familiari diverse, Padova,
1578 (copy at Marciana, Venice).

2) "Lettere volgari e latine scritte à diverse di amici di Marco
Mantova Benavides," Ms. Marciana Ital. #6606: 57 letters in Latin,
96 letters in Italian. Many of the Italian letters were published
in 1578 (see above).

3) Correr Cod. 1349, Bibl. Correr; contains a number of letters whose
summarization are in the seminario codex.

4) Codex 609, 6, Bibl. of the Seminario, Padova. Summaries and
abbreviated copies of lost letters and letters preserved in Correr
1349.

I know nothing of what became of Benavides' vast library, which
included (Portenari, op. cit.) a large number of his manuscripts.

Some of the letters which deal with specific personalities
desserve mention. Those which concern Ammanati will be treated in their
relevant context. Others concerning Giovanni Cavino (Seminario codex
#177, 241, 24, 45, 106, 158, 177, 241, 249) will be discussed in a
forthcoming study by Dott. Giovanni Gorini of the Museo Botticin in
Padova. Let me add here that I am indebted to Dott. Gorini for his
kind assistance, and cooperation in allowing me to photograph a medal
of Benavides in the Museum.

9. (Cont'd.)

Three others involve Valerio Belli. They are from Francesco
Maria Machiavelli to Benavides concerning Belli and his work. The
earliest, of September 20, 1542 is a summary of a lost letter
(Seminario 619 #137). The other two, of May 21, 1543, and 1542 are
originals preserved in the Correr (Cod. Correr 1349, #119, and 191).
In passing, perhaps this is the place to note that at least two of
Girolamo Gualdo's poems (Rime, Venice, 1569, 16, 39) eulogize Belli.
Other letters cited below will be of interest in varying degrees for
those who wish to pursue Benavides' antiquarian and collecting tastes.

Cod. Seminario 619, 6, #52, 53, 63, 176, 197, 215, 217, 239,
240, 266.

Cod. Correr 1349, 27, 60, 127, 152, 164 (an abbreviated copy is
Seminario 619, #225) and perhaps others, as I have not gone through
all the letters thoroughly.

Marco Mantova Benavides, Di lettere familiari diverse, Padova,
1578 (a copy is in the Marciana Library), #27, 62, 68, 73, 111.

Perhaps another relevant letter will have escaped the attention
of bibliophiles. Benavides' acquaintance with Giuseppe Salviati and
Girolamo Campagna is documented by a letter of Salviati's to
Benavides of November 27, 1573 which recommends Campagna for the
commission of the last of the large marble reliefs in the Cappella
del Santo in Sant' Antonio, Padova. Published in B. Gonzati, La
Basilica di S. Antonio di Padova, Padua, 1854, II, Doc. XCIII.

Perhaps included among the 37 "quadri diversi, ritratti, et altro"
(Cessi, loc. cit.) were some portraits of famous juriscounsels possessed
by Benavides, six of which were recorded in Andrea's Inventory under
#78: "Sei quadri di mezi retratti ... con le sue soaze compagne come
sop.a tutti delli piu famosi et illustri Juris Consulti de secoli
passati di buona mano." No doubt the latter are among those engraved
and published by Benavides and Lafrèry in 1566 under the title
"Illustrium iureconsultorum imagines quae inveriri potuerunt ad
vivam effigiem expressae / ex Museo Marci Mantuae Benavidii Patavini
iureconsulti clarissimi / Roma Ant. Lafrerii Seguani Formis Anno Sal.
MDLXVI." This publication contains 24 engravings of c. 10" x 7" of
famous lawyers. Each portrait is labeled and dated. A later edition
of the same with weaker engravings, probably copies, was issued in
1579 in Venice. Copies of both publications are preserved in the
Vatican Library. These portraits, which to judge by style were probably
engraved, at least in part, for the first edition by Enea Vico, include
some men who lived in the fourteenth and fifteenth centuries and pro-
vide interesting information about early, now lost, Italian portraiture,
even if perhaps sixteenth century copies of earlier works. The fact
that only six of the twenty-four are listed in the 1695 Inventory hints
at the extent of the dispersion of the collection before the Inventory.

9. (Cont'd.)

The published engravings serve as a visual complement to Benavides'
Epitoma virorum illustrium ..., Patavii, 1555, which contains 232
brief biographies of famous lawyers, ancient and Renaissance, though
no engravings.

Part III: The Colossal Hercules

No photo can do justice to Ammanati's Colossus (figs. 175-190),
to its sheer overwhelming size, its hulking massiveness and coarse,
pulsating strength. It must be experienced, and approached as it
was meant to be seen. The figure is not visible from a distance,
being concealed from the street by the Palazzo. One approaches it
from a low passageway which runs between the street and the cortile.
As the spectator reaches the courtyard suddenly this mammoth brute
looms in front of him, staring in his direction. The sight strikes
momentary terror into the viewer, and it was no doubt intended to do
so. A similar jolt awaits the unwary who stroll into Giulio Romano's
Sala dei Giganti at the Palazzo del Te. The figure is 20 Paduan feet
high (713 cm. = 23.4 E n g l i s h f e e t) . It is made of eight
pieces of local stone and set on an octagonal base 5 Paduan feet high
(178 cm. = 5.85 feet) which carries an inscription and reliefs of seven
symbols of Hercules' Labors (figs. 183-187, 196-198).[1] On the support
behind the figure is the inscription: Bartholomei Ammanati Florentini
Opus.

Benavides was duly impressed with the Hercules, and had occasion

[1] The eight reliefs on the base represent eight trophies of
Hercules' labors: the Nemean Lion, the Cretan Bull, the Lernian
Hydra, the Cerynitian Stag, the Thracian Mares, the three-headed
Cerebus, the Stymphalian Birds, and the Erymanthian Boar, in clock-
wise fashion.

to speak of it several times. In a letter of February 1549 to the
Archbishop of Florence, Altoviti, he says "non essendo stato fatto
colosso alcuno fin hora da gli antiqui in quà se non da costui, con
tanto artificio poi che è una maraviglia, alto venticinque piedi,
& di otto pezzi, come gia scrissi à V.S. Reverendissima tanto ben
accozzati, & congiunti insieme, che niente ha lassato che si possa
disiderare nell'arte anci che da maraviglia, à cui lo riguarda in
questo cortile, ne si può dar pace il genga del Duca d'Urbino, il
Palladio, il Sansovino & gli altri di questo Maestro, & cosi giovane
che sia riuscito in cosi grande impresa."[2] In 1551 Benavides
published his Enchiridii rerum singularum, in which he compared
Ammanati's achievement to Phidias, Praxiteles, and Polyclitus, and cited
the Colossus three times.[3] The first passage occurs in a chapter which
treats the highest examples of various species of things or deeds, most
of which are ancient. "... Perhaps it will not be irrelevant to adduce
the example of Polyclitus of Sicyon, whose statue, being the culmin-
ation of all [statues] , is called the canon, that is the rule, from
which all artists take up the features of their art, thus in this time
the colossus of Bartolomeo Ammanati the Florentine, stone of a height
of 20 feet, which he, first after the ancients, dared to sculpture,
in our house, and with admirable skill at the age (which appears the

[2] Published in G. B. Rossetti, Descrizione delle pitture e sculture
di Padova, Padova, 1780, 347. The letter is published in full in
Benavides, Di lettere familiari diverse, Padova, 1587 #35 (a copy is
in the Marciana Library, Venice).

[3] Marco Mantua - Benavides, Enchiridii Rerum Singularum, Patavii,
1553, 238, 305, and 292 r.

greatest wonder) of 33. Thus he easily rivals the ancients."[4] Another
passage is included in a chapter which is an exposition of famous
inventions and the authors thereof. "I conclude with Bartolomeo
Ammanati the Florentine, who first since the ancients dared to make a
colossus, stone in our house, of a height of 20 feet ... the like of
which future ages may not produce. May the highest greatest God grant
that he live, because we expect greater things, if however liberality
and breadth of spirit, as well as spur and stimulus, are not wanting.
And, whoever in our time would bo so ardent as to build a temple to
the Graces (like Etheocles, first King of the Thebans), a noble sculptor
can be found, who rivals Phidias and Praxiteles, and who dares to make
anything, then let him (as I said) be the patron."[5] If this were not
enough, elsewhere Benavides directs the reader's attention to the
colossus and calls Ammanati "a noble statuarius, and never sufficiently

[4]. Ibid., 238: forte non ab re erit exemplum Polycleti Sicyonij
adducere, cuius statua cum omnium esset absolutissima, canona, id est
regula, appellata est, unde omnes artifices omnia artis liniamenta
sumebant, ut hac tempestate Bartholomaei Ammanati Flo. colossus,
altitudinis pedum 20 lapideus, quem primus sculpere post antiquos,
in aedibus nostris, admirabili quidem artificio, ausus est, aetatis suae
(quod maxime mirum uidetur) anno .33. ita ut cum antiquis facile
contendat.

[5]. Ibid., 305: L. Piso, primus tulit legem de pecunijs re petundis. q
primi, quibus statuae pro rostris positae sint, Hippolytus, Harmodius,
Aristogiton fuere. Sed quoniam fastidiunt, finiam, cū Bartholomeo Am-
manato, Flo. qui primus post antiquos etiam Colossum facere ausus est,
lapideum in aedibus nostris, altitudinis pedum 20. ut supra.c.228. incip.
uim ui. cui forte nec similem secla futura dabunt. faxit Deus optimus
maximus, ut uiuat, quia maiora speramus, si liberalitas tamen, animiq;
magnitudo, moecenatum, ueluti calcar & stimulus, ei non defuerit. & qui

praised."[6]

Benavides was correct that Ammanati's Colossus was the largest
to be executed in stone since ancient times. It is over two meters
larger than Bandinelli's Hercules and Cacus (ca. 496 cm. or 8.5
Florentine braccia), which in turn is larger than Michelangelo's
David (410 cm.). Even Ammanati's own colossal Neptune is smaller
(9 1/2 Florentine braccia). Renaissance antiquarians were aware that
ancient colossi had been made of more than one piece of stone.
Renaissance artists used the technique of joining pieces of stone to
make statues, and Bandinelli seems to have been the first to implement
the practice on the level of free-standing colossal sculpture for his
Hercules and Cacus. In spite of erosion of the surface caused by years
of weathering, the joins in the blocks of Ammanati's colossus are not
easily located today.

Enormous praise was heaped upon the statue in its own day. In
a letter of April 1546, Aretino says, "la statua che ne la corte de

5. (Cont'd.)

Gratijs (ut Etheocles, Thebarum Rex primus) templum aedificent, quod
hac tempestate, uir tam ardens, tamq; nobilis sculptor inueniatur,
qui cum Phidijs & Praxitelibus contendat, omniaq; audeat facere, dum
tamen (ut dixi) impulsor sit. caetera lector curiosus a se ipso inue-
niat, cui ex his satis mihi superq; satis consultum uidetur.

6. Ibid., 292 r: Et Rhodij Colossenses deniq; à Colosso Charetis
opere Soli dicato, quem ibi mira magnitudine conflauerat, ut nostrum
Bartholomaeus Ammanatus Flo. cuius mentio etiam facta est honorifice,
in discursu fupra.c.228. incip. uim ui. s. non immerito, quia Statuarius
est nobilis, & nunquam satis laudatus. "And the Colossians in Rhodes,
[so-called] from the Colossus the work of Chares dedicated to the Sun,
which there with enormous wonder burned up. Thus our Bartolomeo
Ammanati, the Florentine whose mention was made honorably above ... and
not undeservedly, because he is a noble statuarius [statue-maker] , and
never sufficiently praised."

casa vostra costì in Padova avete fatta scolpire e famosa tanto che
qual si voglia principe ne sarebbe ornato."[7] Orsato noted: "mirae
altitudinis colossus Hercules Bartholomei Ammanati Florentini sculp-
toris celeberrimi opus."[8] It was engraved several times and published
by A. Lafréry in 1549, 1553, and 1557. Lafréry's engraving (figs. 199,
200, 202) copies a drawing which Enea Vico made of the Colossus in
1548 (fig. 201) and which Ammanati himself apparently carried to Rome
and delivered to Lafréry.[9] Vico's drawing gave pictorial expression

[7]. P. Aretino, Lettere sull'arte, ed. Camesasca, Milano, n.d., II,
p. 157, #CCCXL.

[8]. S. Orsato (Ursato), Monumenta Patavina, I, 1652, 157. A Latin
poem commemorating a visit to the Casa Benavides by "Morandiis
Veronensis" mentions the Colossus. Seminario Codex 609, 6, #295:

"Ad Excellentiis Mantuam
 J(?) Morandiis Veronensis

Sit tibi sit quam vij ingentibus aucta colossii,
 Sitque eadem vario culta labore domus;
Plura ubi prijconim congesta numismata Regum,
 Cuique pavem non _ es, Biblioteca nitent;
Hac excire lev(r)ij possunt praeconia vulgi,
 Cuncta sed extremam sunt obitura diem.
Cultior illa tuae, et constantior edita moles
 Virtutis, nunquam laude cavere potest."

[9]. The Louvre drawing, Inv. No. 48, under Ammanati's name. 53.3 x
41 cm. (nearly identical to the engraving), graphite on paper. The
engraving follows the drawing closely except for minor changes in
the classical ruins of the background.

 The drawing can be traced to Vasari's collection (via Baldinucci)
where it was listed under Ammanati's name. The mistaken assumption
that Ammanati executed it (O. Kurz in Old Master Drawings, XII, Dec.
1937, 42 and in Studi Vasariani, 1952, 228) was corrected by Middel-
dorf (Old Master Drawings, June 1938, XIII, 10). There is no reason
to believe that the drawing copies the engraving as suggested by
Gabbrielli, op. cit, 95, n. 20. On the strength of a letter of
Benavides (see Doc. 7 and Chapter 10), it can safely be attributed
to Enea Vico, with whose style it perfectly agrees.

to Benavides' flattering remarks in the Enchiridion, that the figure
rivals the ancients. It is placed among the ruins of antiquity and
a number of buildings evoke Rome. At the right are the pyramid of
Cetius, a circular structure reminiscent of the Temple of the Sybil
at Tivoli, and a domed building with alternating rectangular and
round-headed arches similar to a type used for Roman baths, e.g.,
the Baths of Trajan above the Domus Aurea. This visually equates
the figure with the Colossi of ancient times, and with the grandeur
of Rome. At the left are two or more artists, one of whom is intensely
engaged in drawing the figure, thus echoing Benavides' remarks that the
statue could serve as a model for artists just as the statues of
Polyclitus did in ancient times. Usually, this piece of extreme
flattery is reserved solely for antique works, such as we encounter

9. (Cont'd.)
 Another drawing under Ammanati's name at the Louvre (Inv. no. 52,
22.7 x 42 cm., graphite on paper), representing a triumphal procession
of a Roman Emperor, is clearly by the hand of the Hercules drawing and
may also be attributed to Vico. A print of 1553 is in the **Marucelliana**
Library in Florence (Ferri, Catalogo, ms. v. 31, #115), 40.5 x 53.2 cm.,
inscribed on the base of the statue and at the lower right: "Colossus
p. XL erectus patavii Bartolomeo Ammannato sculpt. / Ant. Lafréry formis
Romae 1553." Morelli (Anomio, Venice, 1800, 149) claimed to have seen
an example dated 1549, I have not seen the 1549 print. It would not
be irrelevant to note that Vico engraved a portrait of Benavides
(Bartsch, XV, #252, p. 337). The Colossus was also engraved by F.
Bertelli and published in Michele Cappellari's eulogy of the statue,
Herculis Colossus Mantuae Benavidiae Patavii Caelatore Bartolomaeo
Ammanati Florentino, Patavii, 1657. However, the engraving is a feeble
work. Vico's drawing and its engraving omit the vine leaves about the
head of Hercules which are present today. These are restored, but it
seems unlikely that they are an invention of the nineteenth century.
The vine alludes to Hercules in his drunken state (cf. V. Cartari, Le
Imagine degli Dei, 1571, 329) a popular theme of ancient statuettes,
such as one of the Hellenistic period in the Metropolitan Museum, N.Y.
The fig leaf on the figure was added before 1831 as it is visible in
an engraving of this time (in P. Chavalier, Memorie architetti sui
principali edifici della città di Padova, 1831, 45).

in a number of Lafréry's prints of ancient colossi.[10] At the right

two "cortigiani" -- differentiated from the other four figures by

their more expensive and refined costumes "all'antica" -- admire the

reliefs of the base. This tells us that Ammanati's figure is the

wonder of the cultured and noble as well as of artists. Vico has

indulged in additional flattery by slightly enlarging the size of

the Colossus in relation to the human figures.

In the Enchiridion Benavides compliments Ammanati by drawing

direct analogies between his sculpture and the ancients. At the same

time, however, Benavides indirectly draws praise to himself, as the

exemplary patron who provided the scope for brilliant artistic achieve-

ment. The inscription on the base of the Hercules -- which was incor-

porated in Vico's engraving -- is more explicit: Hercules "per amplo

hoc signo mantuae cura reflorescit."

At one time it was famous that Benavides put in the base of the

Colossus many portrait medals of himself and a vase of oil that was

said to become balsam within a period of 100 years.[11] Putting medals

of the patron in the base of a statue to commemorate it is not unknown.

Medals of Pope Clement VII and a letter carved in stone were placed in

the base of Bandinelli's Hercules and Cacus. In this case the insti-

10. E.g., Lafréry's print of the antique reclining colossal River
God "Marfuori" in Rome, dated 1550, Uffizi #13594. Later this form
of adulation will be used toward the work of Michelangelo, as in the
drawing by Federico Zucchero in the Uffizi showing artists drawing
in the Medici chapel.

11. A. Portenari, Storia di Padova, 1623, 458: "E fama, che dentro
la base di detto colosso Marco Benavidio Mantoa Famosisimo Iurisconsulto,
che lo fece fare, habbia posto molto medaglie improntate della sua imagine,
e un vaso d'olio, che dicono nella spatio di cento anni diventar balsamo."

gator was the artist rather than the patron, according to Vasari.[12]
But the curious touch of the oil is quite another thing.

Mrs. Kathleen Weil-Garris Posner kindly made the suggestion, to me
quite convincing, that this alchemical transubstantiation of matter from
a lower to a higher state must be another metaphor of Benavides' *ascensio*:[13]
how by practice of the virtues exemplified by Hercules one is gradually
raised from the common to the rare, and reputation becomes enduring fame.
Indeed, after a hundred years had passed the man was already the subject of
legend and biography, and was deeply imprinted in history.

Was there some sort of humanistic cult of Hercules or pagan images with
which this can be associated as well?[14] Benavides' imagination was captured
by antiquity, not Christianity. Ancient writings provided the basis of the
principles of jurisprudence which he taught and practiced. Christian imagery
and doctrine entered his thought relatively rarely, unless associated with
practical and judicial topics. His Tomb in the Eremitani carries eight
statues, none of which are Christian figures.

Hercules was a popular Renaissance exemplar of fortitude and un-
flagging effort. He was a paragon of Virtue. At the famous crossroads,
he chose the difficult path of virtue rather than the easy road of
luxury and vice.[15] Benavides himself informs us that Hercules is a

[12]. Vasari - Milanesi, VI, 158. Letters and medals were also placed
under the cornerstone of St. Peters.

[13]. Note how the concept of **ascensio** is reiterated along different lines
in the Tomb in the Eremitani, see below, p. 144.

[14]. Cf. F. Saxl, "Pagan Sacrifice in the Italian Renaissance," *Journal
of the Warburg Institute*, II, 1938-39, 353.

[15]. See E. Panofsky, *Hercules am Scheidewege*, Leipzig, 1930.

leader of the Muses.[16] He defends their peace, and their voices, in
turn, extol his virtue. He is also synonymous with the glory of the
sun. Benavides does not elaborate on what he means when he says that
Hercules is the "glory of the Heavens and enlightening."[17] However,
we would probably not be far off in assuming that Benavides agreed
that Hercules possessed the intellectual qualities attributed to him
by his friend, Piero Valeriano. For Valeriano,[18] Hercules embodies
principally three qualities: firstly, eloquence; secondly, the soul
of reason (his battle with Cacus signifies the struggle of wisdom and
prudence against passion and pleasure); finally, the power of his
intelligence investigates heavenly, earthly, and infernal things. If
Benavides could be said to have a "patron saint," the traditional
Renaissance concept of Hercules, combined with the Valerian notion of
him, seems to fit the majority of the man's ethical and intellectual
values better than any other figure. At least this conception of
Hercules embodies the qualities which were central to Benavides'
literary and material achievements. Two qualities of this Hercules,

16. Benavides, _Analysis Quaestiones Varionis_, 231 r, s.v. "Musa:
Duxque Musarum et comes Hercules Musagetes. Et sicuti Musorum quies,
ipsum Hercules defensione **iuvari** debet, ita voce Musarum debet ornari
eiusdem virtus." Also p. 206 s.v. "Hercules ... Hercules Musageces
dictus quoque est, idest comes duxque musarum."

17. Benavides, _op. cit_, 206. "Hercules: Idem quod gloriosus
sonat Hercules. victor, laborum amator, qui xxx. fuerunt. quasi
Heracles idest aeris cleos, gloria Solis, et illuminatio, et Sol,
cuius imitatione (signa enim XII. anno cursu, zodiaci lustrat et
consicit) XII. labores etiam praecaeteris, confecit ..."

18. P. Valeriano, _Hieroglyphica_, Basel, 1575, 427.

effort and wisdom, are echoed on Benavides' Tomb, in the allegories
of Fatica and Sapienza. Three other figures -- Honor, Fame, and
Immortality -- are qualities which Hercules also earned. For the
inscription commemorating the monument: Hercules buphiloponus
bestiarius qui tristitiam depulit omnem per amplo hoc signo mantuae
cura reflorescit (Hercules, great lover of labor and animal tamer,
who casts out all the sadness of the world, amply comes to life again
in the monument, erected by Mantua), Benavides coined a word
(buphiloponus)[19] which refers to one of his prized virtues, fatica;
and "bestiarius" here alludes to Hercules' struggle with, and conquest
over, vice. This theme is taken up visually in the lower left of the
right relief of the arch, where a Herculean figure is defeating a
grotesque giant symbolizing vice.

It is in this light that one must view the choice of the central
image in the cortile of the Palazzo Benavides, and the act of placing
portrait medals in its base, where they probably exist to this day.
It seems,then, that the Colossus is nothing less than an allegory of
the man himself. In view of this a certain similarity between the
heads of Hercules and of the effigy on the Eremitani Tomb (fig. 192)

19. Buphiloponus is a composite of the Latin prefix bous (bull, ox)
and the Greek φιλόπονος (laborous, industrious, loving labor).
It means something like "loving labor like an ox."

A. Riccobone, De Gymnasium Patavii, 1598, 37, noted of Benavides
"Cuius valde laudatus est conatus in multis operibus consiciendis, et
libris, ac voluminibus conscribendis, flagrantissimumq; quotidianis
laboribus." I am indebted to Miss Eva Stehle, Charles Davis and my
wife Dale Kinney for help with the translation of the inscription.

is not difficult to explain. We note firstly that Hercules' head, as
the type goes, is rather an intelligent one with a long profile rather
than the shorter, pug-nosed type which would be more archeologically
accurate. The peculiarly large ear placed high on the head, the re-
ceding hair line, the sloping brow which swells above the eyes, the
longish nose with a strong bridge and large tip, the pursed lips con-
cealed by the large mustache -- these features which distinguish the
Colossus are also present in the Tomb effigy. The strong bridge of
the nose is present in the portrait of Benavides published in Analysis
Quaestionis Varionis (fig. 191).[20] The large ear and its placement
are found in Cavino's medal in Padova (fig. 194).[21] The sloping brow
and pursed downturned lips veiled by the mustache are caught by Cavino
(figs. 194, 195) and a medal by Martino da Bergamo (fig. 195). It is
interesting that Vico overlooked Ammanati's subtle flattery. The
drawing of the Colossus in the Louvre (fig. 201) eliminates precisely
those features of the statue which suggest Benavides' physiognomy,
except for the large ear, and substitutes a more archeologically
correct antique facial type.[21a]

[20] Analysis Quaestionis Varionis, Patavii, 1568, opp. p. 142.
This work contains within it several others of earlier date. The
portrait appears as frontispiece to Paraphrasii nova praeter ... of
1562. Fig. 191 is from an edition in the Bibl. Naz., Roma.

[21] For the medals by Cavino see Armand, I, 179 #5; 91 #5. The
reverse of two medals shows the facade of an eight-columned temple with
an inscription: "aeternitas Mant."

[21a] Cf. P. Meller, "Physiognomical Theory in Renaissance Heroic
Portraits," Acts of the XX Intern. Congress of the History of Art,
Princeton, 1963, 53 f., who notes a tradition going back to Lysippus'
portrait of Alexander which is the inverse of the case of the Benavides
Hercules: the practice of flattering political and military heroes by
superimposing leonine physiognomy associated with Hercules on their
features.

The Hercules has one arm crooked on his hip; with the other he grasps his club which rests at one side. Alert and commanding, he stands with both feet firmly planted on the ground. Though more weight is resting on his left foot than on the other, he seems capable of sudden and unpredictable movement. The pose is quite different from a full classical contrapposto, which was a frequent pose for ancient Hercules' when they were not actually wielding their clubs during one of their Labors.[22] Rather, the figure embodies a sense of readiness for mental or physical action, and volcanic energy disciplined by iron will. This expression, fitting enough for Benavides, is a Florentine ideal for a heroic figure which goes back to Donatello through Bandinelli and Michelangelo, and on a colossal scale the David and the Hercules and Cacus. Bandinelli's lost colossal Hercules created for the entry of Leo X in 1515 was a figure somewhat closer in pose to Ammanati's than the marble Colossus today in the Piazza della Signoria. It stood with its weight evenly distributed on both feet, the left arm crooked and resting on the hip, and the club resting on the right shoulder.[23] The crooked arm was a well known ancient motif.

For the massive, leonine physique, the Hercules is indebted to Bandinelli and the antique. Bandinelli's colossal group in the Piazza della Signoria in Florence freshly revived, with a new veracity, the Hellenistic and Roman type of Hercules as a brainless brute, a type

22. E.g. a classical pose preserved on a Byzantine silver bucket of the seventh century in Vienna, illustrated in Beckwith, The Art of Constantinople, 1968, fig. 65.

23. Illustrated in Holderbaum, in Essays in Honor of Rudolf Wittkower, London, 1968, II, 95 ff.

marked by a small, fleshy head with tiny eyes set on a thick neck and
a heavily muscled physique. The most well known ancient example of
this type is the Farnese Hercules in the Museo Nazionale in Naples.
Although this piece was not unearthed until 1546,[24] the type is far
from uncommon and is known in many fragments and on sarcophagi.[25]

Like most antique statues, Ammanati's figure has only a frontal
arc of satisfactory viewpoints, roughly 150°. These views are those
which are visible to the spectator as he walks from the Palazzo across
the cortile and into the garden. The best view is a three-quarter one,
that is visible a few steps from the passageway inside the cortile.
This angle is close to the one given in Vico's drawing in the Louvre
and the engraving after it. The pose is compact, and the body rather
flat when viewed from the side. Working on a colossal scale imposes
considerable formal limits on the sculptor. The weight of the stone
does not allow the limbs, if unsupported, to project from the body
very much and thus the openness and freedom possible on a small scale
are unthinkable. Because the relatively compact and closed composition
agrees rather well with the Apollo and Jupiter, one does not sense a
conflict between Ammanati's formal objectives and the limits of the
colossal scale. Moreover he succeeded in carving a figure in which
one is not conscious of the constricting factor of the scale. This
was also achieved satisfactorily in Michelangelo's David and

[24]. See V. Mockler, Colossal Sculpture of the Cinquecento, from
Michelangelo to Giovanni Bologna, unpubl. Ph.D. diss., Columbia Univ.1967,
54 ff.

[25]. E.g., a Hercules in the Vatican, illustrated by Amelung,
Skulpturen des Vatican Museums, 1903, I, T. 52.

Bandinelli's Hercules and Cacus, but not in Sansovino's attempts at
colossal scale, the Jupiter and Neptune on the staircase of the
Palazzo Ducale in Venice, or the Hercules in Brescello.[26]

[26.] Bronze statuettes of Hercules and Omphale in the Museo Civico,
Padova have been attributed to Ammanati (A. Moschetti, Il Museo
Civico di Padova, Padova, 1938, 224-226, and in the catalogue
"Bronzetti Italiani del Rinascimento," Palazzo Strozzi, Florence,
1962, #108, 109.). Bettini (op. cit, 26, n. 20) observed similarities
with Nicolo Roccatagliata. However, as convincingly argued by J.
Lauts (Berliner Museum Berichte, LVII, 1936, 69 ff.) and followed by
Middeldorf and Ciardi - Dupre (op. cit, 1962, 64, n. 10) these are
attributable to Francesco Segala.

Pope - Hennessey (Essays, op. cit, 191) attributed to Ammanati
a bronze statuette of Hercules in the Huntington Library, Calif.
This was accepted by Weirauch, Europäischen Bronzestatuetten, 189).
Pope - Hennessey attempts to connect the piece to the Colossus in
Padova, but I observe stronger analogies with Bandinelli's work,
especially the statuette of Hercules with the apples of Hesperides.
It has in common with the latter a strong dependence on the antique,
and a powerful muscularity and tension, and possesses the short, stiff
stride of Bandinelli's Orpheus and Jason statuette. The Huntington
bronze has nothing in common with Ammanati's Colossus except a deriva-
tion from an ancient Hercules physical type. The difference in the
heads of the two works is notable. The Huntington statuette is a more
archeologically correct type and, as has been noted, it bears a certain
resemblance to Bandinelli's two portraits of Cosimo in the Bargello.
Since Cosimo rather than Benavides is being flattered, the piece was
no doubt produced in Florence, not Padua. The surface of the
Huntington bronze has a silkiness and highly polished smoothness un-
like Bandinelli's certain statuettes. Perhaps Susini should be enter-
tained as its author. A prolific copyist, he copied at least one other
work by Bandinelli, the relief of the Deposition in the Louvre.

A fine replica of the Huntington bronze is in the Thyssen
Collection, Lugano.

Part IV. The Benavides Tomb

The Benavides Tomb can be fairly precisely dated. We first
hear of the project in a letter of Aretino's to Ammanati of May, 1545,
which praises "L'arte, il disegno e l'ordine ... nel modello de
l'arca."[1] The bozzetto of the Sapienza (figs. 205, 208, 211, 212),
in the Museo archeologico dell'Università di Padova,[2] was created
at about this moment or slightly earlier. Aretino's letter to Bena-
vides of April of the following year[3] mentions that the Tomb had
already been dedicated. However, the dedicatory inscription is dated
"MDXLVI MEN. MAIO."[4] Toward the middle of February, 1546, Ammanati,

1.
 Op. cit, ed. Camesasca, II, 63 #CCXXII.

2.
 61 cm. high; #56 of the 1695 Inventory: "Sotto il sud: to
piedestale vi è nicchiata una statua di terra cotta di color di
bronzo: è un modello d'una delle due statue fatte di stucco del
sud: to scultor almanati che ha fatta nel deposito nella chiesa
delli Eremitai dell'Egreg:⁰ I.C. Marco Mantoa."
 Since Bettini's publication of the piece, the head, which had
broken off, has been reattached. Cf. C. Semenzato, op. cit, 97 ff. n. 5.

3.
 Op. cit, ed. Camesasca, II, #CCCXL.

4.
 The inscription (from Portenari, op. cit, 450 where abbreviations
are filled out): MARCUS MANTUA BENAVIDIUS PATAVINUS IURISCONSULTUS
IOANNIS PETRI MEDICI FILIUS, SACRI LATERANENSIS PALATII, AULAEQUE
IMPERIALIS COMES ET EQUES, IURIS PONTIFICII SUPRAORDINARIUS EX PRAESEN-
TIBUS FUTURA PROSPICENS PRAETER COETERA MAUSOLEUM HOC SIBI VIVENS FIERI
CURAVIT MENSE MAIO MDLXVI. (Marco Mantova Benavides of Padua, counsel at
law, son of Doctor Giovanni Pietro, count and knight of the sacred
Lateran palace, and of the imperial court, chief of pontifical law,
looking from the present to the future, before other things, erected
this mausoleum for himself while still living, in the month of May 1546).

a mason and his helper began to set up the Tomb in the church. A
notebook of Ammanati's in the Riccardiana Library in Florence contains
sketches largely from the period after 1555. But the few entries
dating from the Paduan period include a record of the amount of work
done for Ammanati by one "mastro marco muraro" (i.e., Master Marco
the mason) and "il suo compagnio," which in the case of Marco amounted
to 47 days ("giornate") and of his helper four days.[5] The first dated
record of work by Marco is February 13; the last mention is on April
1. Aretino's letter[6] referring to the Tomb as dedicated was sent in
the same month. The first record cites three days of work "al fondere."
The next two records mention that it took Marco and his companion five
days to dismantle the altar which was removed to make way for the
Tomb,[7] and four days to build "l'armadura," which is the scaffolding

4. (Cont'd.)
The inscription on the base of the Tomb inserted after his death (from
Portenari, op. cit, 450, where abbreviations are filled out): "VIXIT
ANNOS LXXXXII, MENSES IV, DIES VIII, SEXAGINTA PUBLICE DOCUIT. PROXIME
VERO A SENATU SUPRAORDINARII MUNERE DONATUS OCTO INTERMISIT OBIIT NON.
APR. MDLXXXII."

(He lived 92 years, four months, eight days, and instructed the
public for 60 years, and truly he gave eight years to the Senate,
serving as Supraordinarius; then interrupted, he died on the nones
of April, 1582).

5. Published by M. Fossi, La Città, 19, 434-5.

6. Op. cit, ed. Camesasca, II, 157, #CCCXL: " ...l'urna marmorea
ne la chiesa, ci l'avete dedicata..."

7. F. Forlati ("Restauro della chiesa degli Eremitani a Padova,"
Bollettino d'arte, 1948, 80 ff.) found traces of t r e c e n t o
frescoes behind the tomb which probably served to decorate the destroyed
altar.

which would have been erected to attach the architecture to the wall.
In addition Marco spent one day "al cominciare metere el regolone
primo." What sort of work this indicates is uncertain. The last six
notices from February 20 to April 1 do not contain information as to the
kind of work being done. Probably they involve attaching the
architectural framework to the wall.

The Tomb (fig. 207), a three-tiered architectural structure
(372 cm. wide at the base) made of local Paduan stone[8] set against
the north wall of the nave, carries eight statues and two putti
supporting an inscription on the base. Allegories of Labor (Fatica)
and Wisdom (Sapienza), both 172 cm. (68.8") high, flank the sarcophagus
on the lowest level. These two are slightly over life size while the
remaining statues are approximately life size. Above, three niches
containing statues of the deceased (in stucco, the only figure not
carved of stone), Honor and Fame are divided by four columns which
support a frieze of garland swags and the cornice. Above the entabla-
ture are two statues of nude youths and, in the center crowning the
whole, a statue of Immortality. The allegory of Labor, at the lower
left, is signed on a foot support: BARTH. AMANNAT. FLORENTIN.
FACIEBAT. With the exception of the seated stucco effigy of Benavides,
all of the statuary is the autograph work of Ammanati. The three figures

[8]. Portenari, op. cit, 449: "pietra viva dell i nostri paesi."
The same material was used for Ammanati's work in the cortile of the
Palazzo, according to Portenari.

at the upper level, being farther from the floor, are of somewhat less careful execution than the others, as would be justified by their greater distance from the spectator. There is no evidence that Ammanati employed an assistant to whom the inferior parts could be attributed.

The Tomb was considerably damaged when the church was bombed in the Second World War. At this time the sculptures suffered numerous fractures and breaks, which have been admirably repaired, and a few fragments of the stucco figure on the upper level were lost.[9] Already before the War the figures crowning the Tomb were damaged. The Immortality had lost his right leg and hand, and the left ephebe's wrist was broken. This damage is visible in fig. 207, a pre-War photo.[10] It perhaps could have occurred when the nave walls of the church were whitewashed.

The oldest description of the Tomb is by Angelo Portenari in 1623.[11] He identifies the allegories as "fatica," "scienza," "honore," "fama"; at the top: "immortalità" and "due statue con certi brevi in mano." Portenari's identification of the figures, which is substantially correct, was largely accepted by later writers. In modern times, perhaps initiating with Adolfo Venturi,[12] the lower right-hand allegory

9. Photographs of the damaged sculptures are preserved in the Soprintendenza ai Monumenti, Venezia, and others of the Tomb after the 1944 bombardment are in F. Forlati and M. L. Gengaro, La Chiesa degli Eremitani a Padova, Firenze, 1945, 11, 24.

10. Gabinetto Fotografico del Museo Civico di Padova, #456.

11. Portenari, op. cit, 449.

12. Op. cit, X, II, 366.

is more often labeled Sapienza (Wisdom), which is probably more correct than Scienza (Knowledge) (fig. 206). She evokes a Renaissance Athena dressed for a momentous occasion, including fanciful sandals, a cuirass with five grotesque masks, and a jeweled headdress. She holds the Benavides coat of arms in her left hand. In her right hand is a book, which is the only other distinguishing attribute. Since the book and costume could indicate either Sapienza or Scienza a certain doubt must linger as to which personification is intended.[13] Though the two somewhat overlap in meaning in all probability she stands mainly for Sapienza, which has a heading in Benavides' Analysis Quaestionis Varionis (while Scienza has none), in which he says: "Nobody can truly be called a man unless he be wise" (Nemo iure homo dire potest, nisi sit sapiens").[14]

Labor (fig. 204) -- more austerely and sparsely clothed than Wisdom -- holds the skull of a calf, her attribute.[15] For Benavides, she no doubt embodied the Latin "Labor," which encompasses capacity for work and hardship as well as effort. Her half-sitting, half-rising posture indicates her readiness for work. Toil and hardship are also virtues of Hercules, and have a particular relevance to Benavides. He

13. Cf. C. Ripa, Iconologia, ed. 1603, 467 ff.

14. Analysis Quaestionis Varionis, Venice, 1568, 264.

15. Ripa, op. cit, 156.

explains the concept of "Labor" in the Analysis:[16] "Whosoever flees labor, flees glory and virtue, which we can never attain unless by a hard and laborious path." Above, a winged Fame (fig. 216) holds a trumpet at her side, and an elderly figure of Honor (fig. 215)[17] clothed only

[16]. Analysis Quaestionis Varionis, 216: Laborandum est semper, nec ab incepto desistendum, etiam si adversa, nobis centingant. Labor quietem condit, laborem quies. Et nulla dies sine linea sit (decebat ille) considerans, quod nihil sine magno vita labor (inquit Hora) dedit mortalibus. imo qui laborem fugit, fugit gloriam & virtutem, ad quas nunquam nisi arduo calle ac laborioso pervenire possumus, fama labor quaeritur, statque rosa inter spinas, ut virtus (quemadmodum diximus) inter difficultates, ut pinguis ager rursum, sentibus abundat, sic humanus animus erroribus labitur, ea de re, nisi labore assiduo purgentur, fructus aeque in ipso flore pereunt estin- quuntur. Munditiae mulieribus conveniunt, labor viris. Laudis Herculeae fundamentum erat labor, nec aliter cognoscebatur quam laboribus Ulysses.

"One must always work; nor should the commencement of a task be put off, even if difficulties beset us. Labor produces repose, and repose labor. And may no day be without its proper end, considering that life gave nothing to mortals (Hora said) without great labor. Indeed whosoever flees labor, flees glory, and virtue, which we can never attain unless by a hard and laborious path. Fame demands labor, and as a rose stands among thorns, so virtue (as we said) stands among difficulties; and on the other hand as fertile land abounds with brambles, so the human spirit falls into errors, among which, there are none that cannot be purged by assiduous labor, as the fruits pass away and are extinguished in their flowers. Housekeeping is proper for women, labor for men. The foundation of the glory of Hercules was labor, nor would Ulysses have been known otherwise than through his labors."

On the plinth on which the personification is seated is a relief of a garland, bucranae, spade and mattock, implements of farming, which are emblems of work. The image is repeated on the right side but with crossed quills substituting for farming implements. Cf. Valeriano, Hieroglyphica, s.v. "Opus et Labor" and "Fructus ex laboribus."

[17]. See Ripa, op. cit, 219: "la scienza, si fa' immortale la fama di chi la possiede, non di meno non si acquista senza molto fatica, e sudore." Honor shows the effects of his fatiche which leave him bent over, wrinkled and aged. His costume leaves him •scoperto ... dimostrando che con la candidezza si deve conservare l'honore."

in a mantle, supports himself with a crutch. In the middle, the figure

of Benavides is seated (fig. 234), looking at a now lost attribute in

his left hand, which was clearly an open book (visible in the pre-War

photo fig. 207). He wears ceremonial robes, and is barefoot.

According to a tradition originating with Portenari,[18] the present effigy

is a substitute for a bronze statue which was never executed. A lost

terracotta bust of Benavides by Ammanati, recorded in Andrea Benavides'

inventory of his great-uncle's collection,[19] may have been freely

copied by the author of the present figure. Certainly the present

17. (Cont'd.)

The eight-columned temple facade with a female figure holding
a cornucopia inscribed "Aeternitas Mant." on the reverse of two of
Benavides' medals by Cavino (Armand, I, 95 #5; 175, #15) recalls
Ripa, op. cit, 219: "il Tempio dell'onore non si poteva entrare
se non per lo Tempio della Virtù." Valeriano, op. cit, 431, explains
the cornucopia as demonstrating that all abundant rewards come from
virtue. Here the temples of Immortality and of Virtue are fused. The
figure's half-rising, half-sitting posture underlines her readiness to
work, and her scanty garments demonstrate her willingness to work
even in the summer.

18. Portenari (op. cit, 1623, 449) on the effigy: "Statua di
stucco, invece della quale doveva essere porta di bronzo di esso
Marco." That the present figure is not Ammanati's and was executed
after Benavides' death was rightly proposed by Kriegbaum (op. cit,
1929, 90).

19. Inventory of 1695 #50: "Il Ritratto mezo busto rillevato di
terra cotta dell'egreggio Illustre. J. C. ante: to Mar:o Mantoa
Benavides Con: e K:r fatto di mano industre del famoso Bartolomeo
Ammanati Scultore Fiorenti:o"

No doubt the modello of the present effigy, and of the bronze
one cited by Portenari, is #175 of the Inventory: "la statuetta ca-
tedratta di bronzo dello stesso J. C. Marco Mantoa che sta sedente e
tiene nella mano sinistra un libro seratto: fatta da Egregg:o scultore
e fusor de' Bronzi."

head is more like that of a man of 56, Benavides' age in 1546, than 81, his age at his death, after which, presumably the effigy was executed. He is represented with a good deal more hair and a less wrinkled face than is shown in the medal of Martino da Bergamo of 1568 (fig. 195).

At the very top of the Tomb, the figure of Immortality (fig. 222) sits on a truncated pyramid, a symbol of ancient grandeur. He is represented as a youth and places his foot on a globe, thereby indicating his triumph over, and status above temporal and earthly things.[20] In his left hand he holds a partially damaged serpent-like creature which is probably a basilisk, a symbol of immortality. He gestures upward with his right hand. If he held an attribute, it was lost before the War. Perhaps he simply pointed to the heavens. He is scantily dressed in a robe which falls down his back, attached to a fanciful gem-studded strap running across his chest. The two ephebes (figs. 224, 225) above the cornice are nude (their mantles rest on the pedestals), which

19. (Cont'd.)

In both the present effigy and the figure in the inventory Benavides is seated and holds an open book in the left hand. The model of the Tomb which Aretino saw probably included a figure of Benavides. Perhaps a bronze cast of it is the statuette #175, today lost.

The final page of the Riccardiana sketchbook (Fossi, 436) contains figures which pertain to an unidentified bronze casting. This page follows the payments for the Tomb and as Charles Davis suggested (orally), might this refer to the never-executed bronze effigy? In any case, the present effigy on the Tomb which freely copies the statuette, may be the work of a member of the Albanesi family, as is suggested by its affinities with their work in Vicenza (the Basilica, Loggia Capitano and elsewhere) and Venice.

20. Ripa, op. cit, 242. On the right side of the base of the Tomb is a relief of a funerary (?) lamp (eternally) burning, two torches burning,

probably signifies an immortal existence in a pure and otherworldly
realm. The scrolls once held by these figures are lost today. The
youth at the right held an unfurled one, that on the left a rolled one
in his upraised left hand. The scroll held by the right-hand figure
did not appear to bear an inscription when the pre-War photo was taken,
and none has been recorded by the guidebooks. Perhaps the youths per-
sonify guardian spirits, or genii of Benavides,[21] and with their scrolls
proclaim his glory to the world. As such, the satyric mask at the
foot of the base of the right figure is appropriate. The image is
taken over from ancient funerary contexts[22] where it was believed to
frighten spirits which could harm the deceased.

Below the sarcophagus, two winged putti (figs. 232, 233) flank an
inscription added to the Tomb after Benavides' death.

20. (Cont'd.)

and a mermaid with a bifurcated tail, similar to a figure symbolizing
eternity in Ripa, op. cit, ed. Mandowsky, 1970, 140. The right side
corresponds to the left but a dolphin is substituted for the mermaid.

21. Suggested in passing by Perkins, Tuscan Sculptors, 1864, II,
157. However, if they are genii is seems odd that Portenari (op. cit,
449) didn't identify them as such. Instead he terms them "due statue
con certi brevi in mano." Cf. P. Brandolese (Pitture, sculture,
architetture ed altre cose notabili di Padova, Padova, 1795, 219:
"altre due statue simboliche"), G. Rossetti (Descrizione delle pitture,
sculture, ed architetture di Padova, Padova, 1780, 160: "due altre
statue") and A. Moschetti (La Cappella degli Scrovegni e la Chiesa
degli Eremitani a Padova, Milano, 1934, Tav. 44: "due putti, il cui
significato simbolico ci sfugge").

22. E.g., a Bacchus and Ariadne sarcophagus, a Muse sarcophagus, and
a battle sarcophagus, all in the Terme Museum, Rome.

There is an arrangement of the allegories according to logical sequence
from bottom to top. At the lowest level are allegories of the faculties
possessed by Banavides which enabled him to reach the qualities personified
by the allegories of the level above. The allegories of the lower levels in
turn will insure his immortality which is announced at the top. Effort and
Wisdom bring Honor and Fame; the final reward is eternal glory. Though
largely retrospective and commemorative in nature,[22a] the tomb is not
entirely so, as the humanist-coined figure of Immortality signifies. The
largely secular and commemorative nature of the tomb is a characteristic
feature of ancient funerary imagery, and of some earlier north Italian
Renaissance tomb iconography as well. But the Benavides Tomb does not use
explicitly pagan imagery, like Riccio's Della Torre Tomb in Verona. Rather
it employs personifications which, though much indebted to ancient concepts,
were newly coined in the Renaissance by humanists, including Benavides
himself and his friends Piero Valeriano and Andrea Alciati.

As has sometimes been noted the Benavides Tomb reflects Michelangelo's
Medici Chapel:[23] a multi-tiered structure with allegories on the sarcophagus
level, a sarcophagus with a bowed lid, and above this a seated effigy flanked
by two standing allegories in three niches of equal size divided by columns.
At an early stage Michelangelo projected statues for the niches flanking the
effigies, and statues above the cornice, but these were never executed.
Ammanati also shares with Michelangelo a taste for an architectural structure

[22a.] I know of no other instance of the figure of Immortality in funerary
imagery. Could he perhaps incorporate his analogue, God the Father, the
traditional granter of eternal life who crowns many earlier tombs? Additional
research on the iconography would undoubtedly shed more light on the program
and help to arrive at a better understanding of the tomb's uniqueness in the
history of funerary monuments.
On the mingling of prospective and retrospective imagery in tomb imagery
see E. Panofsky, Tomb Sculpture, 53 ff.

[23.] E.g., M. Fossi, Bartolomeo Ammanati Architetto, 23.

unencumbered by rich decorative carving, so as to invest the sculpture
with more visual impact. Like Montorsoli's design for the Sannazzaro
Tomb Ammanati used seated allegories flanking the sarcophagus placed
on a high base, devoid of niches.

Where Michelangelo strives for compression, instability and
disproportion between architecture and sculpture, Ammanati on the
contrary balances, harmonizes and unifies them. He has enlarged the
architectural framework and reduced the size and force of the sculpture.
Each of his figures has space to move and breathe comfortably as well
as to be visually effective. No weight is unsupported, no structural
member disguised. Architecture lends structural support to the figures;
e.g., the ephebes rise above the two outside columns (instead of being
placed between architectural members), and the seated allegories are
lined up with the two consoles of the base.

The Tomb evokes Venetian rather than Tuscan tombs in its great
height.[24] Ammanati has stretched the levels of the Medici Tombs,
added a high base, and a vertical thrust at the top by raising the
figure of Immortality above the two flanking figures. The three-figured
crown above the cornice vaguely evokes the arrangement of earlier
Venetian tombs[25] in which God the Father or Christ standing on a seg-
mented arch is flanked by angels. But stabilizing horizontal accents

24. Observed by Fossi, loc. cit.

25. E.g., the Tomb of Pasquale Malipiero in SS. Giovanni e Paolo
or that of Doge Tron in the Frari.

prevent the Tomb from taking on the slender soaring thrust of
fifteenth-century Venetian tombs. The Tomb is wider in relation to its
height than they are, and its width is stressed by placing the ephebes
above the cornice over the outside columns rather than over the figures
below. Only two figures are exactly lined up with each other verti-
cally: the effigy and Immortality. This provides a strong central
axis, while the placement of the allegories at different distances
from the center axis interrupts the upward movement of the eye. The
placement of the figures and their individual movements set up a gentle
centrifugal rhythm of which the Immortality, the effigy and the sarcopha-
gus form the anchor. Notice how the Labor rotates away from the center.
Her movement is echoed by both figures above, and even by the putti
below. Similar things are happening on the other side. All levels
on each side, and as a whole, relate visually to one another by echoing
variations on key movements of the figures above or below -- or by rever-
sals thereof. In addition, an inverted triangular rhythm is established
by the combination of a putto on the base with a seated allegory above,
which is repeated with variations in the standing allegories and the
ephebes. This brings the eye inward and guides it toward the center
axis and the effigy. A balance of opposing horizontal, vertical,
centrifugal, and diagonal rhythms is established around a stable
central axis which provides an overall organic and harmonious inte-
gration of sculptural and architectural members.

The structural coherence of the Tomb, its sophisticated organic
balance and its mode of classical vocabulary, derive from the aesthetic

of Sansovino's Library and Loggetta. The capitals of the columns are
very close to those of the Loggetta (fig. 235) but otherwise the
classical vocabulary of the Tomb is lighter and more delicate than
Sansovino's. The planarity and fragility of its members are strikingly
different from the robust triumphal arch whose austere strength can
rival Sansovino's Villa Garzoni (now Carrerotto) and the Palazzo
Cornaro. The differences between them are due in large part to
different modes and orders rather than to date. Perhaps a motive for
the Tomb's lightness would be the attempt to present the sculpture
clearly and incisively.

The allegorical statues of the Tomb, compared to the Sannazzaro
and Nari Tombs, display a new dynamic strength, emphatic contrapuntal
and spiraling rhythms, and heightened abstraction, all of which can
be attributed to the greater influence of Michelangelo, especially the
great impact made by the New Sacristy. The garments are now broader,
stiffer, and more regularized (as in the case of Wisdom), the folds
more angular, the faceting more sharp-edged (as in the case of Fame).
Every prettiness and lyrical note seems freshly disciplined by a
search for impersonal monumentality, austerity and dynamic strength.

The stuccoforte bozzetto of Wisdom in the Museo Archeologico
carries no attribute and differs importantly from both seated allegories
on the Tomb, in costume and pose (figs. 204-206, 208). She represents an
intermediate stage in the evolution of the design of those two figures,
perhaps even before her identity had been decided. The key movements
of her arms and legs are related to both figures, and the attributes

of either one could conceivably have been accommodated in a later model.
At the time of her creation Ammanati was working out formal problems
without careful regard for the eventual placement of her major attri-
bute. The model's exuberant, lyricism, slenderness, delicacy and
sweetness are missing in the stone figures. In feeling and proportions
she evokes the Sannazzaro Tomb allegories and the Leda. But Ammanati
had shifted his aims by the time he carved the stone figures. The
elegant flourishes and ripplings of the drapery have been toned down
in the stone figures. The stone Wisdom is more compact and arrested.
The energy of the bozzetto has been drawn within and coiled up. The
source of the change is once again the Medici Chapel. In the bozzetto
the rotation of the shoulders, the legs wide apart at the knees and
crossed at the ankles, the right arm propped palm-outward on the thigh,
derive largely from the Lorenzo de' Medici. In the finished work the
obvious borrowings from Michelangelo have been modified, but in fact,
the stone figure ends by being closer to Michelangelo's aims in the
Giuliano: poised strength and iron resoluteness of will.

Labor, as if ready to undertake a task, seems about to stand up,
like the Naples Minerva, but now a note of imbalance and rotation is
introduced by the backward-leaning movement and the forward thrust of
the left shoulder. Fame is hefty, with a powerful neck and shoulders,
and small breasts characteristic of Michelangelo's females, and she is
reminiscent of the Nari Victory. She strides vigorously forward, like the
Apollo by Ammanati in the Cortile. But unlike the Apollo, the figure is
off-balance and veering, to the right. Contrapuntal and rotational accents

are introduced by a sharp twist of the shoulders and the head in
opposite directions. The conflict between the thrust of her body and
the focus of her attention builds up tension. The Apollo adheres
basically to the balanced, planar and frontal compositions derived
from Bandinelli and antiques such as the Apollo Belvedere. Fame
instead is an expansion of Michelangelesque formal concepts: contrap-
posto and imbalance are employed in a figure with strong forward
momentum. The figure of Honor is stationary, and develops a different
theme: strong spiral rhythms are created by crossed legs and twisted
shoulders. In the three crowning figures and the putti on the base,
movement tends to be linear rather than circular.

The refined, delicate features of the modello -- small nose,
with mouth and eyes barely incised on the gentle slopes of the face --
are reminiscent of the Leda and Bandinelli's bronze figurines and por-
traits of Cosimo and Eleonora in the Bargello. Much of this sort of
classicism is carried over into the stone figures though here the
faces are broader and fuller, more like Sansovino, the Loggetta bronzes and
Michelangelo. Like the Nari Victory, the figures are heavy and inflated.
But now there is apparent an acute abstraction which verges on geometrical
form, as well as mask-like faces. At the same time, the faceted and vi-
brating surface of the earliest works has been enhanced. Now the marks
of a raking chisel are visible on many areas of the figures: e.g., on
the Fame a network of strokes and chips on the eyes and lips are left
unfiled and unpolished. This is the fabric of the intense abstraction and
vibration which the figures display when viewed from the proper distance

in situ. The three figures above the cornice, more than the others, possess a soft texture reminiscent of stucco. Here as elsewhere in his search to render aspects of liquid and light, Ammanati displayed great ability to transpose the qualities inherent in the material of a bozzetto (wax, clay, stucco) into intractable stone. As in the case of the young Vittoria, the artist's deepest leanings seem best suited to clay rather than stone.

Part V: The Triumphal Arch

The rear and one wing of the Palazzo Benavides form two sides of a cortile, in the center of which stands Ammanati's Colossus. A third face is formed of a low structure which is a later addition to the palace. The fourth face is formed partly of Ammanati's triumphal arch, and partly of a garage which occupies the area of an earlier construction whose walls are visible from the garden. The arch serves as a majestic portal dividing the garden (which once contained exotic plants and was populated by terracotta satyrs by Ammanati[1]) from the cortile.

The arch (fig. 236), "come que' di Roma," as Benavides termed it,[1a] has a central opening with two Victories in relief in the spandrels, holding laurel wreaths and palm branches. Two niches flanking the central arch contain life-size statues of Apollo and Jupiter. Above the cornice is an attic containing two reliefs on either side, and in the center two putti support an inscription which reads: Id facere laus / quod decet / non quod licet (it is praiseworthy to do what is fitting, not what is permitted.) The putto on the right (fig. 249) steps on a tortoise, a hieroglyph of sloth,[2] once again alluding to Benavides' "fatica."

[1] See p. 168, n. 2.

[1a] Lettere di familiari diverse, p. 27. Published in part by Rossetti, op. cit, 347.

[2] Ripa, Iconologia, ed. Venice 1669, I, 6, 490, who cites Valeriano as his source for the meaning of the tortoise.

1545 was a momentous year for Benavides. In this year he was
knighted for the first time by Charles V;[3] secondly he was appointed
Paduan ambassador to the Doge Francesco Donato in November, "e molto
honoratamente vi venne (to Venice), e con elegante oratione suppl' al
tutto."[4] About this time or earlier, Paul III appointed him to the
Sacra Rota. At the close of 1545 Benavides could justifiably feel
proud of his newly won honors, and at this time he probably conceived
the idea of commemorating them in the triumphal arch. Most probably,
the right relief allegorizes him receiving his knighthood, while the
left relief comments on his ambassadorship. Both relate to the in-
scription in the center, where we witness his duty to the State and
to justice ("quod decet"), and the award of his "laus." Further dis-
cussion of the reliefs follows shortly.

Jupiter (fig. 242), the king of the gods, is the archetype of
the ancient Emperor as well as the Renaissance prince, an image which
is metaphorically appropriate to the maxim, as well as to the subject
of the right-hand relief above it. A statue of Apollo (fig. 237) --
the leader of the Muses and champion of the arts and music -- is a
fitting image for the dwelling of a man whose house was the "accademia
delle Muse" in Padova. Apollo was also "distinguished by the beautiful

3. A. Riccoboni, De Gymnasio Patavino, Padua, 1598, 37.

4. Marco Guazzo, Cronica..., Venezia, 1553, 415 r.

order of things / thereupon the gift of business and of law..."[5]

The Victories (figs. 245-47) balance themselves on masks of satyrs (horns sprout from the skulls). The satyr at the left is particularly stunning. He deliriously rolls his eyes down toward the spectator walking through the portal. Curiously, the masks lie horizontally with faces upturned, and the Victories' feet are placed directly on their open mouths, almost as if the figures had sprouted, full-grown, from these mouths. The right Victory places her other foot on the cheek.

Are the masks more than simply decorative? We suspect so, since Ammanati could have used spheres, as on the Library in Venice, or some other motif less charged with associations. The absence of other significant decoration and the masks' large size call attention to them. The mask was a well known sign of imitation.[6] If we accept the masks as such, the fact that the Victories issue from their mouths signifies in visual terms the concept that triumph and glory "issue" from proper imitation of the ancients. The masks, therefore, are a

5.
 Benavides, Analysis Quaestionis Varionis, 174: "Apollo. Et iuris peritus de quo sic Iuvena: Ipse dies pulchro distinguitur ordine rerum. / Sportula deinde foru, iurisq peritus Apollo."

6.
 Ripa, Iconologia, ed. Siena, 1613, I, 365. On another level the satyric mask alludes to the theatre, poetry and the muses (ibid., 110), and is appropriate to Apollo and cultural life at the Palazzo.

visual expression of "all'antica," signifying to the Renaissance
spectator that the path to glory lies in the emulation of the
ancients, particularly of the virtues embodied in the three classical
gods in the cortile, and the inscription.

The subject matter of the reliefs (figs. 250-52) is obscure and
no attempt has ever been made to identify them. What follows here
are only some hypotheses which will hopefully lead to a fuller identi-
fication and clarification of their meaning. Unfortunately, attempts
at analysis are now badly hampered by the sad state of preservation
in which all the sculptures of the arch are found. The reliefs them-
selves are a ruin. Today we have no choice but to approach the
figures with the help of old photographs. Nearly the entire original
surface has blistered and peeled away. In addition, many heads and
limbs are lost.

In the right relief (figs. 250, 255-56) a man costumed "all'antica"
in military dress -- perhaps a Roman Emperor, general or consul -- is
seated. He clasps hands with a figure standing before him, clothed
in a toga and mantle, perhaps an orator, councilor or lawyer. At the
right stands a group of soldiers. The soldier in profile seems to
be restraining his companions in front of him. Above, a winged
Victory with a palm branch in her right hand swoops down to crown the
"general" with a laurel wreath (now entirely lost), and to the right
a military band plays a triumphal march; two members of the band play
long-stemmed trumpets. At the foot of the "general," a dwarf cuddles
his dog. The face of the figure before the "general" -- in spite of

severe erosion -- bears a considerable resemblance to the features
of Benavides as recorded in a medal by Giovanni Cavino, which one
supposes is not accidental (cf. figs. 256, 193-194). Still percepti-
ble in the relief is the long, somewhat flattened nose, the shallowly
set small eyes, and the protruding chin; as on the coin he is cos-
tumed "all'antica." The features of the "general" might suggest
Julius Caesar but the severely damaged surface makes a positive
identification impossible. Benavides is probably cast in the guise
of an ancient orator or councilor receiving his "laus," and the event
presumably is one recorded in ancient literature which parallels in
some way the knighting of Benavides by Charles V, who was regarded as
the modern "Caesar" of contemporary Europe. A ceremonial and trium-
phal occasion is indicated by the horn players in the background.

Slightly left of center a soldier with a helmet listens to the
advice of a man wearing a skirt and toga. Perhaps this man is the
same one before the "general" at the right, but in an advisory capa-
city, at a different moment in time. A playful touch of a child and
dog tugging at a cloth is included. At the far left side of the
relief a nude man battles an over life-size figure with a huge beastly
head. The fact that the figure is nude removes him in time and place
from the other narrative, historical action. The grotesque, beast-
like head and over life-size dimensions of the figure he combats also
suggest a mythological subject inserted for conceptual reasons to
comment on the historical scene. We suggest that this represents
Hercules conquering a vice, perhaps Ignorance, Avarice, or some other
which leads to ill-judgment on the part of generals and princes. Like

the Colossus in the courtyard the group would of course allegorize
Benavides and in this case his advisory capacity.[7] Behind them is
a group of bystanders: an old woman at the upper left, a mother
supporting a child on her shoulder, an elderly man at the right. Their
rapt attention and glances suggest involvement with the action at the
center and far right. Perhaps they are the "populus" who are affected
by wise judgment. There is no architectural backdrop on the right side
but on the left, all of the figures stand before schematically rendered
rectangular panelling with garland swags above, separated by attached
pilasters with capitals of the Doric order, a background which might
suggest the interior of a basilica.

The subject of the left relief (figs. 257-60) is equally obscure.
At the right a turbaned, bearded figure holding a book in his left
hand is seated, engaged in dialogue with two figures before him.
Around him are other turbaned men. In the background are two arches
through which one can perceive another arcade. A small dragon is
visible below the seated figure. It does not appear to be a decorative
member of the throne. To the left are nine figures -- three pairs of
women and children, a nude man carrying a basket of leaves on his
shoulder, a woman carrying a vase, and a reclining river god. A

[7]. Correspondence preserved between Benavides and the secular and
ecclesiastical authorities of his day (see Chapt. 9, part 2, n. 9)
demonstrate in what high esteem his legal advice was held.

landscape for the left two-thirds of the relief is indicated by
schematically rendered trees in the background.

Only the seated dignitary and the two figures behind him are
turbaned; the turbans suggest a Near Eastern location. The action
could perhaps represent an event such as a western ambassador, with his
train of servants bearing gifts, paying homage to a Near Eastern court.
If so, the event would probably parallel in some way Benavides'
ambassadorship to Venice. The costumes of this relief are different
from the "all'antica" mode of the right relief. They have greater
resemblance to Renaissance fashions, and to the vocabulary of costume
used by Ammanati in Benavides' Tomb. They perhaps suggest an event
which is taking place in post-classical times.

The Byzantines were noted for their classical erudition. If they
are represented, this may explain the book in the lap of the seated
figure. The dragon is a symbol of imperial power and is associated
with heretical and demonic forces, and could conceivably indicate
either the Byzantine or the Turks. Yet, it seems odd that the
representative of a demonic power, if the dragon indicates such,
should appear without arms present and with a book. The river god
has no attribute which would identify him.

On the surface another problem is the relation between the relief
and the figure of Apollo below it. Since the Jupiter on the opposite
side has obvious relevance for the relief above him, one would expect
some connection. Perhaps a hint of it is found in the book held by
the seated figure. It could signify wisdom and learning or patronage

of the arts and literature.

Francesco Sansovino, in his elucidation of the sculptural program of
the Loggetta, takes pains to point out how the statue of Apollo
symbolizes Venice. Perhaps this level of meaning is also intended
here. If so, it would be reasonable to associate the "ambassador"
in the relief with Venice.[8]

The obscurity of the subject matter of both reliefs is probably
intentional, though to a Renaissance scholar they probably were not
as remote as them seem today. Benavides had hieroglyphs painted in
his Palazzo by Guariento,[9] and we have observed the use of erudite
symbolism elsewhere. The use of the "secret language" of hieroglyphs,
emblems, and of other symbols drawn from obscure classical texts was
widespread among humanists. The flattery of suggesting Benavides'
features in the historical or mythological figures which allegorize
him was also a common practice in the Renaissance. Benavides' friends
who entered the cortile would have expected to find a connection
between the subject represented and the life and character of their
patron. Following this, the depth of their erudition would have been
tested against the historical events depicted in the reliefs. We have
failed the test but, hopefully, not missed the point.

[8.] Clearly, if Benavides were to be allegorized in any figure in
the relief, it would be the "ambassador." Thus, the vague resemblance
between the "ambassador" and Benavides' features in still another por-
trait published in his Locatus Opusculi (fig. 195a) may not be wholly
accidental.

[9.] C. Ridolfi, Meraviglie dell'arte, Padova, 1835, I, 118; and
Portenari, op. cit, 458.

Although Ammanati's arch displays superficial resemblances to Roman triumphal arches, actually it is profoundly unlike any particular one. Like the Arch of Titus in Rome, it has a facade divided by four columns surmounted by an attic carrying an inscription; a central passageway with Victories in the spandrels is flanked by two niches. But Ammanati's arch is smaller, wider and squatter than Roman arches. The low attic with oblong reliefs was no doubt inspired by Sansovino's Loggetta. The severe and robust classicizing architecture, and its particular Doric order, derive from Sansovino's Library. The frieze and the decorative bands of the aedicula frames are drawn from classical ornament. The aediculas themselves are remarkably akin to a type published by Serlio, Book 4, in 1537.[10]

The architecture contains visual interest for those who allow the eye to linger on it. Paterae and bucrania in the Doric frieze are standard classical vocabulary. But Ammanati alternates a calf skull with the head of a live calf (another allusion to the Herculean fatica of his patron),[11] and deviates from a rigid alternation to juxtapose the two over the archway. This arrests the eye in the center and visually supplements the opening below. There are twists also: the paterae in the third metope from each end are reversed.

[10] Noted by W. Arslan, "Di alcune architetture toscane a Padova," Miscellanea di Storia dell'arte in onore di I. B. Supino, Firenze, 1933, 497 ff.

[11] As we have learned in our discussion of the Colossus and the Tomb, both the skull and head of a calf or ox are charged with allusions to fatica, Hercules, and "buphilopomus."

We see the disc flipped over instead of the usual front side. The two paterae at the extremities contain images at the center. At the left the face of Sol (another form of Apollo) peeps from the spiraling ribs of the disc. The corresponding patera on the other side contains an image of an eagle, the symbol of Jupiter.

Throughout the figural sculpture of the arch, the influence of ancient art, Bandinelli and Sansovino is notable. The work as a whole is a break from the austerity and monumentality of the Tomb where Michelangelo's influence had more impact. However, carried over from it is a figure type, sometimes attenuated, sometimes broad and powerful, often characterized by a high degree of abstraction and inflation. Generally the draperies are more ample and lyrical than in any work since the Sannazzaro sculptures. Elegant swirls and ripplings now make themselves felt again. The faceting is less angular and sharp-edged than in the Tomb and there is somewhat less emphasis on circularity and imbalance to dynamize the figures. This shift is perhaps partially explained by the important difference in theme between the two works. For a work which is "all'antica" the obvious models would be ancient remains and the teachers whose art corresponded most closely to them. The new notes of lyricism, elegant drapery play, and refined classicism will be further elaborated in Rome.

The Apollo (191.5 cm. high) is signed on the strap which runs across the chest: BARTH AMMANATI FLOR. He holds his bow at his right side, and grasps the strap at his shoulder which is fastened to a robe which falls behind him. The fig leaves are a later addition,

probably of the nineteenth century, to all three statues in the
cortile. The figure's compact classicizing form (note the classical
'bow' where the torso joins the pelvis) smooth petal-like surface,
serenity and grace r e m i n d us of the Sannazzaro sculptures and
Sansovino's Apollo on the Loggetta. But the Benavides Apollo is more
abstract than either of these works. The face is more veiled and the
body inflated like the allegories of the Tomb. There is present a
new hyper-ideality, coolness and distance very different from Sansovino
as well as the Sannazzaro sculptures. The composition is frontal and
the movement planar, conforming to principles of ancient sculpture
which were revived with new rigor by Bandinelli, e.g., in the Orpheus,
and which Ammanati used in the Leda and the Nari Victory. The broad
head with shallow-set, widely separated eyes recalls the Apollo in
Naples. The downturned, slightly open mouth echoes ancient Apollos
such as the Apollo Belvedere.

Ammanati constructed a large base about four feet wide
(51"= 127 cm.), which projects about two and a half feet from the
front of the niche. This provides a comfortable space for the figure
as he energetically strides forward out of his shallow niche. The
Apollo freely abandons his niche rather than being contained within
it, as is the case with Sansovino's Loggetta bronze. The figure
approaches a free-standing statue for which the niche behind offers
a scoop of shadow, the primary function of which is to accent
the silhouette of a figure in motion.

The stride and sharp glance to the right would surely have evoked
memories of the Apollo Belvedere with sophisticated antiquarians such

as Benavides. Like the Apollo Belvedere, but quite removed from
Sansovino, Ammanati's Apollo is a sudden apparition of the god which
is frozen as if with a camera, though the movement and intent of each
figure is different. Ammanati represents him as he grasps his bow
and robe, glances at the horizon, and swiftly moves to some unknown
destination. The ancient statue represents the god coming to a halt,
perhaps after having shot an arrow.

The Jupiter (196 cm. high) in the other niche held a thunderbolt
(now lost) in his right hand and drapery with the other. He raises
one foot on a sphere (astrolabe ?) and looks to his right, addressing
(like the Apollo) the stroller who walks through the portal of the
arch. In broad, stocky physical type he is reminiscent of the Colossus
and Bandinelli's canon. A slightly twisting movement of his shoulders
and his raised leg energize his serene and benign bearing.

The Apollo has a silky and petal-smooth skin. In the Jupiter,
on the other hand, the sculptor's feeling for irregular, nervous
movement and faceted surfaces is superimposed on the body structure
to the end of impressing the spectator with the nervous energy and
mature age of the god.

The reliefs[12] (each 90 x 187 cm.) are of considerable interest

12. A small terracotta female head (fig. 264) in the Museo Archeo-
logico of the University of Padova (height 13.25 cm.), as observed by
Bettini (op. cit, 25, ill. fig. 12), is reminiscent of the crouched
female in the center of the left relief on the arch, and can be attri-
buted to Ammanati. It probably was preserved by Benavides from
Ammanati's bozzetto for the relief. The veiled, yet intimate ex-
pression and the rippling flow of the locks recall the Sapienza bozzetto
and the Leda. The head appears to be formed of the same reddish clay
used for the Sapienza, and carries traces of a similar patina, now
largely rubbed away.

because they are the only examples of narrative relief by Ammanati
which have survived. Unfortunately, today they are a nearly total
ruin, and we must study them in the best and earliest photos which
are available (figs. 250-60 ´). The complex drapery and fluid contra-
pposto of the "orator" in the right relief recall the statue of S.
Nazaro in Naples. The clothing, faces, and contrapuntal movement of
the ladies in the left relief bring to mind the allegories of
the Benavides Tomb.

In composition, several analogies are noticeable with Sansovino's
second set of tribune reliefs for S. Marco (fig. 253). The figural
types and compositions used by both sculptors are related, though
this may be due to Ammanati's influence on Sansovino rather than vice
versa. Due to the proximity of the two artists when Sansovino's
reliefs were executed it is hazardous to say who influenced whom. We
can say with certainty only that Sansovino revealed his solution to
the relief problem at an earlier date. The influence of Bandinelli
on both artists is an important factor. Bandinelli's reliefs in the
Minerva in Rome (fig. 18, 21-22) and in Piazza S. Lorenzo in Florence
(fig. 261) foreshadow certain features of the later reliefs by Sanso-
vino and Ammanati: spatial compression both in depth and over the
surface, close emulation of ancient poses and motifs, and violation
of traditional Albertian spatial illusionism. These characteristics
were hardly the exclusive province of Bandinelli. Advanced painting
was exploring similar potentialities. But Bandinelli was a pioneer in
learning a non-rational relief vocabulary from Roman art, and in

applying it on a monumental scale in prestigious sculptural commis-
sions. It may be that Ammanati, as well as others, passed on the
new fashion to Sansovino, who utilized aspects of it in the second
set of tribune reliefs. It is also conceivable that Sansovino
could have seen drawings or a model of the Medici monument reliefs
when in Florence in the Fall of 1540.

The soldiers and the seated "general" in Ammanati's right relief
may echo a similar trio on the right side of Sansovino's Execution
of St. Mark. Ammanati's larger group of soldiers, however, seems to
have been inspired mainly by an Antonine Adlocution of the Emperor
on the south side of the attic of the Arch of Constantine. Like
Sansovino, Ammanati employs a shallow foreground stage crowded with
figures placed in front of a schematic backdrop. This is taken over
from Roman relief. Sansovino's backdrops are composed of Renaissance
structures and schemes similar to those employed in Serlio's stage
sets and Raphael's tapestry cartoons. But Ammanati is more rigorously
archeological. He simulates the doll-like architecture and land-
scape of reliefs such as the Hadrianic tondi on the Arch of Constan-
tine. The condensed narrative of Ammanati's right relief -- the
juxtaposition of three events probably isolated in time and space
without marked separating devices -- is analogous to the presentation
of narrative in Roman sarcophagi (e.g., Diana and Endymion or bio-
graphical sarcophagi) and to Imperial reliefs such as Trajan's Column
and the Arch of Septimius Severus. Ammanati's reliefs reject a
fifteenth-century tradition of illusionistic relief for a conceptual

relief style based on ancient models. This relief "all'antica"
gives greater weight to individual figures on the frontal plane and
treats everything behind the foreground stage conceptually or sche-
matically. The sculptor employs a tilted-up background plane which
presses the figures in the background toward the front. Figures in
the background are raised above those in the foreground in order to
bring them into view rather than being represented in diminishing
scale by degrees as if on a rationally receding ground plane. This
method is most noticeable in the extreme right and left of the right
relief and in the far left side of the left relief. Hints of this
method of relief composition are found in Sansovino's first set of
tribune reliefs, in the left side of the St. Mark Healing the Possessed
Woman (fig. 254) (which may be echoed in the left side of Ammanati's
right relief), where figures are stacked up and compressed on a narrow
stage as on a late antique battle sarcophagus. Ammanati, however, had
good reason to employ the device more frequently than Sansovino:
since the reliefs are high above the spectator, the device serves --
as it sometimes did in Roman times -- to make the relief more legible
from a point of view a good distance below. Perhaps for the same
reason, Ammanati favored a somewhat higher relief and considerably
fewer figures than were used by Sansovino. Generally, Ammanati's
composition is more open and the figures less compressed than in
either Bandinelli's reliefs or Sansovino's second set.

Ammanati's reliefs lack the dramatic focus and concentration of
Sansovino's two tribune sets. They seem diffuse and confusing by

comparison. This is a natural result of the accurate emulation of Roman relief, and in the case of the right relief, the fact that three events are compressed into a small space. However, the left relief represents only one event and may be fairly compared to Sansovino's tribune reliefs. In the latter the action of every figure is subordinated to an overall psychological and formal unity dependent upon the main event. With Ammanati it is a different case. His reliefs contain fewer figures and a number of these stand out as entities of beautiful form; we are conscious of their dramatic role only secondarily. In a few instances, such as the kneeling woman in the center, movements seem isolated and not in any clear manner determined by the action at the right. Bandinelli's reliefs in Rome and Florence, as well as his Martyrdom of St. Lawrence (fig. 262), probably done when Ammanati was in his shop, provide a precedent for Ammanati's tendency to stress independent forms and movements above dramatic unity and formal cohesion.

The spatially coherent and illusionistic reliefs of Donatello's Santo Altar provided the backbone of relief style in the Veneto through the first quarter of the sixteenth century, including the most important cycle of reliefs to follow it, those of the Cappella del Santo in the same church. Sansovino's reliefs for S. Marco retain the formal cohesiveness and dramatic unity of this style, and even much of the spatial illusionism. But with the Benavides reliefs, this tradition is severed. Ammanati's reliefs reject coherence, illusionism, rationality for a conceptual relief style which violates the laws of Albertian pictorial rationale, elaborated by Donatello

and others for over one hundred years. Ammanati's reliefs are more "modern," "improved" (as Vasari would put it) by a more profound emulation of antiquity, to which Bandinelli first opened his eyes.

For the spandrels of the Arch, Ammanati provided himself with more space than was available on Sansovino's Library, and the figures are correspondingly larger, more attenuated, and the poses more open. As on the Library, the integration of figural and architectural elements remains carefully and harmoniously balanced. The hyper-refined heads, the soft, swelling limbs and complex draperies, while containing echoes of the Pisa lunette and Nari Victory, seem to announce the del Monte allegories.

In the Arch as a whole Ammanati displayed a sophisticated knowledge of ancient art, without sacrificing personal invention, which must have gratified his patron. For its time the Arch was among the most antiquicizing monuments in North Italy. It seems entirely at home in the city of Mantegna and Andrea Riccio.

Part **VI:** Lost Works for Benavides and Giovannandrea
Dell'Anguillara

In addition to the major projects already described, Ammanati
executed a number of smaller works of lesser importance for Benavides,
all of which are lost, but of which a record is preserved in the In-
ventory compiled by the juriscounsul's grand-nephew Andrea Mantova
Benavides in 1695. These lost works are:[1] 1) a portrait bust of
Marco Mantova Benavides in terracotta (Inv. 50); 2) a putto relief
in terracotta (Inv. 321);[2] 3) a terracotta model of a satyr (Inv. 344);
4) two large satyrs in the garden of the Palazzo, for which the
aforementioned satyr served as a model (Inv. 344);[3] 5) an "anfithea-
trino in sette nicchi compartito in semicircolo; vi sono reposti nelli
suddetti 7 nicchi modelli di terra cotta in statue alte due piedi in
circa le 7 Deità delli 7 pianetti," Diana, Mercury, Venus, Apollo, Mars,
Jupiter, Saturn (Inv. 163-169).[4] The margin of the inventory contains

[1]. Excavated from the Inventory by Sergio Bettini, op. cit, 25 ff.
Cf. also C. Semenzato, op. cit, n. 1.

[2]. Un Quadretto con suaza pezzo dentro vi è un'Amorino di mezo
rillevo di cotto che stà appogiato ad un bastone: è un modello di
Bartolomeo Amanati Scultore Fiorentino che ha fatto il nostro Gigante."

We will recall that Lorenzo Lotto purchased a putto in relief
(see Chapt. 8) from Ammanati which was apparently shipped from Florence.
This coincidence, Lotto's desire for such an object, and the odd pre-
servation of this subject in the collection, are all matters of utter
bewilderment to me. Why would Lotto pay to have Ammanati ship the putto
when the sculptor probably could have made one in Venice with little
bother?

[3]. The complete Inventory notice in Bettini, op. cit, 24.

[4]. One Paduan foot = 35.65 cm. Thus the figures were about 71 cm.
high.

4. (Cont'd.)

Bettini (op. cit, 24, figs. 1, 2), followed by Semenzato (op. cit, 98, n. 7), believed that a terracotta statuette of a female figure in the Museo Archeologico was a sketch for the anfitheatrino. It should be observed that the figure (43 cm. including base) is 28 cm. shorter than the two Paduan feet cited by Andrea Benavides for the statuettes. In any case, this lovely figurine is clearly a modello by Alessandro Vittoria for the figure of Architettura supporting the cornice, together with Scultura, of the sculptors tomb in S. Zaccaria in Venice, designed and erected before his death in 1602-03 (documents and illustration in F. Cessi, Alessandro Vittoria Architetto e Stuccatore, Trento, 1961, 66-67). Virgilio Rubini was paid in 1603 for executing the figure of Architettura. His figure corresponds closely to the Padua modello.

Vittoria used similar figures for a tabernacle in the Palazzo Ducale, Venice, at an earlier time. It is not impossible that Vittoria presented Benavides with the figure before his death, and produced another later for Rubini to follow in executing the marble. Perhaps he remembered Benavides' patronage and assistance which is documented as early as 1552 by three letters (published in G. Bottari - S. Ticozzi, Raccolta di lettere ..., Milano 1822-25, VIII, #CLVI, CLVII, p. 354. I came upon Bottari's source in the Library of the Seminario, Padova (Cod. 609, 6, #54, 129, 130).

Benavides owned at least two other works attributed to Vittoria, now lost, recorded under Inventory #252, 253: "Sopra le Due Colonnette una per parte delle suddette scancie del sopradetto Vano del mezo Vi sono Due Termini sive piccole Statue de stucco seu Gesso de Vecchi tratti dall'Egreggio Scultore Alessandro Vittoria sopradetto." These figures might suggest the herms by Vittoria for the Contarini Tomb in the Santo.

This is not the only time Vittoria and Ammanati have been confused. Ciardi - Dupré ("Prima Attività," 22) wrongly attributes Vittoria's terracotta figure of Apollo in Vienna to Ammanati.

sketches which Andrea Benavides made as visual records of a few of
the works which he inventoried. His fancy was caught by Ammanati's
statuette of Diana in the Anfitheatrino and next to the description
of the latter he sketched it (fig. 263). The sketch, which is 5.3 cm.
high, can give no more than tantalizing hints of the two- Paduan
foot high original. The figure holds the leash of one of her dogs
and a lance. She appears to be scantily covered above the waist,
but otherwise clothed. She steps forward lightly, twisting to the
right while looking left. In fact her movement is similar to Fame's
on the Tomb (fig. 216) except that it is not so vigorous and she veers
to the left instead of the right. Her feet are pulled together like
Honor's, enhancing a delicate s p i r a l and imbalance. The figure
thus appears to reflect the formal problems being probed in the Tomb.
However, similar problems were taken up in the arch sculpture and in
the del Monte chapel, and one could hardly advance a more precise date
for it than between the Tomb model and 1548.

In one case, a work by Ammanati was not recorded in the inventory.
This is a statue mentioned by Portenari in the early seventeenth
century: "una statua d'huomo dormiente di Bartholommeo Ammanati molto
lodato dalli statuarii."[5] It disappeared without a trace, probably
sometime between 1780 and 1795. Temanza, writing toward the middle of
the eighteenth century, believed it ("un modello di un fiume") was a

5. Portenari, op. cit, 459.

work by Jacopo Sansovino.[6]

Ammanati can be documented as working for one other patron in
Padova. He built, or helped to build, a theater set for Giovannandrea
dell'Anguillara in July 1545 and later he was involved with the same
patron while working on the concluding phase of the Benavides Tomb.
A note of July 24, 1545 in the Riccardiana Sketchbook records certain
procedures followed when he erected a "prospetiva fatto nela sala del
Capitano di Padova fatto recitare dal gobbo dell'angullara cioè Mx
Giovanadrea."[7] Giovannandrea dell'Anguillara was the owner of a
theater company for which Battista Franco and Ammanati built theater
decorations after November, 1548 in Rome.[8]

In the same sketchbook a few folios later Ammanati recorded eight
payments totalling 81 lire and 14 soldi to "Mxro marcho," who can
safely be identified with "marco muraro," who helped him erect the

6.
Temanza, _Vita de Giacomo Sansovino_, Venice,1752, 49. Between
Rossetti (op. cit 1780, 347) and Brandolese (op. cit, 1795, 221, n.a.)
it disappeared.

Cf. Inventory #243: "Un Modello bellissimo di huomo fatto di
sua Mano di terra cotta dormiente sopra un terreno steso, che decade
di qualche cosa di grandezza del Naturale, con un Gallo posto sotto
la gamba destra" given to Marco Benavides by Girolamo Campagna together
with his portrait by Leandro Bassano.

7.
Published in Fossi, _La Citta_, 429.

8.
Vasari - Milanesi, VI, 583.

Benavides Tomb. One of the payments, of February 27, notes that "mx[ro] giovannandrea" paid Marco for work done on Ammanati's behalf.[9] The payments run from February 13, 1546 to April 3 (or slightly later) of the same year, dates which coincide closely with the payments for the Tomb. In fact the two sets of payments are recorded on two facing pages in the sketchbook. Unfortunately, the notations contain no hints as to the nature of the work.[10] Although Giovannandrea is mentioned in only two of the eight payments, all of the work may have been done for his company. It probably involved either the dismantling of a used stage set (that erected by Ammanati roughly six months before?) or the construction of a new one. Another payment, of February 13, notes that Marco was employed by Giovannandrea to work for Ammanati at an earlier time. This may mean July of 1545 when Ammanati could have used assistants in erecting his prospettiva.[11]

9. Fossi, Loc. cit.

10. Could the Benavides "Anfitheatrino" have been a study or model for a larger work such as Ammanati might have built for Anguillara?

11. Among the misattributions to Ammanati of the Paduan sojourn –

1) Allegorical female figure of terracotta, Museo Civico #28, Padova. Attributed to Ammanati by Gabbrielli, op. cit, 91, n. 11. Bettini (op. cit, 25, n. 17) thought perhaps it might be a work of the nineteenth century. I believe the figure is the work of Francesco Segala, whose Sansovinesque, painted stucco figures in Sta. Giustina in Padova it resembles. I am very grateful to Dott. Luigi Grossato, Director of the Museum, for his time and assistance in allowing me to consult the piece in the museum storerooms.

11. (Cont'd.)

2) Monument of Giovanni Naldo, church of the Carmine, Padova attributed to Ammanati by Bettini (op. cit, 26), Ciardi - Dupré ("Brevi note," 64, n. 10) attributes it to Segala. The statue of Naldo appears to be of painted stucco, not bronze. The forms and handling are close enough to Tiziano Minio's altar in the Museo Civico and the stucchi in the Palazzo Cornaro to seriously consider an attribution to this artist. **Scardeone** (De Antiq. Urbis Patavii, Padua, 1560, 429) gives the epitaph and its date of 1528. Minio at about this time was emerging as a stuccatore.

3) A small terracotta copy of Michelangelo's Aurora, Museo Archeologico, Univ. of Padova, #239, attributed to Ammanati by Bettini (op. cit, 24). It is listed in the Inventory without attribution (#239). Semenzato (99, n. 9) suggested the name of Aspetti. Today in the Museum it is more accurately labeled anonymous sixteenth-century Italian.

4) Terracotta portrait of Michelangelo, Museo Archeologico, Univ. of Padova, attribution by Bettini (26, fig. 14). The head seems too close to Daniele da Volterra's well known bronze portrait (an example is in the Bargello, Florence) to be coincidental. Probably it is a later sixteenth-century copy or cast of the bronze.

5) A small terracotta head, Museo Archeologico #85, Univ. of Padova. Attributed by Bettini (op. cit, 25, fig. 12). This head is later than another by Ammanati mentioned in Chapt. 9, part 5; probably it is seventeenth century. Semenzato (102, n. 15), rightly noted a resemblance to Roccatagliata's work.

6) Hercules and Cerebus, Palazzo degli Specchi, Padova, associated with Ammanati by M. Checchi et al., Padova Guide ... 1961, 588. This work is of the seventeenth century or later.

Part VII: Activity in Vicenza

Ammanati's documented work in Vicenza consisted of a large two-storied architectural fountain comprising a grotto and loggia, and two smaller free-standing fountains supporting figures of Fame and Time. The sculptor's activity in this city was entirely overlooked by Vasari and Baldinucci. Long forgotten, it was called to the attention of modern scholarship by Bernardo Morsolin in the late nineteenth century and more recently by Sergio Bettini in 1941.[1]

Following an erroneous statement by Girolamo Gualdo the younger (the grandson of Ammanati's patron) that Ammanati executed the fountain in the Giardino Gualdo in 1550,[2] which probably derives from Vasari's mistaken assertion that Ammanati left Padua in 1550, it has been believed up to the present day that Ammanati worked in Vicenza following the completion of the Benavides Tomb, until his marriage to Laura at Loreto in April, 1550. Actually Ammanati's activity in Vicenza began as early as April, 1545, if not earlier, and the fountains which he built for Girolamo Gualdo were completed by the end of 1546.[2a]

Sadly, Ammanati's fountains have disappeared without a visual trace. However, we possess four seventeenth-century descriptions of

[1]. Op. cit, 22

[2]. In the 1650 description of the fountain published by B. Morsolin, Il Museo Gualdo in Vicenza, Vicenza, 1894, 51.

[2a]. The date of the two dedicatory inscriptions on the fountains. See below, doc. 16, p. 237, and doc. 20, p. 243.

the large fountain, and one of the two smaller fountains, which provide us with some idea of Ammanati's achievement.

Apparently Ammanati's large fountain survived until 1820, when it was demolished by Alfonzo Garzadori, then owner of the Casa Gualdo, who carried the pieces to his villa at Creazzo, just outside Vicenza.[3] However, no trace of them remain at this villa today.

The first evidence of Ammanati's presence in Vicenza is a letter of April 21, 1545 from one Francesco Maria Machiavelli, a little known sixteenth-century Vicentine writer, to Benavides (Doc. 3). The letter begins with "lo scultor fiorentino doveva farmi molto raccomandato a V.E.," for favor(s) which Benavides had done for Machiavelli. Later on he adds: "io credo, che egli (the sculptor) il facesse (did it; i.e., recommended me), perche mi parve molto gentile." The letter then goes on to other topics. Machiavelli recommends the writings of a "Gentilhuomo Vicentino" and says that the latter wishes to give him "una figuretta di bronzo antica assai bella che c' una diana." The letter suggests that Ammanati and Machiavelli had a cordial, formal relationship, but not an intimate one nor necessarily one which would exist between a patron and an artist. It is difficult to say whether Ammanati's involvement with

[3]. A note from Da Schio, Memorabile, ms. Bibl. Bertoliana, Vicenza, s.v. Gir. Gualdo: "Questa fontana venne distrutto nel 1820 da Alfonzo Garzadore e ha ne portò il villa propria a Creazzo." Cf. Ant. Ciscato, Guida di Vicenza, Vicenza, 1870, "questo prezioso sacrario delle belle arti fu eretto nel 1563 dal Canonico Girolamo Gualdo ... tutto fu disperso in men di due secoli; e nel 1854 cadde l'ultimo residuo del Palazzo, già divenuto da molto tempo proprietà della famiglia Garzadori."

Cf. Morsolin, Museo Gualdo, 7; and "Girolamo Gualdo," Arte e Storia, Dec. 31, 1889, VIII, n. 33-34, 257 ff.

Machiavelli was more than as a messenger between him and Benavides.
Whatever the favors exchanged, there is no clear indication that a
project of Ammanati's is involved.

A testimony of Ammanati's work for Gualdo is a copy of a letter
from Girolamo Gualdo to Benavides of August 26, 1545 (Doc. 4). In it
Gualdo asks Benavides to allow Ammanati to come to Vicenza after he
has finished his work in Padua, to execute two stucco figures for a
fountain which he has already built ("lo lasci lavorare intorno a due
figure di stucco, che doveano collocarsi in una fontana da esso M.r
Bartolomeo fatta"). It is not certain which of the three fountains
is meant by "una fontana ... fatta." Ammanati's entire project,
or all three fountains may be intended. The large fountain was a
structure of considerable size and sophistication. One doubts that
it could have been erected in less than five months, that is, between
Machiavelli's letter and Gualdo's letter. It is doubtful that
Ammanati would have been carrying messages between Machiavelli and
Benavides if he did not already have some kind of project of his own
in Vicenza. In lieu of other documented projects there, we can only
suppose that at least as early as April, 1545, and probably earlier,
his work included the Gualdo fountain complex.

Girolamo Gualdo, "conosciuto amator de virtuosi, premiator de
buoni et amico de Poeti, amator di pitture, sculture in marmi, in
bronzi, et in altri metalli,"[4] was born in 1492 and studied law at

4. Girolamo Gualdo, *Rime*, Vicenza, 1569, introduction by Girolamo's
nephew Giuseppe.

Padua as a young man. In 1526 he went to Rome where he took the
habit and served Cardinal Pompeo Colonna as courtier and diplomatic
emissary to France and Germany. Colonna had appointed Cardinal
Niccolo Ridolfi Bishop of Vicenza and when Colonna died in 1532 Gualdo
returned to Vicenza with Ridolfi. Later Ridolfi secured for him an
appointment as Canon of the cathedral of Vicenza. Gualdo remained in
Vicenza for the rest of his life, devoting himself to literary pur-
suits and art collecting. He died in 1566. He was an outstanding
"letterato" of his day. His friends included artists as well as
humanists, among them Trissino and Valerio Belli. The latter named
him one of the executors of his will. He wrote poetry in Greek and
Latin as well as in Italian, and formed a distinguished art collection,
which was housed in two palazzini in the Pusterla, a district of
Vicenza.[5]

We don't know how Ammanati was introduced to Gualdo, though it
could easily have been via Benavides. These two may have struck up
a friendship when Gualdo studied law in Padua. Moreover, Giuseppe
Gualdo, the nephew and heir of Girolamo, studied under Benavides at
Padua and received a degree from him in 1543.[6] Aside from law, the

[5] Girolamo Gualdo, Memorie della Casa Gualdo, ms. Bibl.
Bertoliana, Vicenza, 1638, 117 ff; Ant. Magrini, Notizie intorno a
Girolamo Gualdo, Vicenza, 1856; Paolo Calvi, Biblioteca e Storia
degli Scrittori Vicentini, III, 1782, s.v. Gualdo.

[6] Girolamo Gualdo, Memorie, op. cit, 121 ff.

two men shared interests in literature and the arts, and had similar
collecting tastes. Gualdo's museum had much in common with Benavides':
the passion for modern as well as ancient art, with a love of coins
and small-scale works like gems and crystals as well as natural curio-
sities and scientific instruments.[7]

Ammanati's fountains were ornaments for Gualdo's garden, which
opened off the back of the two modest palazzi in Pusterla. One of
the palazzi was built by Gualdo's grandfather, Girolamo, in 1482.
The other building, next door to it, was perhaps acquired at a later
time. The garden contained part of the museum, including fragments
of ancient statues, inscriptions, capitals, columns, and vases placed
among olive trees, laurels, herbs and exotic flowers.[8]

The large fountain was built against the flank of the church of
the Misericordia (figs. 266, 267), which formed the rear wall of the
garden, and it faced a frescoed vaulted arcade (now demolished) which
connected the two palazzini. It is not clear where in the garden the
two free-standing fountains were set up.

[7] On collecting in the Veneto cf. B. Morsolin, Le collezioni di
cose d'arte nel secolo decimo sesto in Vicenza, Vicenza, 1881;
Museo Gualdo, passim.

[8] By 1782 (P. Calvi, op. cit, VI, 1782, s.v. Gualdo, VI) the
collection was largely dispersed; remaining only were "pitture corrose,
di tronchi busti, e di pietre, quaste, logare e trascurate."

According to Da Schio (Memorabile, ms.cit. s.v. Gualdo) the
collection became the nucleus of the collection of Canon Brogliani
Gualdi at Padua, then it returned to Vicenza and came into the Museo
Tornieri in Palazzo Thiene. This was also dispersed.

We have four descriptions of the large Gualdo fountain. Two
are of major importance; the other two are brief, but add some useful
information. The two major descriptions are those written by Girolamo
Gualdo the younger in the descriptionsof his museum. One of these
and the two minor descriptions were published by Bernardo Morsolin
in 1894. The fourth description i s i n an unpublished manuscript
in the Marciana. It is unknown to the scholarly literature, and is of
great importance because it goes into greater detail than the other
descriptions, even so far as to provide approximate measurements of
several of the elements. This manuscript was written by the younger
Gualdo in 1643, seven years before the Museo Gualdo, which contains the
description published by Morsolin. The sections which describe Ammanati's
fountains are included here (doc. 16). The other three descriptions,
published by Morsolin, are re-published here for convenience, with a
few corrections (docs. 17-19).

From the four descriptions we can piece together a skeleton of
the large fountain, and it is possible, with the invaluable advice
and drawings of Slobodan Curcic, to offer a visual reconstruction in
plates I-II. For a more detailed discussion of the reconstruction the
reader is referred to Appendix 2.

The large fountain was a two-storied structure roughly 36
Vicentine feet high (ca. 43 feet, 13 meters; one Vicentine foot equals
35.6 cm.). This i n c l u d e d a g r o t t o, a loggia, and probably
a vase at the top which was about 5 feet high (all measurements will

be cited in Vicentine feet). The exterior walls of the fountain were square in plan, each 20 feet in length.

The lower story was a grotto with floor plan, walls, and vault ovoid in shape. The exterior was faced with large rusticated stones. It had three entrance doors each 9 feet high and 6 feet wide. The middle door, which faced east, contained in its inside faces two fountains with half-figures the vases of which were ca. 5 feet around. Opposite this door in the rear wall, in a niche of the same dimensions as the doors, was a fountain with a statue of a Triton and a vase four feet deep and ca. ten feet around, raised about one foot from the floor. The niches of these fountains were made of shells, stalactites "grottesche"). The grotto contained four benches or seats.

In the vault of the grotto was a mosaic of the Gualdo stemma contained within an oval ca. five feet around. The same stemma, carved in stone, was set into the floor. The walls and vault of the grotto were faced with different colored shells in various patterns, among which ovoid and circular ("capo") are mentioned. The floor was made of white and black pebbles. Water jets were hidden in the walls and pavement and could be turned on by four or five keys. To the surprise of those caught inside, these could have flooded the grotto in seconds.[9] Hot as well as cold water sources are mentioned (doc. 21).

[9] The 'sweet horror' of being soaked by the hidden jets is evoked in one of Gualdo's poems, doc. 22.

The upper story, a loggia, had three open sides, each of which was articulated by one round-headed opening ("a volto") flanked by rectangular openings ("finistre quadre"). The f o u r th side, that to the west, was closed, as the complex abutted the wall of the church of the Misericordia. The piers separating the openings carried attached stucco harpies which supported an entablature[10] containing an inscription, with letters six oncie (1/2 foot) high. Above the rectangular openings there were as many tondi containing large stucco masks. Above this was a cornice with two copper gutter pipes which carried water from the vault. Above this was the vault which was covered with slabs of lead. At the top of the vault was the vase five feet high.

From the loggia one could probably have commanded a view of the Astichello River and a meadow to the east, and to the south the fringes of the center city and the Bacchiglione River. One ascended to the loggia via one of two stone staircases which ran along the wall of the church of the Misericordia. These staircases had landings halfway up under which, in the vaults, were uccellieri.[10a] The rectangular openings served as doorways to the loggia.

The Triton in the rear of the grotto spouted water from many openings, and from under its scales. The figures in the other two fountains in the center door also contained spouts that were not confined to the mouths.[10b]

10. Three different types of herms were used by Ammanati in the Villa Giulia Nymphaeum: those in the grotto and in the attic of loggia #II survive, but those of stucco attached to the wall flanking the niches of the upper story of the Nymphaeum are lost. The latter are visible in a drawing preserved at the Villa, showing the Nymphaeum before it was stripped, and provide an idea of what the Gualdo harpies might have resembled.

10a. The uccellieri were perhaps decorated with painted or sculptured vegetation, and could have served as large bird cages.

10b. See doc. 16, p. 236.

These two half-figures were carved of stone. It is not stated, but the Triton was probably also made of stone. Stucco figures may not have been able to withstand running water for long.[11]

In his two descriptions of the fountain Girolamo Gualdo does not associate the figural sculptures with another hand, and the clear implication is that Ammanati was responsible for both the architecture and sculpture, as we would expect to be the case. However, in the Museo Gualdo, in Girolamo Pironi's entry, Gualdo says that three figures in the grotto were executed by Pironi in 1560.[12] If this is true we must believe that Ammanati left the fountain incomplete in 1546, for it is very unlikely that Gualdo would have had Pironi execute replacements for Ammanati's figures. It would be very odd indeed if Ammanati left Vicenza without installing these figures, whose complex water jets are the major decorative feature of the

11. Serlio (Opera Completa, Book II (1545), ed. Venice, 1619, p. 47) says he saw a marvelous satyric stage set by Girolamo Genga created for Francesco Maria della Rovere which included many stones of diverse colors, coral shells, snails and crabs on rocks, satyrs, nymphs, sirens, various monsters and strange animals. The vocabulary of the grottos by Tribolo and Ammanati is linked to such sets.

12. In B. Morsolin, Museo Gualdo, 54: "Girolamo Pirone ... operò nella nostra casa un Satiro con effigie humana fino al mezzo, e dal mezzo in giù di pesce, che getta acqua da più parti.

Vi sono ancora due mezze figure per parte della fonte, una d'huomo, che getta acqua dalla bocca, e di donna l'altra dalle mammelle. 1560."

grotto. Moreover, is it likely that the fountains would have been
dedicated in 1546 if the sculpture was not yet complete? Gualdo's
letter of 1545 clearly indicates that he was waiting for Ammanati
to execute two figures to bring the fountain to completion; we can
only assume that this was in fact done by the time of the dedication
in 1546.

Gualdo the younger was writing almost one hundred years later
than the activity of Ammanati and Pironi. There is a prominent ten-
dency in his description of the Museum to attribute pieces to local
Vicentine artists and to the more important Italian artists, which
may be reflective more of wishful thinking than of fact and family
records. This tendency may underlie Gualdo's association of the
three fountain figures with the Vicentine Pironi.

The identity of two of the statues is unclear. The statue at
the rear of the grotto was certainly a Triton of sorts. He is called
a "Dio Marino" and elsewhere "un satiro con effigie humana fino al
mezzo, e dal mezzo in giù di pesce, che getta acqua da più parte."[13]
Gualdo the younger's unfamiliarity with the original project of his
ancestor's fountain may account for his simplified labelling of the
other two figures as "doi Deità maschio e femina" and elsewhere as
"mezze figure ... d'huomo ... e di donna," rather than as something
more specific.

[13]. See documents 16-19, p. 238 f.

The fountain was "dedicated to **genius,** the Lymphae, and to
the Camoenae" ("Genio, et Lymphis, Camoenisq dicavit").[14] Lymphae
were classical water nymphs. Camoenae were originally fountain dei-
ties but in ancient and Renaissance literature they came to be
identified with the Muses, sometimes with the Muses of the Greek poets.
Originally their cult was centered on an unidentified spring within
the boundaries of the Villa Mattei in Rome,[15] but they were also
worshipped at the fountain of Egeria in Rome.[15a]

Several overlapping historical concepts may be intended by
"Genius." In common sixteenth-century usage it means the tutelary
spirit under which a person is born, but in our context it no doubt
also means the spirit of poetic inspiration itself. The fountain on
one level is a metaphor of the Hippocrene on Mt. Parnassus, the source
of poetry. That this metaphor is implied is suggested by another

[14.] It seems very likely that the "Lymphis" of the inscription
is inspired by a Roman inscription found on a hill near Schio known
to Vicentine letterati as early as 1577 (Bernardinus Triniqium,
Veteres Vicentinae Urbis Inscriptiones, Vicentiae, 1577, 44: Nymphis,
Lymphis / August, ob. reditum / aquarum / P. Pomponius / Aurelianus
C.F. Vir. C. vovit / vir c. vir clarissimus. Cf. G. G. Maccà, Raccolta
delle iscrizioni sacre gentilesche della città e del territorio di
Vicenza, Vicenza, 1882, 62: Nymphis. Lyphsq. / Augustis ob reditum /
aquarum / T. Pomponius / Cornelianus C.F. / ut. vovit). At the time
of Maccà, the inscription was in the Casa Tornieri, and therefore may
have once been owned by Gualdo, who possessed other assorted antiquities
including inscriptions. In the sixteenth century the inscription was
believed to have commemorated a fountain dedicated to the nymphs. Thus,
Gualdo's fountain may have been in part a conscious gesture to reinstate
a sacred dwelling for the local goddesses near their ancient "templo."

[15.] Platner and Ashby, A Topographical Dictionary of Ancient Rome,
London, 1929, 89. Cf. also Lomazzo, Della forma delle Muse cavata de
gli antichi autori, 1591, 7 and Pauly - Wissowa, Real-Encyclopädie,
s.v. Camenae.

[15a.] On classical nymphae, see below, p. 190, n. 23.

reference to Mt. Parnassus (the Camoenae) and by the fact that the
fountain served as a deep source of poetic inspiration not only to
Girolamo Gualdo but to other poets of Vicenza as well.

The sculptural program need not have illustrated the deities
commemorated in the inscription. As in the case of the Triton,
the presence of the other two figures could be justified solely by
their association with water. Water flowing from the mouths and
armpits would be rather inappropriate for a major classical deity,
or even for the Nymphs and Muses to whom the fountain was consecrated.
Perhaps the two unidentified figures were types of hybrid human-marine
animals. In any case, the complete program of the fountain eludes us.
Gualdo's poems (docs. 21-28) mention certain features not cited in
the descriptions, hints as to the significance of the individual
parts, and perhaps clues as to the identity of the two deities in
the entrance.

The waterworks of the Gualdo fountain were a novelty which were
a wonder of Vicenza in their day. One anonymous seventeenth-century
writer[16] noted the "bellissime fontane artificiose con molti inganni
per bagnare et huomine et donne all'improviso, et questa fu la prima
che fosse veduta in questi paesi havendo egli (Gualdo) portato la
foggia da Roma e da Napoli ... Piacque tanto questa non piu veduta
maniera di scherzare d'acqua che tutti li poeti di queste contrade si
posero a poeteggiare e volgarmente e latinamente in lode di questa

16.　　See doc. 18;　also in Morsolin, Museo Gualdo, 13.

nuova fonte..." Whatever is meant by techniques from Naples and
Rome (no doubt meaning ancient fountains)[17] the actual precedent
for Ammanati's water tricks is Tribolo's fountain complex at Cas-
tello. Vasari's detailed description of Tribolo's project,[18] and
the finished works themselves, contain a pavement with spouts to
surprise strollers, keys from which the hidden jets could be con-
trolled, a tree which "rained," running water which made bizarre
sounds, and a statue of *Fiorenza* with water dripping from her hair
later carried out by Giambologna. Most of the kinds of tricks in
Ammanati's fountain were probably at least in the planning stage in
the Castello gardens before Ammanati left Florence for Venice in 1541.
Ammanati's fountain demonstrated a sophisticated understanding of

[17]. Francesco de Hollanda's drawing (reconstruction?) of the grotta
di Egeria has several similarities to Gualdo's fountain (Cod.
Escorial., ca. 1538-40, f. 33v, illustrated in Pinelli-Rossi, Genga
Architetto, pl. IX, fig. C). It is a grotto with a rustic facade and
a single-arched doorway flanked by two statue-bearing niches (in
Gualdo's fountain the niches are on the inside faces rather than on
the exterior) and apparently contained a statue of a satyr. Both
Ammanati and Gualdo could have seen this famous ancient fountain when
in Rome. An additional link between the two lies in the fact that in
the Renaissance the Camoenae were often identified or closely associated
with Egeria (cf. Pauly - Wissowa, Real -Encyclopadie, s.v. Camenae).

[18]. Vasari - Milanese, VI, 76 ff. Vasari also mentions that
Tribolo planned a loggia at one end of the garden to which one rose
by steps and which provided a splendid view of the countryside. This
was never carried out. However, Ammanati's fountain appears to have
been the first to unify a loggia with a grotto. Vasari, in treating
fountains in general, indirectly comments on grottœs such as those by
Tribolo and Ammanati (Le Vite, ed. P. Barocchi, 1970, I, 71-72).
He mentions keys, rain, sunken piping, etc., which he claims were
Tuscan inventions.

these hydraulic systems; in fact so much so that one is inclined to
speculate that Ammanati may have worked at Castello under Tribolo
at some point. Cosimo de' Medici commissioned Tribolo to begin the
garden-fountain complex at Castello shortly after he took power as
Duke in January of 1537. Vasari relates that during the initial
phases of work the Duke was spending freely and Tribolo employed
many helpers. It is not unlikely by any means that Ammanati found
work at Castello sometime between October 1538 (the death of Fran-
cesco Maria) and October 1539 -- a period when we have no record
of his activity.

Shortly after 1555, Cosimo placed Ammanati in charge of carrying
on the work left incomplete by Tribolo. Ammanati's experience as a
fountain-builder in Vicenza and Rome qualified him for the job; if
he had indeed been employed earlier on the same commission he would
have been the ideal choice to carry forward Tribolo's uncompleted
project.

In at least two ways the hydraulics of Ammanati's grotto seem to
be more complex and advanced than Tribolo's grotto at Castello.
Firstly, Ammanati's had hidden jets in the walls as well as in the
pavement. Tribolo's grotto, as it exists today, aside from water
which issues from the sculptures has jets only in the floor. Ammanati's
system would have made a surprise drenching all the more sudden and
dramatic. Secondly, Tribolo's projected sculptures for the fountains
and the grotto -- which in the end were executed with the help of
others, including Ammanati -- were not so elaborately fitted with water

jets as the sculptures at Vicenza. The Triton at the rear of
Ammanati's grotto issued water from all over his body, including
his tail. Appropriately his home was a grotto which could be flooded
in a few seconds. In the darkness of the moist grotto, the figure
must have seemed startlingly lifelike, "getting drunk" on the water
he is drinking, as Gualdo observed him.[19] This appears to have been
a piece of engineering and art that justifies the humanist cliche
'art conquers nature' which Gualdo used in his poems eulogizing the
fountain.[20]

The other two creatures in the doorway had similar devices, pro-
viding a foretaste of the water surprises within.

The exterior appearance of the Gualdo grotto, formed of "belle e
grosse pietre alla rustica o a' Grottesche" which was probably partly
covered with ivy, would create the impression of a natural cave. It
may have resembled the exterior of Tribolo's grotto at Castello as it
appears in Uten's lunette of the Castello garden of 1598, in the
"Museo di Firenze come era." On the other hand the doorway as repre-
sented by Uten may reflect the intentions of Ammanati himself after
1555. In the lunette the grotto exterior, which beckons to us like a

19.
 See doc. 21.

20.
 See docs. 21 and 22. The engineering employed here is reminiscent
of Leonardo's inventions, such as a silver lion which stepped forward
and roared, revealing a bouquet of lilies, created for Ludovico Sforza.
Such tours de force were much appreciated in the Renaissance, the
taste having been stimulated by ancient literature which mentions
similar things, for example, the gold singing birds made by Arab
artists for the throne of the Byzantine emperor.

natural cave, appears to be made of rusticated rocks, perhaps with
stalagtites around the door. Its size is about one-third smaller
than it is today.

There are a number of analogies between the Gualdo fountain
and the Villa Giulia Nymphaeum, which Ammanati built a few years
later: a multistoried architectural complex comprising a vaulted
room below and a loggia above with flanking staircases connecting
the two levels. Uccellieri are associated with the stairways, and
stucco decoration was featured in both structures. But in the Villa
Giulia Nymphaeum Ammanati has used this combination of loggia with a
lower vaulted room in a very different and more elaborate architec-
tural complex. He added a third level below the other two, and he
shifted the fountain to the lowest level. The vaulted areas beneath
the loggie were transformed into cool, shady rooms which contained
statues, painting and stucco decoration.

Perhaps the closest architectural antecedent for the Gualdo
fountain is the Villa Imperiale at Pesaro,[21] where a rustic fountain
or "grotta" was set in a deep niche in the center of one face of the
cortile.[22] Above it is a terrace, and above that still another
terrace with loggie at the corners of the opposite face of the cortile.
At Vicenza, Ammanati shifted a loggia of the upper level directly over

[21] Cf. C.H. Smyth's observations on the relationship between the
Imperiale and the Villa Giulia ("The Sunken Courts of the Villa Giula
and the Villa Imperiale," Essays in Memory of Karl Lehmann, Glückstadt,
1964, 304 ff.).

[22] Described in a manuscript of 1631 published in G. Gronau,
Documenti artistici urbinati, Firenze, 1929, 144-45.

the fountain and in doing so profoundly changed the character of
both levels. The unification of the loggia with the grotto was a
clever innovation, unique for its time, which was suited to the parti-
cular location of Gualdo's garden and provided several luxuries in
a minimal amount of space. The two palazzini lack loggie at the upper
levels and the terrain of the site is completely level. The flank of
the Misericordia prevented a view from the garden to the west, and at
ground level the two palazzini and the corridor blocked a view to the
east. The loggia of Ammanati's fountain, then, provided Gualdo with a
much improved view toward the north and south, and east over the
corridor. By climbing into the loggia, Gualdo could command a "bel
vedere" and perhaps a breeze, and escape the somewhat cloistered space
of the garden. The grotto level offered the stroller a still cooler
retreat, as well as water tricks and visual delights which provided
amusement and opportunity for relaxation.

Ammanati makes an interesting leitmotif of the oval form in the
garden. The oval of the grotto is echoed by the "mandorla" mosaics
inside, probably by the segmented saucer-shaped vault visible from
the exterior and by the two oval basins of the two free-standing
fountains elsewhere in the garden. Later, for the grotto at the
Palazzo Pitti Ammanati returned to the oval form; but as we see it
today with later additions, the grotto is otherwise different in
internal articulation and program from the Gualdo grotto.

At least one oval-plan nymphaeum existed in Roman times, in the

Domus Flavia on the Palatine in Rome.[23] However, the oval form was used primarily in various other ancient structures, preeminently amphitheaters, and it began to be revived in the early sixteenth century. Peruzzi was fond of it and Serlio[24] recommended its use in a variety of contexts, though not specifically for fountains.

Since the seventeenth century it has gone unnoticed that Ammanati also executed two smaller fountains for Gualdo's garden. This is due to the fact that these two were not described in the Museo Gualdo of 1650. However, they are described briefly in the earlier manuscript of 1643 (see doc. 20) and Basilio, in his letter of 1644 mentions that Ammanati in addition to the large fountain made "doi altri ma picoli."[25] They were free-standing fountains composed of a carved decorated base which supported an oval basin (ca. 8 Vicentine feet round, 5 feet high). Above this, in one of the fountains, a figure of a winged Fame playing a trumpet stood on a vase. Water issuing from the vase spilled into the oval basin. On the other fountain, a figure of Time holding a clock and a scythe stood on a vase, which likewise spilled water into the large basin. The inscription on one of these fountains is recorded in the 1646 manuscript: HIERONIMVS GVALDVS CO: V: HORTVM / HVNC IN SOLATIVM SVI ANIMI APER. / ANNO DO: MDXLVI.(Girolamo Gualdo made this garden for the delight of his soul in the year 1546.)[25a]

[23.] N. Neuerburg, L'architettura delle fontane antiche, 1965, #176 p. 222, ill. fig. 99. Cf. figs. 107-08.

[24.] Serlio, Book I, 1545, 14.

[25.] This phrase is omitted from Basilio's text as published in Morsolin's Museo Gualdo and this omission is partly responsible for the eclipse of the two smaller fountains. For the corrected text see doc. 19.

[25a.] See doc. 20, p. 143.

does not mention who carved the fountains but the old inscription leaves little doubt that his grandfather commissioned them from Ammanati at the same time or shortly after the latter executed the large fountain. The inscription and the matching bases of the two fountains indicate that it is these which, following Basilio, may be ascribed to Ammanati rather than any of the other fountains which were erected in the garden at later times, by Basilio himself ("Siciliano") and other artists.[26]

It will be recalled that Gualdo's letter of 1545 mentions "due figure di stucco." The only stucco figures on the large fountain were the harpies of the loggia and the masks. Would two of these have been worthy of a special plea by Gualdo to Benavides to let Ammanati come to Vicenza? Perhaps the word "fontana" is meant in the sense of "fountain complex." If so the letter is likely to have been written on behalf of the two free-standing figures. These statues themselves did not throw water. It issued from a vase at their feet. Thus the medium of stucco was permissible, and more likely that it was for the three figures in the grotto.

The dedicatory inscription on the small fountain ("Girolamo Gualdo made this garden for the delight of his soul"), as well as that of the large fountain, echo the tenor of a number of poems written by Gualdo inspired by Ammanati's fountain. Published posthumously by Girolamo's nephew Giuseppe Gualdo, these poems (docs.

26. Including "Giovanni Vicentino" who made two fountains, a dolphin and a "testudine" for Girolamo Gualdo in 1560 (Morsolin, *Museo Gualdo*, 54). See docs. 19 and 20.

21-28) tend to be rhapsodies and flights of fancy celebrating Apollo, Diana, Venus and nymphs, the charm of the garden like the "shady caverns," the fragrance of flowers and herbs and the play of water. The fountain is an inspiration for these poems as the Hippocrene is for the Muses. They abundantly reflect Gualdo's awe over Ammanati's "opre alte e rare" ... "fatto ad arte, e vince essa natura."[27] It is said[28] that other poets wrote verses inspired by Ammanati's fountain, some of which were apparently published. However, I have not been able to locate any of these.[29]

[27] Doc. 21; Gualdo, _Rime_, 28[r].

[28] See docs. 17 and 18.

[29] Additional study of the fountain, the poems, and fountain iconography in general is likely to shed further light on the program of the garden-fountain complex. See below, p. 244, n. 1.

The twin fountains of Fame and Time are linked to the grotto, a metaphor of the Hippocrene, in that poetry brings fame, and is a means by which mortality is transcended.

Chapter 10

SOME OBSERVATIONS ON THE ROMAN ACTIVITY

Following the completion of <u>Benavides' Tomb</u> and the Gualdo
fountain complex Ammanati apparently sought work in Florence. This
can be gathered from a letter by Luca Martini in Florence to Ammanati
of August 27, 1547 (Doc. 5): "... volessi iddio che la possibilita
mia potesse trattenere qua (in Florence) la vertù et buone qualita di
vostre ... mi pasco con l'animo il quello, è prontissimo in tutti gli
vostri piaceri aspettando occasione, se mai però verrà, che io in parti
se non in tutto possa mostrarvi quanto vi ami, honori, et tenga caro,
disiderando ogni vostro bene, et rallegrammi d'ogni acquistato honor ..."
".. à questa hora havei in casa piu d'una opera di vostro mano." Al-
though full of rhetorical courtesy and affection, the letter actually
seems to offer nothing in the way of concrete work: "mi pasco con
l'animo il quello è prontissimo in tutti gli vostri piaceri
aspettando occasione, <u>se mai pero verrà</u>" (my emphasis) ".. et se io di
qua vedrò nulla in ch'io possa giovarvi, che potria esser facil cosa,
vene donò aviso." The letter does not bear an address on the outside
of the sheet, as is the frequent sixteenth-century custom. The letter
found its way into a batch of letters written to Benavides, and it
seems likely that it was sent to Ammanati in Padova in care of his
patron, presumably with a cover letter to Benavides which has been lost.
Probably in the period between the end of 1546 and the date of Martini's
letter Ammanati finished work on the triumphal arch and may have helped

complete the Palazzo. The latter was completed by no later than
September 20, 1547. The closeness in time between this date and
Martini's letter suggests that Ammanati's work for Benavides was drawing
to a close in the summer months of 1547, and consequently he was looking
for work elsewhere.

It is uncertain what Ammanati was doing between August 1547 and
October 1548. There is no trace of him in Florence, and perhaps he
was unable to find work there and remained in Padova. It is possible
that he designed the Villa Barbaran and the Casa del Toso at this time.
However, these buildings are undocumented and until they receive a
thorough study, it is impossible to be certain of their architect
or date. Conceivably they could have been executed as early as the
early 1530's or sometime between 1541 and 1548. It is not known when
Ammanati began his theoretical treatise on the ideal city. Benavides'
vast library and print collection offered an environment conducive to
theoretical work. It is not unthinkable that Ammanati initiated his
treatise in Padova, or that Benavides encouraged him to begin such
studies in want of other immediate commissions, while awaiting his
departure for Rome. In any case, Ammanati returned to the Casa Bena-
vides briefly in October 1548 to pick up at least three letters of
recommendation which Benavides had written for him, to prepare his way
for emergence in centers of artistic patronage in Rome.

Two of these letters -- those to Ridolfo Pio Cardinal de' Carpi
(doc. 8), and Cardinal de Rodes (doc. 10) -- are preserved and dated
October 16, 1548. Ammanati arrived in Rome by November 17, the date of

Alessandro Corvino's answer (doc. 11) to a lost letter of recommendation
by Benavides which acknowledges Ammanati's presence in the Eternal
City. In another letter Benavides mentions Ammanati's intention to
go to Rome. This letter, to Antonio Centani [1] (doc. 7), mentions that
"nostro Enea" (Vico) ... ha dato principio à l'Hercole" and that
because "partendo il nostro M. Bartolomeo ... disidera portarlo
(the drawing) seco a Roma, si perche è cosa degna vista la dove le
nascono ogni giorno." This "Hercole" is surely the engraving copied
by Lafréry or the preparatory drawing for it (fig. 202).

Thus Ammanati set off for Rome armed with at least three of
Benavides' very strong recommendations[2] and a drawing of his Colossus.
Apparently his aim was nothing less than to work for the Pope. This
is evident from Corvino's letter which says: "... ne avrà (Ammanati)
poi più bisogno di mezzi con S.S.issima la quale ebbe martello ancora
con meco dello studio del Leonico." Apparently the Pope was involved
in a philosophical debate with Corvino about Leonico and thus not in
a position to lend a receptive ear to his recommendations.

1. "Antonio Zantani Cavalliere," in addition to Benavides,
Alessandro Corvino and Andrea Loredan, is mentioned by Vico (Discorsi
sopra le medaglie de gli antichi, Venice, 1555, 16) as possessing a
collection of ancient medals.

2. Benavides' letter of 1549 (doc. 12) thanks Altoviti for earlier
favors done on Ammanati's behalf, and alludes to earlier correspondence,
now lost. Perhaps this also was directed at the Pope, and coincided
with Ammanati's likely stopover in Florence on the way to Rome, though
it could also have been connected with Ammanati's search for projects
in Florence in 1547.

Cardinal de' Carpi's letter (doc. 9) is a brief and courteous reply to Benavides' letter of recommendation, but it tells us nothing about Ammanati's activity. Corvino's letter is somewhat more informative. He says that he has talked with Cardinal de' Carpi and that they will see to Ammanati's food and lodging ("dimestico"), but still no hints about his possible future sculptural activity.

Corvino was a wealthy Roman whose large collection of ancient sculpture, medals and vases was sold to Cardinal Alessandro Farnese in 1562 for 1000 scudi.[3] Ridolfo Pio, born February 22, 1500, was created Cardinal by Paul III on July 23, 1537.[4] He occupied a position of high favor and responsibility under Paul III and Julius III. Pope Paul frequently appointed him to special commissions, and he was one of seven cardinals who were the Inquisitors General of the Roman Inquisition. He died on May 2, 1564, Deacon of the Sacred College. His family possessed a palace at the Campo dei Fiori, but he reportedly lived in the Palazzo di Firenze before Julius III had Ammanati renovate it for his brother. His collection of antiques was substantial and famous. He owned a villa on the Quirinale, the garden of which, called a "paradise on earth" by Aldrovandi, contained a good number of ancient statues. The smaller objects of this collection -- including bronzes, terracottas, and vases -- were kept in his palace.

[3] R. Lanciani, Storia degli scavi di Roma ..., Rome,1903,II, 162; IV, 71.

[4] G. van Gulik and C. Eubel, Hierarchia Catholica ..., III, 1910, 21, 371; L. von Pastor, Storia degli Papi, XIII, 217, 396 ff, 402, 422. Moroni, Storia Ecclesiastica IX, 109 ff. For Card. de Rodes see van Gulik and Eubel,III, 28, 288.

With the favor of these collectors Ammanati would have had ample
opportunity to deepen his study of ancient art. And in fact, according
to his biographers, this is how he spent much of his time. Borghini[5]
says that when Ammanati came to Rome he "mise a studiare le cose
antiche." Baldinucci[6] adds that in Rome Ammanati "di gran proposito
attese a fare studi dell'antiche architetture: onde pote poi, come
diremo, con suo modello condurre molte maravigliose fabbriche, e
lasciare scritto di sua mano un bellissimo trattato di tale arte."

In the year and three months between November 1548 and February
8, 1550 (the election of Julius III) we know of only one sculptural
project: statues for theater decorations. This allows considerable
time for the study of ancient monuments and theoretical investigations.
Probably it was about the same moment that Ammanati's old friend and
collaborator Battista Franco was also studying antiques in Rome.
According to Vasari Battista "attendeva a disegnare non solo le statue,
ma tutte le cose antiche di quella città, per farne, come fece, un
gran Libro, che fu opera lodevole."[7] Apparently Franco's "Libro" was
a collection of drawings after ancient sculptures, which may have been
intended as models for engravings.[8] There is no evidence that theore-
tical studies were involved. It is less clear what form Ammanati's
studies of ancient art took. What, if any, are the links between

5. Op. cit, 165.

6. Op. cit, 413.

7. Vasari-Milanesi, VI, 583.

8. Cf. Rearick, "Battista Franco," Saggi e Memorie di Storia dell'arte,
 II, 1958, 46 ff.

ancient architecture and Ammanati's treatise on the city? Whatever he
learned, it probably was useful when he built the Nymphaeum at the
Villa Giulia, which was designed to contain a large number of antique
statues, some of which were restored under the supervision of
Ammanati.

According to Vasari,[9] it was while Battista was compiling his
"Libro" that the opportunity came for him and Ammanati to build "una
ricchissima scena ed apparato per recitare comedie di diversi autori"
for Giovannandrea dell'Anguillara. Dell'Anguillara was the head of a
travelling theater company for whom Ammanati had already worked in
Padova three years earlier. The work was for "la scena ed alcune
storie e ornamenti di pitture; le quali condusse Battista con alcune
statue, che fece l'Amannato tanto bene, che ne fu sommamente lodato."
These were set up first in the "maggior sala di Santo Apostolo," but
later, because of the high cost of the production, were forced to move to
the "tempio nuovo di San Biagio." The work included the making of
various sorts of seating for different classes of spectators, including
rooms where high-ranking personages, such as Cardinals, could view the
performances without being seen. Apparently no trace of the project has
turned up. Vasari gives the impression, for what it's worth,[10] that
Ammanati's share was that of providing decorative statues for Battista's
sets.

9. Vasari - Milanesi, VI, 583.

10. An example of Vasari's short-changing of Ammanati is his treatment
of the Paduan works. He mentions (VII, 521) only the Colossus
(erroneously saying it was made from one piece of stone) and the
"sepoltura con molte statue," omitting the arch and the works in Vicenza.

With the election of Pope Julius III on February 8, 1550 Ammanati's dreams of achieving papal recognition began at once to materialize. Says Baldinucci: "per lo medesimo Pontefice Giulio III erasi il nostro Amannato affaticato molto sopra gli ornamenti, che furon fatti in Campidoglio in onor di lui dal Popolo Romano; le quali tutte opere erano tanto piaciute al Papa, che volle, che egli mede-simo nella Sua Vigna fuor della Porta del Popolo facesse la fonta ..."[11] These temporary decorations were apparently those made at Julius' coronation on February 22. With the commission for the del Monte Tombs and the Nymphaeum at the Villa Giulia which followed, Ammanati in fact became chief sculptor in the Pope's service, and was active in an architectural capacity as well.

We should recall that Benavides' Enchiridion, published in 1551 and again in 1553, is dedicated to Julius III. Nor should we forget that the passage where Ammanati is compared to Phidias contains a plea for an enlightened patron to step forth with grand commissions for Ammanati. These lines were not overlooked in humanist circles in Rome. In fact, Ammanati as much as says so when, in a letter of April 25, 1553 (Doc. 14), he writes to Benavides expressly to thank him for citing his Colossus in the Enchiridion. He says, "mi e stato riferto da molti, che in alcuni luoghi parlando ella del Colosso, che io feci nel vostro Cortile, mi ha immortalato nelle sue opere nuovamente stampate, ch' e stato gran favore." Of course, the del Monte commission came to

11.　Op. cit, 414.

Ammanati before the publication of the Enchiridion, but the latter
probably was influential in strengthening his position in artistic
circles and helps to explain his large role in the construction of
the Villa Giulia and the commission of another project dealing with
colossal statuary to be discussed shortly.

After leaving Padova, Ammanati kept up a correspondence with
Benavides which seems to have been rather frequent during Ammanati's
years in Rome. After Ammanati moved to Florence it tapered off, but
they still occasionally exchanged letters, the latest one preserved
being of 1572. In the above cited letter of April 1553 Ammanati men-
tions that "mie lettere ho scritte a V.E. in risposta delle sue." Of
these none of Benavides' have survived and only four of Ammanati's
are preserved, which is probably a small fraction of the total number.
Ammanati wrote to keep Benavides abreast of artistic activities in
Rome, and about his own activity, which Benavides seems to have over-
seen like a stepfather. The fact that Benavides was childless, and
Ammanati left fatherless at an early age, may have strengthened their
intimate bond.

Of the four preserved letters, one is the well known one in
which Ammanati describes the Villa Giulia. Another is of 1572, and
was published by Gaye.[12] The remaining two I publish here for the

12. Gaye, Carteggio, III. The original is preserved in the Correr
Library, Correr Cod. 609, 6, #215 (August 13, 1573 di Firenze). The
letter was also published in Sei Lettere d'illustri Italiani del
secolo XVI ..., Venice, 1853, #6.

first time. The first is that quoted above, of April 1553. The
other, of September 29, 1554 from Rome (doc. 15), concerns a commission
of the Pope's to have Ammanati make a grandiose fountain containing
two colossal statues with horses similar to (or identical with) the
Horse Tamers on the Quirinal. Apparently nothing else is known of
this project. Perhaps Ammanati was to have turned his attention to
it after completing the Villa Giulia Nymphaeum, but the death of the
Pope in the next year prevented its realization.

The role which Benavides played in furthering Ammanati's rising
star at the court of Julius III has been underestimated. It is re-
vealing that the first notice we have that Ammanati is to carve the
del Monte Tombs is found in Vincenzo Borghini's letter of May 28, 1550
to Vasari,[13] in which he says he had learned of it from Benavides in

13. Published in K. Frey, Der Literarische Nachlass Giorgio Vasaris,
Munich, 1923, I, 288, #CXL. On the Chapel see p. 292 ff.

Ammanati was married to Laura Battaferri on April 17, 1550.
Some papers of Laura's father, Giovanni Antonio Battaferri (ASF,
Gesuiti, 1036, 238, n.c.) contain the contract of Laura's dowry and
the interesting item that Laura was "moglie in seconda nozze di Messer
Bartolomeo Ammanati."

By May 28, it is clear that Ammanati has the commission for the
del Monte sculptures (Frey #CXL). On July 23, 1550 he is documented
in Carrara. Frey (293) assumes that the marble arrived in Rome at the
beginning of October. Actually it must have arrived slightly later,
as according to a document (ASF, Gesuiti, 1306, bta. 238, n.c.) the
marble was loaded on boats in Carrara on October 17. However, Ammanati
was already in Rome before October 13, 1550 (Frey letter #CXLII). An
unpublished letter (unknown to Frey) by B. Borgarucci (Doc. 13) from
Rome to Benavides in Padova of September 13, 1550 states that "Lo
Amanati hora no' si trova qui in Roma." Ammanati must have returned
to Rome sometime between September 13 and October 13.

Padova. Vasari says that he himself wanted Raffaelo da Montelupo

to carve the statues and that it was Michelangelo who suggested

Ammanati. The full story is unknown. But in the light of what we

know about Mantova's role in securing Ammanati's Roman patronage,

Vasari's words regarding the del Monte commission take on a ludicrous

ring: "perche avendogli (Ammanati) il Vasari porto amore, lo fece

conoscere al detto Iulio terzo."[14]

 Vasari's account of the del Monte chapel suggests that Ammanati

was an assistant who carried out his designs. Vasari signed the

contract for the chapel and the general outlines of it are recorded in

13. (Cont'd.)

 Ammanati worked on the del Monte sculptures,for roughly two years,
as the chapel is described as "finita" on October 22, 1552 (Frey
#CLXXV), and a date of 1552 is painted on the archivolt of the chapel.
Although payments to Ammanati continued through the summer of 1553,
these may be late payments for work already done, and one need not
assume, as does Frey, that Ammanati was working on the sculptures
through the summer of '53. Moreover, Ammanati's work for the Villa
Giulia must have begun early in 1552. He presented a model of his
project to the Pope at Easter, 1552 (mentioned in a statement of Paolo
Pianetti who worked under Ammanati preserved i n t h e A.S.F.
Gesuiti,vol. 1036, no. 240, n.c.). According to Ammanati's personal
statement (ASF, Cesuiti, vol. 1036, no. 238, n.c.) he worked at the
Villa Giulia "34 mesi ... à tutte dette fabbriche, come architetto,
a ogni bisogno, e anco lavorando di scultura, e rittocando i lavori
à giovani che i vi servivano, si di pietra, come di stucco, e di
marmo, secodo che occurreva ..."

14. Vasari - Milanesi, VII, 521.

his drawing in the Louvre (fig. 271).[15] But the chapel as executed differs in many ways from the Louvre drawing. The rich decorative carvings and polychrome marble in the drawing were later discarded owing to Michelangelo's intervention. The difference between the figures are probably due to Ammanati alone. Ammanati followed Vasari's format for two effigies reclining on sarcophagus lids and two standing allegories of Religion and Justice (figs. 268-69). But he eliminated the bowed sarcophagus lids (which Vasari took over from the Medici Chapel), placed the effigies in more upright poses, and represented them in different clothing. The poses, movements, costumes and attributes of the standing figures differ from the drawing as well. The most important difference is in the figure of Justice. Instead of Vasari's static figure, Ammanati realized a forward-striding one with vigorous contrapuntal rhythms which contrast sharply with the calm pose of Religion opposite her.

15. Regarding Ammanati's work for the del Monte Chapel, what of the "fanciulli tutti tondi ed altri ornamenti di marmo" and the "Giustizia con angeli" cited by Borghini (op. cit, 166)? Baldinucci also cites "alcuni Angioli, e nel balustro certi putti tondi." Baldinucci's explicit distinction between the angels and the putti in the balustrade is probably not sheer invention. Could there be lost pieces once at the high altar, or perhaps two flanking each effigy? The latter arrangement would have been quite similar to the disposition of the four sculptures of the Nari Tomb.

The classicizing elegance, the gently rippling draperies and the
heavy, swelling figural type visible in the del Monte sculptures are
emerging in the sculptures for the triumphal arch, and are present
in pronounced degree already in the Sannazzaro sculptures. The cir-
cular contrapuntal movement of Justice is another variation of one
of Ammanati's favorite themes. What sets the del Monte sculptures
apart from the Padovan arch is a heightened delicacy, sweeter lyricism
and greater surface refinement reminiscent of the Sannazzaro allegories,
which seem attributable in part to Ammanati's use of marble which is
capable of far greater subtlety than Padovan stone. The exceedingly
thin and silky garments, in their delicacy and complex eddyings, are
worthy of Pontormo more than Vasari.

The interest in optical effects noticeable in the Justice is
hardly a new concern for Ammanati. In Rome it takes on new propor-
tions: the attempt to render the palpable movement of air which
flutters the drapery at the feet of the figure. The folds are very
deeply and carefully undercut to catch deep shadow and simulate the
movement of very light, silky garments. The pose of the figure with
upraised left arm is more open than anything yet carved by Ammanati.
Such undercutting and openness would have been a treacherous risk in
Padovan stone which is softer and coarser than marble. The Justice
is yet a further step in Ammanati's recurring interest in transforming
an obdurate block into materials as soft as silk and as intangible as
a breeze of haze. Like many of the other optical effects pursued by
Ammanati, its potentiality in sculpture would be more fully explored

with the arrival of Bernini and the Baroque. The connoisseur of the
sixteenth century would have weighed Ammanati's statues against
ancient sculpture. The sculptor's optical goals in the Justice are
analogous to those of the author of the Victory of Samothrace or the
Niobid Group in the Uffizi, to cite well-known examples of a widespread
preoccupation in Hellenistic art and Roman art inspired by it.[16]
Kriegbaum[17] rightly noted a renewed scrutiny of ancient art on Ammanati's
part, visible primarily in the resemblance of the heads of the alle-
gories to a Praxitelian facial type. He also observed a certain
convergence of Ammanati's aims with those of the style of Vasari and
Salviati being practiced in Rome in the 1540's. He believed that the
del Monte sculptures were an extremely radical break with Ammanati's
previous work because he saw them principally in relation to the
Benavides sculptures, especially the Tomb, rather than Ammanati's entire
early development. His lumping together of the Tomb and the arch ob-
scures the fact that the arch represents a step in the direction of
the works in Rome and Florence; thus the break between these and the
Padovan works is not as sharp as he characterized it. He also erred
gravely in believing that Michelangelo had no significant influence

16. E.g., an ancient statuary group which emerges from this tradition,
probably known by Vasari, is the Nymph with a panther in the Uffizi.
The forward movement and fluttering wind-tossed drapery are reminiscent
of Ammanati's Justice.

17. Op. cit, 93 ff. Kriegbaum (95) assumes that Fabiano del Monte
(on the right) is the earlier of the two effigies because it is closer
to the Paduan works in style. Kriegbaum's perception of the differences
between the effigies is correct, but Borghini says that Cardinal
Antonio and Religion were carved first. In any case Vasari's drawing
suggests that the two tombs were conceived simultaneously. The differ-
ences between them are slight and are due to Ammanati's diversity of
style at any given moment.

on Ammanati before he arrived in Rome and that Ammanati obtained it via
Vasari and Salviati. In fact, many of the characteristics of the style
of Vasari and Salviati of the 1540's -- its imitation of Michelangelo,
Raphael's circle and the antique; its emphasis on sweetness, grace and
richness of detail -- are fully present in the sculptures for the
Sannazzaro Tomb. Ammanati's early works are rooted in the sources of the
Roman style of the '40's itself. This is no doubt in part traceable to
the fact that Ammanati, Vasari and Salviati studied, perhaps together,
under Bandinelli in the mid-1520's. Thus a certain convergence toward
this style in Rome on Ammanati's part can hardly be termed a
"capitulation."

Ammanati's work between the Sannazzaro sculptures and Rome took
him on a different, more complex and variegated stylistic course than
Vasari or Salviati. The distinction which Kriegbaum drew between
the styles of the Padovan Tomb and the del Monte Chapel is a valid one,
but his lack of knowledge of Ammanati's early style led him to infer
that Ammanati's development was linear and progressive rather than
oscillating. When Ammanati arrived in Rome in 1548 he found the styles
of Vasari and Salviati in high favor in papal circles and at the court
in Florence. A highly ambitious sculptor who was just beginning to
find his way into the mainstream of artistic patronage could hardly
ignore the success of Vasari's frescoes in the Cancelleria. To run
counter to this vogue would have been to go against the tide, and
perhaps fall into disfavor. Chiefly the Roman style of the '40's
stimulated Ammanati to accentuate those features of his own early style

which were most consonant with the latest developments in Rome, and
to modify them through fresh study of ancient sculpture, while always
exploring new challenges and new forms. The sculptural forms and
concerns perceptible in the del Monte sculptures tie them strongly
to Ammanati's early work. They seem almost naturalistic and Sanso-
vinesque alongside the rarified and highly conceptual formal world
of the Palazzo Vecchio fountain of the mid-1550's. The shift between
the del Monte Tomb and the fountain is as great if not greater than
that between the Padovan arch and the del Monte Chapel. Thus,
Kriegbaum's notion that the style of the Palazzo Vecchio fountain is
already formed in the del Monte Chapel should be revised. To be sure,
it is in the fountain sculptures that the stylistic aims of the Vasari
circle and Ammanati most closely converge. But even here there are
sharp differences, which cannot be examined here, between Ammanati's
aims and those of Vasari or any other painter. Moreover, the Palazzo
Vecchio fountain is an entirely new step for sixteenth-century
sculpture, however much of it may overlap with the concerns of current
and later painting. As we noted earlier, the optical and formal
concerns of painting and sculpture are not separate, but continually
overlap. Thus analogies between the work of Ammanati and of painters
should not lead us to assume that one is necessarily dependent on the
other.

Chapter 11

CONCLUSION

Ammanati's overall development as exhibited in the preserved works
from the Strozzi Neptune through the del Monte Chapel reflects primarily
the art of Sansovino, Bandinelli, Michelangelo and the antique. In the
Strozzi Neptune all of these influences are detectable. Gradually the
influence of Bandinelli fades (although it never entirely disappears)
and that of Michelangelo grows. Michelangelo's work is constantly
being re-evaluated and transformed within a basically Sansovinesque
style which is characterized on the whole by lyricism and harmony.
Despite consciousness of Michelangelo's art from the beginning, Ammanati's
major study of the New Sacristy, which made a profound impression on him,
probably began only after he completed the Pisa lunette, perhaps in
1535 -- rather than earlier as is suggested by Borghini and Baldinucci.

The influence of Michelangelo takes different forms at different
times. In the earliest work it is Michelangelo's means of obtaining
dynamism and strength which interest the sculptor. Later, in the Nari
Tomb and the Sannazzaro sculptures, Michelangelo's forms and motifs are
incorporated into a classicistic mold characterized by a greater degree
of Sansovinesque melodiousness. Both types of influence are freely
manipulated in later works, e.g., the works executed for Benavides.
During Ammanati's work on Sansovino's Library the influence of
Michelangelo is overshadowed by a resurgence of Sansovino's influence
which reflects current taste in Venice. Despite this Michelangelo's

art was not forgotten, and Ammanati's work exercised considerable influence not only on Sansovino but on Vittoria, Pietro da Salo and other masters who carved spandrel figures for the main facade of the Library. The influence of the New Sacristy emerges more strongly in the sculptures for the Benavides Tomb, where it catalyzed a heightened dynamism and abstraction. In the sculptures for the arch and in Rome, the austerity of the Tomb gives way to more calmness, delicacy and lyricism, a revival of the Sansovinesque qualities of the Sannazzaro sculptures, Ammanati's style approaches the aims of advanced painting in Florence and Rome.

Ammanati's development is not linear and steadily progressive. Rather the sculptor constantly shifts his aims, which affects the sources he uses, and how he uses them. The direction in which he oscillates is affected by the location of his works, the taste of his patrons, his desire for novelty, and other factors and influences which are unknown to us. Formal problems -- problems of rhythm, of contrapuntal, circular and forward movement, of beauty type, of atmosphere, and relation of form to nature, to mention a few -- were always being pondered, and new solutions being formulated. Ingenious and sophisticated invention was always a key aim of his art. He balanced Michelangelo and Sansovino off against one another and elaborated both with the strength of his own imagination, which was **stimulated** by a great many other influences: the antique, Bandinelli, Venetian art, to mention those most clearly identifiable.

Like his mentors, Ammanati was deeply influenced by ancient sculpture in many ways, and occasionally, as with the Paduan <u>Apollo</u> and reliefs, he emulates certain features of it which sculptors before him had ignored. His exploration of movement, textures, light, moisture and atmosphere, though owing much to Venice, is more akin to the interests of Hellenistic sculpture than to any other sculpture before Bernini, and he seems to have been inspired by echoes of it known to him through Roman copies, reliefs, and sarcophagi, though it is difficult to point to his exact sources.

Ammanati's dedication to formal problems, the boldness of his mind and ambitions, the brilliance and originality of his solutions, based on the established authority of the ancients as well as moderns, utterly conquered the heart of Mantova Benavides. Indeed these very qualities were those pursued by Benavides himself in his life and writings. This kinship helps explain the deep bond which arose between the two and persisted as long as they lived, almost as foster father and son.

The self-consciousness of Ammanati's art and his obvious will not to repeat himself predisposed him to be continually receptive to outside influences and led him to develop the capability of selecting from a variety of formal options at a given moment, e.g., with the River Gods for Sansovino's Library, or the architecture of the Benavides Tomb and triumphal arch. This wide latitude of options helps explain why the bronze statues of the Neptune fountain in Florence have been attributed to a variety of other sculptors, despite lack of convincing stylistic evidence.

Overall, as time goes on the sensuousness and naturalism of
Ammanati's earliest works tend to be replaced by greater and greater
abstraction and inflation of the forms. In the early works, e.g.,
the Strozzi Neptune and the Sannazzaro gods, the figures are warm
and human. They seem creations of flesh and blood and impress us as
psychological entities with distinct, if aloof, personalities. As the
abstraction becomes more intense the personality and humanity of the
figures tend to be masked behind an impenetrable veil which becomes
much denser as time goes on. It reaches a phenomenal high point with
the Buoncampagni Tomb at Pisa, where the figures seem encased in a
thick plaster shell. In this tendency, Ammanati participates in a
movement widespread throughout Italy which seems to have been determined
by the direction in which Michelangelo was moving, and which Ammanati
picked up initially from the New Sacristy.

The abstraction merged, and at times conflicted, with Ammanati's
innate love of the irregular, shifting movement of surfaces, like
moonlight on a Venetian canal,which is present in all of his works in
varying degrees. The interest in qualities of liquid, light and air,
while having Florentine roots, was stimulated by Venetian culture.
Sansovino also strove to capture similar Venetian qualities, primarily
in the tribune reliefs and the Sacristy door of S. Marco. But
Ammanati's exploration of it went further than Sansovino or probably
any other sculptor up to this time. Ammanati prepared the way for the
young Vittoria and may even have stimulated Sansovino's deeper explo-
ration of light and atmosphere.

Ammanati's obsession with problems of formal diversity, invention
and novelty was a deeply ingrained outlook which he shared with the
artists of Bandinelli's and his own generation, who awoke to the
brilliant and seemingly matchless formal solutions of Raphael and
Michelangelo.[1] In the attempt to emulate and go beyond these two
masters the formal solutions of many artists became bizarre, rhetori-
cal, artificial and self-conscious. Occasionally, Ammanati's figures
take on rhetorical and exaggerated movements and uncalled-for postures,
as in the reliefs in Padova. But usually the function and spirituality
of Ammanati's figures are an important determinant of their form, as
they were for Sansovino. Ammanati's figures and compositions never
become as rhetorical and artificial as we find them in the work of
Rosso, Bandinelli, Vincenzo de' Rossi, Cellini, Salviati, Vasari and
his pupils. Ammanati is closer in spirit to Vittoria, Titian, Tinto-
retto and Veronese, whose work occasionally borders on excessive formal
rhetoric but never fully embraces it at the expense of squelching
the significance of the spiritual; nor do the narrative or spiritual
become solely a pretext for artful and witty manipulation of forms.
In this respect also, the impact of Sansovino and Venice was a crucial
determining factor for Ammanati's art.

Emotional expressive force and physical strength were often less preferred
than formal inventiveness, melodiousness, delicacy and atmospheric effects.

[1] See J. Shearman's characterization of this generation (Mannerism,
Penguin Books, 1967, 60 ff.).

However, the former qualities are present in considerable degree in the earliest works and reappear in varying degrees in later works, especially the Colossus and the allegories of the Benavides Tomb, and in the bronze sculpture for the Neptune Fountain in Florence. Overall, they hold less interest for the sculptor as time goes on, as the abstraction and inflation of his figures become more intense (e.g., the Pratolino fountain sculptures and the Buoncampagni Tomb.)

The challenge which Ammanati recurringly set for himself was to dissolve the intractability and the rigidity of a block, transposing into stone qualities of the intangible, the impalpable, the very soft and pliable, the transient and the fleeting. This predisposition underlies his exploration of dance-like rhythms (the Leda) and the problem of synthesizing Michelangelesque contrapposto with forward momentum. Here his exploration reached out beyond his sources and toward the Baroque, and lies at the core of his unique contribution to sixteenth-century sculpture.[2a]

[2a]. As a footnote to this unwieldy study I should say a few words about the nature of what I have done, and what might be worth pursuing further. I began with the hope to be able to fully investigate from a documentary, iconographical and stylistic point of view each of Ammanati's sculptural projects through the Vicenza fountain. However, this proved to be a task requiring more labor than anticipated, and I simply put my resources where I thought they would bear most fruit and lead to the most clarification in the time that I had available. Thus the cut off point for each of the projects is in some cases arbitrary and arrived at in medias res In many instances, where major problems are unresolved I have noted so at an appropriate place within the text. As it turned out, the emphasis placed on the sculptures themselves meant in some cases that the role of the architectural environment is not always given its due, as in the case of the Paduan and Vicentine works. The iconography of many works needs additional investigation, particularly the Sannazzaro Tomb, the Gualdo Fountain, and the Benavides works. I entered into the Roman period gingerly, only because some of the documentation I found covering the preceding period extended beyond it, and this chapter is by no means comprehensive in its treatment of Ammanati's Roman activity. It is my hope that Charles Davis of Florence will one day enlighten us more fully about Ammanati's projects

2. (cont'd.)

in Rome, and those subsequent to them. My concentration on Ammanati's projects themselves, their documents and immediate sources, meant that I will not, at this stage investigate their ambient, and weigh them in light of it, as much as I would have liked. The entire work, then, is a kind of interim report on studies in progress more than a comprehensive presentation and evaluation of the man, his art, and its place in sixteenth-century culture. Hence the tendency to avoid generalizing on an abstract level and the sparseness of the concluding chapter.

APPENDIX OF DOCUMENTS

Table of Contents for Appendix of Documents

Document 1

Die primo Julij 1544, indic[tione] 2.

Cum sit et fuerit quod providus vir magister Michael Ferrarius olim
Ioannis antea Ferrarii de Carraria se per scripturam privatam scriptam
manu propria anti mihi obligaverit et solemniter Michaelis promisit
solis et in solidis obligando ad danna, expensis, et interesse et ad
cambium et recambium pro magistro Angelo Maria Ioannis Sixli. Casum
de Torano et Andrea et Baptista fratribus et filiis olim Iacobi
Polline de Casapodio, scoijs dicti magistri Michaelis omnibus, per
quarta parti cuilibet eorum cotingente de conducendo Messina tria
petia marrmorum pro sculpendis figuris per magistrum Bartolomeum
Mannati, sculprum Florentinum, ad instantia illustrissimi ducis Urbini
per totum mensem Iunii. Pro Christo decursi et volentes dicti, magis-
ter Angelus Maria rilevatur in dictionem et pentus sine danno predictum
magistrum Michaelem de omnibus dannii, expensis, et de cambio et
recambio quod dictus magister Michael incurrerit tam personaliter quam
rationaliter vigore et occaxione predictae scipturae privatae in omni
casu quo dicta tria petia marmor non transmitterentur Mesinnam per
totum predictum mensum Iunii. Ideo sic publico intrumento dictus
Angelus Maria, Andrea, et Baptista pro dictis tribus quartis eis
cotingentibus promiserunt et sese simul et quilibet eorum pro sua
quarta parte obligaverint eidem magistro Michaeli presenti stipulanti
et acceptanti e mihi notario Minti uti persone publice presenti et
stip)lanti et acceptanti pro omnibus et singulis quorum interest

intereritque facere, curare, et operare ita et taliter quod dictus

magister Michael neque sui heredes non incurra[n]t neque incurrent

in aliquibus dannis, expensis neque interest neque in aliquo cambio

et recambio occaxione dicte sue obligationis factis ut sint quia ipsi

intendunt transmittere dicta tria petia marmor ad civitatem Messinam

quamprimum iter sit liber et expeditus a Classe et galies Turcorum

speciales quia dicti socii habuerunt scuta triginta auri pro totis

tribus quartis.

(Archivio Notarile di Carrara, LL, f. 139)

Document 2

D̄llo stesso (Fr.[o] Maria Malchiavello). Gli raccda una psa . esi
raccoglie che il Colosso a que' tempi era fatto. 1545. 16. ap. Vic.[a]
Padua, (Bibl. Seminario, Cod. 609, 6, #188).

Document 3

I. M.

Lo scultor fiorentino doveva farmi molto raccomandato a V.E.: et la somma della mia raccomandatione era, che io talmente mi intendevo esserle tenuto; che ne per conto dei beni di fortuna, ne di corpo, ne di animo, mai mi parebbe di poterla satisfare. So ben essi fussero in mia abondevoli cosi come sono tutti tenuti: et quantunque io a lei satisfacessi, essendo ella di natura virtusissima, et che risguarda L'animo altrui solamente; io non però satisfacevo a me stesso: et che finalmente tanto a lei mi raccomandavo, quanta alla molta osservantia che io la portavo, si conveniva. io credo, che egli il facesse perche mi parve molto gentile. Hora s[or] compare io le scrivo questa lettera, perche di man ne ho a fargliene un' altra, che le portava un gentilhuomo Vicentino, il qual va a Vinetia: et voglio che questa sia come un messo innanzi dell' animo mio. perche la E.V. sa bene, che la lettera di raccomandatione, quando colui, che dev esser raccomandato, la porta, sono dubbioso appresso di chi lor riceve; per che egli pense, che il raccomandatone non possa haver di meno fatto di non raccomandare; ma ch forse l' animo suo non saria stato tale. onde io per farmi bon intendere a V.E.: dico cosa non poter essermi fatta piu grata; che il mio scrivere i favor suo voglia: et nessuno ossere piu da bene, et ama piu amico di lui, soltante non di meno fara la E.V. i gliele raccomando adunque di una piccola cosa, picciola dissi; perche non

credo che sara di fatica, ma solamente di vedere delle sue scritturelle
et dirli il parer suo: si come del modo esso le dirà, et di man io
scrivero anchora. egli al ritorno suo da Venetia vuol donare alla
v.Extia una figuretta di bronzo antica assai bella, c͞h e una Diana.
et perche gia io L' hebbi nelle mani, et dissi, che voleva mandare
a mostrare alla V.E., et dissi in offerto di haverglila mandare; sarà
contenta quando egli gliele darà far segno o sorridendo o con altro
atto di haverla veduta anchora. Non ho altro che dirla, se non che la
prego, che longa per cortesia sua qualese volea memoria di me, c͞h cosi
son suo, di vica, ai XXI di Apr. MDXLV.

Franco Maria Malchiavello compare et store.

(Venice, Bibl. Correr, Correr Cod. 1349, #155).

Document 4

Di Geronimo Gualdo. lo p̄ga che voglia p̄mettere a M.r Bartolomeo /
f. Ammanato / che nel tempo che gli avvanza dopo il lavorare (in
casa del Mantoa dove facea una grand' op̄a f. il Colosso) lo lasci
lavorare intorno a due figure di stucco, che doveano collocarsi in
una fontana da esso M.r Bartolomeo fatta. il Gualdo era Canonico, e
in sua casa il suddetto artefice avea lavorato. 1525.[1] 26. ago. di
Vicenza

Padova, Seminario, 619, #171.

[1] This letter, as all those in the Seminario Codex, are eighteenth-
century copies. The date of 1525 makes no sense, and must be a slip
of the pen for 1545.

Document 5

Ad una vra lettera, m. Barto vertuosso, et gentile, molto
amorevole et à nel sopra modo grata feci risposta quanto m'occorreva,
la quale' secondo intendo dal mó Rdo et Ecc.mo mo Zaccaria no' havete
ricevuto il che mi duole perche sò mi havete fino à qui havuto per
iscortese dll ch vi priego veni rimutiate[1], et rendervi cnto, ch le
vostre cose mi sono state sempre care, et in honore, et ch io no hò
mancato per qllo, ch hò potuto farvi conto l'animo mio, et darvi ris-
posta offerendomivi tutto, comi sono stato sempre, come persona ver-
tuosissima ch voi siete, et cosi sò hora di nuovo, et vi priego che in
tutto qllo ch voi[2] vistessi,[3] che io potessi, o giovarvi ò piacervi,
che no mi rispiarmiate in cosa alcuna, ch non potrei haver da voi lor
maggior gratià, et volessi iddio ch la possibilita mia potesse trattenere
quà la vertù et buone qualitadi vostre, ch à questa hora havei in casa
piu d'una opera di vostra mano, ma qllo no posso co' li forze, mi pasco
con l'animo il qle è prontissimo in tutti gli vostri piaceri aspet-
tando occasione, se mai però verrà, che io in parti se non in tutto
possa mostrarvi quanto vi ami, honori, et tenga caro, disiderando ogni
vostro bene, et rallegrarmi d'ogni acquistato honor, che intendo
costa mostrate il valor vostro, et lor vertù acquistata con tanta
fatica, et in parte riconosciuta; le quali cose mi hanno dato non

1. "Venir renunziate?"

2. noi?

3. "Volessi" is probably meant.

piccolo piacere, pregandovi, ch̄ segnifiate la vra Magnanima impresa,

in tanto occorrendo cosa come ho detto, ch̄ io possa per voi no vi paia

fatica farmelo intender, ch̄ farò come se per me proprio havesse à fare,

et se io di qua vedrò nulla ińch'io possa giovarvi, ch potria esser

facil cosa, vene dono aviso. Et qui per no faticarvi sono fine offeren-

domivi, et raccom^{vi} infinitame'te, pregandovi, ch̄ attendiate a star

sano, et amarmi come fate. V. di Firenze alli 27 d'Agosto. 1547.

A Comandi Vostri Luca Martini.

Venice, (Bibl. Correr, Cod. Correr 1349, #121).

Document 6

Di Roberto Maggio Protonotario. Gli scrive che il D.r dell'arme
avea risolto di \bar{n} ptir da Bologna. Esi raccoglie, che fin a \overline{qll} 'anno
il Mantova s'avea fabbricata la sepotura, non che il palazzo 1547 da
Bologna. 20 Sept.

Padua, (Bibl. Seminario, Cod. 609, 6, #175).

Document 7

Al[1] Magnifico Cavaliere (Antonio)[2] Centani suo S. Io son stato dalla infinita cortesia di V. M. Clarissimo Patrone, tanto vinto e hora, e per avanti, che io non so come mai potrò uscire di debito con esso lui contratto, considerando minutissimamente la bella e honorevol faticha sua et del nostro virtuosissimo M. Enea, e le sententiose epistolette che la fa à i lettori, con le vite dei cesari cosa degna certo di loro, e utile al mondo quàto disiderar si possa, e però la ringratio sommamente, e disidero me venga occasione, di poterle mostrare la gratitudine dell'animo mio in recompensa del suo magnanimo e glorioso, Anci che, l'obligo cresce maggiormente havendo inteso che il prefato M. Enea ha dato principio à l'Hercole, cosi la supplico sia contenta sollecitarlo, che si habbi presto perche partendo il nostro M. Bartholomeo, disidera portarlo seco à Roma, si perche è cosa degna da esser vista la dove le nascono ogni giorno, si etiandio perche è persona da satisfare tanto suiscerato dalla bontà virtuosa di V. M. e di Enea nostro, quanto di signor che conosca ne di questo la potemo ambedui piu pregare.

 (Benavides, Lettere di famigliari diverse, op. cit, #39.)

[1] A manuscript copy of the original is in Marciana Cl. It. 6606, c. 38, but unfortunately it does not bear a date. If Ammanati took Vico's drawing to Rome, which seems likely, the letter should date shortly before October 16, 1548.

[2] "Antonio" is written in an old hand in the volume in the Marciana Library.

.

Document 8

Allo Illustrissimo Cardinal Carpi suo Signore. Questo è quel
scultore che ha fatto cose assai in casa nostra, Mons. Reverediss.
degno del la gratia & protettione di V.S. Illustrissima mecenate et
Padre de gli huomini virtituosi et eccellenti, nel numero de quali
veramente egli si puo connumerare, et ampia fede, ne potrà far Monsig-
nore Reverendissimo di Rodes, che ha vedute l'opere sue, per tanto
amandolo come io l'amo, et essendo io anticho servitor di V.S.Illus-
trissima lo ho voluto inviare à quella supplicandola, per amor mio, et
per il valor suo, che li faccia quel favore che merita la virtu sua, et
la divota servitu mia, et di tanto tempo, che oltre che farà cosa degna
di se colocarà favore in tal soggetto, che certo à niun tempo se ne
potrà pentire, et egli ne girà altiero di havere un tale et tanto fau-
tore, ne credo che mi trovarà haver detto se non il vero, et forse
manco di quel che è & che si puo disiderare in un scultore quale è
questo nostro M. Bartholomeo Amannati Fiorentino, che cosi si domanda.
Non altro se non che inchinevole mi raccommando à V.S. Illustrissima
et supplicola del suo servitore tal volta sia ricordevole, che osservo
sempre et che esserva la infinita humanita amorevolezza & cortesia sua.

(Lettere di famigliari diverse, #35. A copy is in Marciana Cl. It.
6606 #34 with crossed out date "Di Padoa la de XVI di ottob. MDXLVIII.)

Document 9

Mag.^{co} et Eccto S.^r Marco mio, io confesso aver obligo a M.^r
Bartolomeo Amanato Scultore, pchè è stato causa che io ho avuto lre
di V.E. quale amando, e avendo semp' amato cō tutto il cuore grandiss^o
piacer ricevo q̄lo intendo nuova di lei, onde ne la ringrazio, et al
prefato M.^r Bart.^o io non son p̄¹ di far sp̄re ogni cosa, ch'io possa
a beneficio suo, si pchè le virtù e buone qualità suo p̄ sestesse
meritano esser agiutate, e sollevate, come p̄ la raccomandazion, che
voi me fate con la l̄ra v̄ra, alla quale io non dirò altro di più , se
non ch'io son tutto vostro al solito, e desidero occas.^e fa voi s̄pe
piacere. Di Roma alli XX di Decembre MDXLVIII. Tutto di V.E. il

Cardinal de Carpi

(Padua, Bibl. Seminario, Cod. 609, 6, #3).

1. This abbreviation is not clear. It seems to be a sloppy "p̄"

Document 10

(Oct. 16, 1548 in Padova)[1] Allo Illustrissimo Cardinal di Rodes

suo S. Sendo V.S. Illustrissima Mecenate, et Padre, de i virtuosi,

& di quegli massimamente che hanno qualche eccellentia in se, non mi

ha parso macare di questo ufficio, in dirizarli il lator della presente,

qual è molto eccellente nella scoltura, & ha fatto qui in casa nostra,

assai opere degne e parte ne ha vedute V.S. Illustrissima per tanto la

supplico sia contenta servirsi di lui in cosa che la conosca, potersi

valere, e oltre cio amarlo, e favorirlo che certo è suggetto degno da

esser da amato & favorito dallei, e tanto piu che disidera li venga

occasione di poter mostrare la virtu sua, qual cosa non puo essere,

senza l'aiuto & favor suo, qual al lui e à me servitor suo, farà tanto

piu grato e caro quanto che egli il vedrà con gli effetti, et io cono-

scerò le mie raccommandationi esser state di qualche peso appresso lei.

alla quale inchinevole mi raccommando.

(Marco Mantova Benavides, Lettere di Famigliari Diverse, Padova,

1587, #31).

1. No date accompanies this letter as for most of those in this
publication. However, a copy of the original is preserved in Marciana
Cl. It. 6606, c. 30 where a crossed-out date is still legible.

Document 11

Al Mto Mco etc.

M.r Bartolomeo è capitato in Roma, et io già l'amo, et amero qto

debbo, e p̄ le sue virtu', e p̄ le raccomandazioni, che V.E. mi fece

con la sua lr̄a già scritta son due mesi, alla q̄l̄ē n̄ ho risposto prima,

p̄chè mi fu data tardi e fuor di Roma, et in essa mi dicea, che tosto

sarebbe venuto, ho indugiato a posto p̄ poterla in un stesso tempo

ringraziar del favore, che mi fece scrivendo, e di qŭo, che ricevo ora,

conoscendo un cosi raro, e gentil spirito come è qŭo, al qle n̄ mancherò

di fare q̄t̄o faria p̄ me stesso, e più, se più saperò o potrò con le mie

deboli forze. Q̄do la sua mi fudata io era in Campagna, e la mostrai

subito allo illm̄o Cardinal de Carpi, d̄l̄ q̄l̄ē in essa ragione, a cui fu

cariss.o intendere qto mi scrivea, et ora ne ha veduto mt̄o volentieri

M. Bartolomeo q̇ɫ farò tosto tanto suo dimestico, che n̄ avra poi più

bisogno di mezzi con S.S. issma, la qɫe ebbe martello ancora con meco

dello studio del leonico, che dio p̄doni a chi ne fu cagione, che certo

ne ho tanta doglia q̄l̄o se uscisse di Roma, et ancor spero di venire a

godere q̇ɫche tempo a Pad.a, qɫe amo glo la patria, e le sono obbligato

p̄ mti rispetti e massime p̄ le cortesie di continuo usate al mio gallo,[1]

o piuttosto a me stesso, che io posso dire che sia un me medesimo, et

anco p̄ li favori che mi fa, tenendo cosi dolce memoria come tiene di

me, scrivendomi talvolta, ch'io mene tengo un poco superbo, et altiro, e

[1]. The first letter of this word is unclear.

me ne gloria fra me stesso. La promessa piacque al Carde dico $\overline{q1o}$
al venire a Roma l'anno \overline{s}to, ma \overline{p} starvi un pezzo. E s'io avero`
potuto aspettar fin allora, che no credo, faro` poi compagnia a lei
verso Padova, ma piuttosto credo q\overline{t} ch'io desidero, cioe` ch' io la
condurro` lei allora a Roma. So \overline{p}go \overline{ap}po mi ra\overline{cc}di ad \overline{nro} ec\overline{c}mo Cavino,
e la dica se vuole, che li mandi la propria medagla $\overline{d1a}$ $\overline{q1e}$ gli mandai
quei soldi, che gliele mandero`, accio` possa meglio ritrarla, e sodis-
farsi. Non altro se \overline{n} che a lei mi \overline{r}acco senza fine. lo di 17 \overline{nb}re
1548. in Roma.

di v.e. S.re Alessandro Corvino

(Padua, Seminario 609, 6, #105)

Document 12

Al Reverendissimo Altoviti archivescovo di Firenze sua S. Hammi

scrito, Monsignor mio Reverendissimo M. Bartolomeo Amannati nostro,

le amorevoli accoglienze che V.S. gli ha fatte, e le larghe offerte,

che gli fa di continuo, usando li pur cortesia infinita, la qual cosa

mi e stata tanto grata, e di tanta satisfattione, nell'animo quant' altra

che da me si havesse potuta disiderare à questi giorni perche nel vero

è soggetto grande e degno, e merta d'esser amato e favorito da ogn'uno,

e massimamente da patroni tali, qual ella ne è , e quale ne è stata,

sempre con esso lui; ne ha mancato anchora di ufficio lo Illustrissimo

Carpi, si come mi e stato scritto, e da esso Monsignore à punto, del

che la humanità dell'uno et l'altro considerando, et una cosi fatta

demostratione colma di affetto, resto stupido e pieno di maraviglia,

e confesso ingenuamente, haver loro tanto obligo, quanto haver deve,

un animo grato à servigio di grande. Una sola cosa mi duole, e preme,

che non habbia veduto l'archo che egli ha fatto, come que' di Roma ò

la sepoltura qui nella chiesa vicina, overo il colosso, che ciascuna

de se sola è tale che da odore al mondo che costui habbia di gran

lunga à superare ogn'altro scultore famoso e chiaro, se Dio gli presta

vita qual che anno, e che non gli manchi occasione, e ne fa fede questo

solo, che egli sia tale, non essendo stato fatto colosso alcuno fin

hora da gli antiqui in quà se non da costui, con tanto artificio poi

che è una maraviglia, alto venticinq; piedi, e di otto pezzi, come

gia scrissi à V.S. Reverendissima tanto ben accozzati, & congiunti

insieme, che niente ha lassato che si possa disiderare nell'arte anci
che da maraviglia, à cui lo riguarda in questo cortile, ne si può dar
pace il genga, del Duca d'Urbino, il Palladio, il Sansovino, e gli
altri di questo Maestro, e cosi giovane che sia riuscito in cosi
grande impresa, senza l'altre cose che egli ha fatte, e piu le dico,
che il Cardinal di Rodes che passo di qui, e Hannibao, non si potean
satiare di mirarlo. Et però supplico V.S. Reverendissima un' altra
volta non li manchi, che il favore che ella gli farà sarà molto ben
collocato, e in un soggetto tale brevemente, che le farà honore, sia
pur la impresa ardua et difficile quanto si voglia ne dubito punto.
Non altro se non che io disidero mi conservi nella gratia sua, et
allei inchinevole fra questo mi racommando.[1]

 (Benavides, Lettere di famigliari diverse, #37).

[1] A copy of the original is #36 of Marciana Cod. Cl. It. 6606,
which bears a date of Feb. 4, 1549, Padua. Part of the letter was
first published by Rossetti, op. cit, 1776, 342, and often cited since.

Document 13

Ecc.mo Sor mio.

Non ho possuto dar resposta piu presto alla di V.E. datami a questi
di da m. Gio'ant.o Battiferro suocero de lo Amanati per no - lhaver
havuta in tempo et prima che partisse la posta passata, hora per
questa respondo a quãto occorre all' ecc.te. m. Franc.o Saxonia per l'
offitio ch' egli desiderava no s' e' possuto far per l'absentia del R.mo
Cornaro, si come piu apieno li scrivo nell' all'gata, et quando egli si
risolva che l si proceda di ragione in tal suo negotio mandandomi le
scritture necessarie no mancato io di essequir quãto sia di besogno,
trovomi anco haver' una causa cõtro esso R.mo intimata Brixien' pensionqs
et^{1} tuttavia procedo alla executione, si che a servigio del saxonia faro
io il medesimo et volentieri senz' un respetto al modo, satisfaccisi
mo' lui di quãto li torna co' modo. Altro nò ho che dir occorrendo
ch' V.E. per l'avenire me scriva potra indirezare le sue lrẽ a me
drieto a San Biagio presso al Baccodi dove habito, percioche lo
Amanati hora no' si trova qui in Roma. et có questo faro fine raccomãdã
domi all' E.V. alli ecc.ti m. Gioandreo, e.m. Piero, a Madona et a m.
Gianetto, de qui nò havemo nuova alcuna. Di Roma alli 13 di Settembre
1550.

Deditiss.o B. Borgarucci v.e.

(Venice Bibl. Correr, Cod. Correr 1349, #160).

1. "Che?"

Document 14

Al Mto' Magnifico ed Eccell.^te Sig.^r Marco Mantova, mio sempre'
osservandissimo.

Mtō Eccell.^te Sig.^r Mio Molte mie lettere ho scritte a V.E. in
risposta delle sue, nè ho poi novella avuta del riceverle. ora di
nuovo le scrivo, e le dico ch'io del continuo son memore e ricordevole
di lei, e di tutta la nobil casa sua, dalla quali io ho ricevuti tanti
e tanti beneficj; ed appresso, che le son perpetuo, ed amorevole
servitore, pregando sempre Iddio che mi porga occasione, acciocché io
le possa dimostrare in parte la servitù, e divozione mia; e massime,
siccome m' è stato riferto da molti, che in alcuni luoghi parlando
ella del Colosso, ch' io feci nel vostro Cortile, mi ha immortalato
nelle sue opere nuovamente stampate; ch' è stato gran favore; avveg-
nachè io non sia degno, a che mi attribuisca più di quel che mi si
conviene. del che però confesso averlene obbligo infinito; e le rendo
di tanto dono grazie immortali. Mi rallegro sommamente anco, sentendo
da alcuni dire, che disegna sviluppata dalle onorevoli imprese di
costì, venirsene un poco a goder la felicità di Roma. il che io, come
il più affezionato servitore, ch'ella abbia al mondo, desiderei bramo;
pregando Dio che ciò sia con contento e onor suo. Alla quale, quanto
più so e posso, con ogni umiltà bacio la mano, e mi raccomando. Di
Roma à 25 d' Aprile. 1553.

Di V. e. Servitore

Bartolommeo Ammanati

Florentino, e Scultore

(Padua, Seminario, 609, #225)

Document 15

Di Barteo Ammannati Scultore Fiorentino; scrive al Mantoa che vi trova in Roma ove ' \bar{p} comiss.e del Papa dovea, fare due colossi con due cavalli \overline{sli}^1 alle statue di Fidia,e di Praxitele poste in M.e Cavallo; da porsi in una fontana. R.a 29 \bar{S}bre 1554.

(Padua,Seminario, Cod. 609, 6, #200)

1. "Simili" probably. However, the first letter of the abbreviation is unclear.

Document 16

Andando per direttura per mezzo via il Giardino fuori p(iede)
12: si vede avanti una grotta, tutta piena di ingani di acqua, dentro
la quale si entra per tre portone alte p. 9 larghe 6. Questa grotta,
o fontana è fatta fina al mezzo di belle, a grosse pietre alla rustica,
o a' grottesche, con due niche pure a grottesche, uno per parti alla
porta di mezzo, che sta àl Levante, ne' quale vi sono due mezze figurone
di pietra, come di due Dieta maschio e femina, quella alla destra dell'
usciti geta acqua dalla bocca, sotto le bracce, et altorno il nichio, e
cosi l'altra dalle mamele et altri luoghi, come il primo. Questa acqua
cade in due vase di giro di p. 5 nel mezzo di quale esce due spiti belli
di acqua altissimi, molti vaghi. Dentro la detta loggia[1] in faccia le
porte di mezzo, vi è un nichio pure della grandezza della porta sudetta
dentro il quale vi è (un) vaso alto da terra poco piu di un piede,
profondo quatro, e di giro di X p. o piu per capire l'acqua di quel
nichio, dentro il quale, sopra certe conchiglie naturale di smisurata
grandezza, sta un Satiro, o Dio Marino per la coda, e le squami, che
geta l'acqua, come da una urna, e fra le gambe piu spinelli c' cobbe
il nichio tutto.

Et compartita tutta la grotta in otto equali spatij con il
preditto, e le tre porte, et è ovato tutto il corpo della detta, ne'
quatro spatij che ristano a d u e, v i s o n o d i p i e t r a

[1]. "Grotta" rather than "loggia" must be meant here.

quatro bancheti da sedere, tenute da tre piedi fatti il tutto a ponta
di scarpelo per imitare il rozzo et è incrostata tutta, con il volta
a scaglie di piu colori, che fano come una capa, et in mezza un ovado
pure di p. 5 in circa, con la impresa solita del delfino, e galana
avitichiati per le code, e sono cosi minutamente conussi che si vedono
le delineamenti delli due animale per -- le. Il selizato c' fatto poi
di cogoli bianchi, e rari (neri?) nel modo del volto, e nel mezzo la
stessa impresa ma di pietra intagliata, e' cosi le quatro facciati de'
muri sono di scaghi minuti fatti a piu forme vaghi di mandoli, o cape,
per li quali tutti scaglie, e gogoli, e pietri escono spiriteli di rame,
et anco piombo sotilissimi, che portano fuori aqua con ingano chi vi
entra.

Questa fonte ha le sue chiavi in quatro, o cinque lochi. E di
sopra via vi sono tre gran finistroni, come le porte da basso, e sei
fenestre quadre, sopra le quale vi sono sei tondi, e dentro quelli tanti
mascheroni di stucco, e tra l'una finestra, e l'altra tante arpie,
come dei terminali, nell' architrave, che è fra li sudetti tondi, e
fenestre quadri, vi stano scolpiti lettere grande di sei oncia cosi.

> HIERONYMVS GVALDVS COM:VIC:ET PR:AP.P.
> GENIO, ET LYMPHIS, CAMOENISQ:DICAVIT.
> ANNODOM: MDXLVI.

Nella somità avanti cominci il volto; vi è una cornice con due
canoni di rame, che porta via l'acqua del volto, quali è tutto coperto
di lastri de' piombo, e nella somita un vaso alto circa p. 5. e tutta
la detta fonte è alta circa p. 50, e venti per ogni via delle quatro
facciate; si ascendi a questo per due scalli di pietri longo il muro

della misiricordia, che e un ospitali di Giovanne ben educati, per
di quelli finestri quadri, che servano per porte, dal mezzo in giu
queste fonte e cornisato d edera con le suoi volti, e perfili. Fu
questa fonte opera dell' eccelente architeto Bartholameo Ammanati
Fiorentino.[2]

(Giralamo Gualdo, Raccolta delle inscritioni, cossi antiche come
moderne, quadri e piture, statue, bronzi, marmi, medaglie, gemme,
minere, animali, petriti, libri, instrumentj mathematiche, si trovano
in Pusterla nella casa, et Horti, chi sono di me Giralamo de Gualdo ...
MDCXLIII nel mese di Decembre 27.

Venice, Bibl. Marciana, ms. Cl. It. 5013, c. 10-11).[3]

[2] I wish to thank Dott. Fernando Bandini of the University of
Padova for his kind assistance in transcribing the manuscript.

[3] Recently it has come to my attention that Prof. Lionello Puppi
of the University of Padua has published the entire manuscript of
which the parts concerning Ammanati's fountain have been excerpted here,
but I have not been able to obtain a copy of his publication.

Document 17

Si entra in questa fonte via tre porte formate alla rustica, con bella incrostatura; si ascende per due scalli di pietra con comodo sotto a mezzo, e sotto vi sono nei volti alcuni uccelieri, corrispondente a quelli che sono nell' entrare[1] del giardino sotto il corridore, che unisca le due case; sopra vi sta una loggia, che sta sopra all'ovato della grotta di sotto, dove sono gli ingana dell' acqua; attorno per fori, vi sono tre finistrone a volto, et sei altre finistre quadri, compresi le porte delle scalle, seperati l'una dall' altra di tanti termini di stucchi, che sustendano la cornice, et la volta di piombo sulla cima della quale sta un bel vaso. Sopra le finestre quadre sono altri tanti tondi, con certi mascheroni molto degni, e l'altezza di queste fonte è cerca piedi 36. Nell'entrare di questa fonte si trovano due mezze statue in pietra, e gettano acqua; et in un nicchio un satiro, pure che geta acqua si come il lastriccato, la testudine et li muri tutto sono pieni d'ingani in quel tempo di molte ammirazione. Questa fonte, come cosa nova, fu stimata assai, egli furono appliccati molti versi, e vano alle stampe; e la troverano sappia (?) gli fu scolpito a chi fossi dedicata cioè al Genio, alle Linfi, et alle Camine ninfe bellissime.

(Giralamo Gualdo, Giardino da Cha Gualdo cioe raccolta de pittori, scultori Diccato Dal Co: Giralamo Gualdo Vicentino ..., 1650. Venice, Bibl. Marciana, ms. Cl. It. 5102, 3, C. 46-47[2]).

1. Or perhaps "entrate".

2. The differences between my transcriptions of ms. 5102 and those published by Morsolin are probably due to errors made when the original

2. (Cont'd.)

5102 in the Marciana was copied in 1830. This copy, now in the Biblioteca Bertoliana in Vicenza, was the version published by Morsolin (see Morsolin, _Museo Gualdo_, 19).

Document 18

Et per accrescer al giardino bellezza straordinaria vi fece una
bellissima anzi alquanto bellissime fontane artificiose con molti
inganni per bagnare et huomini et donne all'improviso, et questa fu
la prima che fosse veduta in questi paesi havendo egli portato la
foggia da Roma e da Napoli, sopra la qual fece una bellissima loggia
con un moto che deceva Genio et Limphis. Piacque tanto questo non più
veduta maniera di scherzare d'acqua le tutti li poeti di queste con-
trade si posero a poeteggiare e volgarmente i latinamente in lode di
questa nuova fonte, siccome pure egli stesso compose sopra quella
bellissime compositioni che si veggono stampate nel suo libro di Rime.
La bellezza e vaghezza di questo luogo, che al'hora in Vicenza non
v'era il più riguardevole allettava ad andare a vederlo non solo i
gentilhuomini e gentildonne della città, ma non compariva fostiero
alcuno che non fosse condotto a goder un luogo in quei tempi così nobile
e delicioso.

("Articolo di autore anonimo inserito dal P. Barbarano nel suo
MS intitolato Selva Vicentina." Source as doc. 17 c. 321).

Document 19

Da questi portici, e cortillo si passa in' un giardino, nel
mezzo del quale sta una fonti di due ordine rustico a basso, e composto
(i.e. composito) di sopra, copirta di piombo, che in molti, e varie
forme spruzza acqua, fra quali un satiro, e due altre dietate; fu
dedicata dal Giralamo Conti al Genio et alle Ninfe, e con due altre,
ma[1] picoli, fu opera del valoroso Bartholomeo Ammanato Fiorentino.
Vi ha aggiunto il Padrone altre Fontane in piu maniere per abbellimento
del loco.

Description by Nicolo Basilio ["Il Siciliano"] dated August 1649
Source as doc. 17, n.c.

[1]. This word is not entirely clear. The only likely alternative
would be "più."

Document 20

Tutto questo Orto è compartito in quatro quadroni(,) tre uno dietro

l'altro et il quarto sopra il terzo, e queste due benche unite, e di

qualche de litra sono cultivate ad utile (,) gli altre à fiori, nel

mezzo de quali, sono poste due fontane, chiamate da noi anco Pile(.)

Queste sono sopra due Piedi fatti di intaglie bellissimi e sostengono

due ovade di giro di P. otto alti 5 ne quale cade l'acqua che usce vi

due vasi sopra l'uno di quale li sta la fama col'alle, et una tromba

nelle mane, l'altra alla basa per sonare(.) Sopra l'altro vaso sta

il tempo con l'orologio e la falce paramente all'altre fatte dal Sici-

liano, nel piedi di una di questi fonti sta impresso:

<div style="text-align:center">

HIERONIMVS GVALDVS CO: V: HORTVM
HVNC IN SOLATIVM SVI ANIMI APER.
ANNO DO: MDXLVI

</div>

(Source as doc. 16, p. 16).

Document 21

Nascon piu fonti in questa parte, e in quella

 Pieni di meraviglia, e di virtute,

 Caldi, freddi, qual danno, e qual salute,

 Che morte arreca, e chi s'oppone ad ella.

Spenge uno, e poi raccende ogni facella,

 D'un altro l'acqua da che s'han bevute

 Inebrian, d'altri il proprio è che gl'immute

 E'l bianco, e'l nero, ond'huom si rinovella;

Quel regge il ferro, od altre cose gravi,

 In quell' altro la paglia si profonda

 Evi chi legno e foglie impetra, e indura;

Ma più mirande son l'acqua soavi

 Del fonte ch'l giardin adorna, e inonda

 Che 'è fatto ad arte, e vince essa natura.[1]

(Giralamo Gualdo, *Rime*, Venice, 1569, 28r)

[1] This poem is more concretely descriptive of the grotto than
the others, and provides clues to the program of the fountain. Pre-
sumably by "several fountains hidden here and there" Gualdo refers to
the grotto rather than the garden as a whole. Figures "getting drunk"
suggest the large satyr in the rear niche. Carved "wood and leaf"
we could expect to find in the grotto. But what figure "holds iron,
or other heavy things" and where is the "straw deep?" The latter might
suggest a lair of a faun or nymph in one of the niches. Hot and cold
water sources which give death and harm are mentioned, in addition to
"the white and the black, where man renews himself." In another poem
(doc. 23) Gualdo mentions "Nymphs which come here (to the fountain)
to play, and behind and in front of them, little putti squirt,
playing." "T h e three graces and the divine Venus have come to rest
at the birth of the fountain," and the "cornucopia of the goat Amalthea"
s p r a y s the garden. Which, if any, of these are actually part
Ammanati's work? Or are they metaphors only? At least the three graces
and Venus would seem to fall into the latter category. The Nymphs and

1. (Cont'd.)

putti might also derive from literary imagery.

In another poem (doc. 28) the Graces, Muses, and Apollo are involved as protectors of the fountain, but figuratively rather than descriptively, one would think. The rustic aspect of the imagery (a satyr occupies a focal point of the grotto) is in keeping with Vasari's notion of what is appropriate to a grotto.

Document 22

Quanto più à dir del fonte rime spargo
 Ove se stessa l'arte vincer volse
 Et à Natura il vero pregio tolse,
 Entro in mar sempre più profondo, e largo;
Da pietre, terra, legni, esce, e dal margo
 Del vaso acqua, che spesso accoglie; e colse,
 Ben cauti, nè alcun mai però si dolse
 Ch'à schivar lei non bastan gli occhi d'Argo;
Poggià gentil, che senza oscuro nembo
 Da luoghi occulti con si dolci inganni
 Empi bagnando altrui di grato horrore,
Se in treccia bionda, ò sovra ricco lembo
 Di Donne cadì, habbia felici gli anni,
 Nè provi in se se non cortese amori.

(Gualdo, Rime, 30)

Document 23

Ridon nel bel giardino hor l'herbe, e i fiori,
 L'hedere, i lauri, e l'altre gentil piante,
 Poscia ch'è nato il fonte che con tante
 Lodi ciascun che'l mira, par c'honori;
Più non può con gli ardenti suoi fervori
 Nocerli il caldo Sol, le Ninfe, sante
 Vengonvi a schiere, e lor dietro, e inante
 Spruzzan scherzando i pargolette amori;
Con le tre Gratie l'alma Citherea
 al nascer de la fonte quì si pose
 che più bel loco elegger non sapea;
Cosi in gran copie il corno d'Amalthea
 Sparga il verde terren de gigli, e rose,
 Nè manchin l'acqua à le caverne ombrose.

(Gualdo, Rime, 28)

Document 24

A l percuoter col piè del gran cavallo
 Che per l'aria portò Bellerofonte,
 Nacque quel saccro, e glorioso fonte
 Che Febo honora, e tutto'l mondo sallo;
Per fuggir Aretusa e biasmo, e fallo
 Cangiò in freddo liquor sua bella fronte,
 E'l famigliar di Dio trasse del monte
 Col fatal verga l'humido christallo;
Cose tutte stupende, e che la meta,
 E l'ordine trappassan di Natura.
 Ma che non può chi potea lei formare?
Hor qui non Pegaseo, Ninfa, o Profeta
 Spargon tra questi sassi l'onda pura,
 Ma sol d'umana industria opre alte, e rare.

(Gualdo, *Rime*, 28r)

Document 25

Fra verd'edera errante, e di fiori piena
 V'l'api sussurrando d'ogni intorno
 Fanno pascendo il di grato soggiorno,
 Quasi in piaggia d'un colle aprica, amena;
D'horride pietra, e non si crede à pena
 Risorgon l'acqua che'l giardin' adorna
 Bagnano si, che quivi havrebbe scorno
 Qual si vuol rio di piu abondante vena;
Tacciano homai di Ciane sparsi, honori,
 E de la fonte in cui Diana stando
 Trasformò in cervo il misero Ateone,
E sian celebri hor questi sacri humori,
 Che san dolce tra sassi mormorando
 Rinverdir l'herbe per ogni stagione.

(Gualdo, Rime, 29)

Document 26

Fresc' herbe, lieti fior, schietti arboscelli,
 Ch'entro e d'intorno il giardin vago ornate,
 Quanta invidia m'accorgo hora portate
 a bei nati fra voi nuovi ruscelli;
Gia foste soli in pregio, hoggi son quelli,
 sol l'alte meraviglie son mirate
 Del chiaro fonte, e non è chi voi quate
 Si le bellezze lor vi san men belli;
Ma non ven' cagliano, che'l stesso humore
 C'har si v'offende, e par c'habbiate à schivo,
 V'accrescerà virtù, vaghezza, odore;
Perche sendo in voi il bel mai sempre vivo
 con le lodi del pari andrà il favore,
 cosi vi giuro, e cosi in carte il scrivo.

(Gualdo, Rime, 29)

Document 27

L'altro Motor, che le superne ruote
 Volgendo à gli elementi sempre intorno,
 Rende de vari effetti il mondo adorno,
 Come colui ebe solo il tutto puote;
L'anima impressa di mirabil note
 Di lui, perch' à lui poi faccia ritorno,
 Move ad oprar in questo fral soggiorno
 Cose, che mai non fien di fama vuote,
Onde s'alcun del Nobil Magistero
 Si meraviglia de la nova fonte,
 Quasi opra che qua giù non trovi pare,
 Ne dice più non fù Giano bifronte

(Gualdo, Rime, 30)

Document 28

Ne la passata mia più verde etade

Mentre mi tenne Amor dentro al suo Regno,

Destar solea l'adormentato ingegno

D'aspra Donna à cantar l'alta beltade;

Ma p oiche la perduta libertade

Racquistai, tacqui; Hor pur di novo io vegno

a dir il mio ben, la mia felicitade;

Sol canterò l'adorno, e bel lavoro

Del novo fonte, a cui consente il cielo

Tutte le Gratie, e di Parnaso il Choro;

Ne'l giardin tema più d'horrido gelo.

Poscia che inserto del'amato alloro

L'hà preso in guardia il gran Signor di Delo.[1]

(Gualdo, Rime, 28)

[1.] Two other sonnets referring to the Hippocrene, probably also inspired by Ammanati's fountain, are on p. 29.

APPENDIX 2

RECONSTRUCTION OF THE GUALDO FOUNTAIN

(See Reconstruction Drawn by Slobodan Ćurčić, Plate I)

One should bear in mind that the measurements provided by Gualdo
are probably estimates. In several cases he himself specifies "in
cerca." This allows a certain latitude in any reconstruction. The
paucity of dimensions for many crucial parts and ambiguities of the
wording make it impossible for any reconstruction to be definitive.

1) Although the descriptions do not explicitly state it, we should
assume that the rear wall (facing West) of the fountain, like the
staircases, abutted the wall of the church, which probably closed off
the rear of the garden on either side. Because it abutted the church,
we know that the rear wall of the grotto had no door,[1] and we can assume
that the rear wall of the loggia was also closed. Thus the 3 large
openings and the 6 smaller ones can be conviently fitted into three open
faces, two smaller ones flanking a larger one in each face.

[1] The height of the present flank of the Church of the Misericordia
I estimate to be about 10 1/3 meters. The fountain rose about 11 meters
(36.6 American feet) to the summit of the loggia vault, which would
necessitate a closed rear face in the loggia.

Today ivy has overgrown a large area of the Church wall and it is
not possible to examine its surface for marking or holes which would
provide an idea of the fountain's location. Another means would be to
enter the Church, presently closed, to determine if the windows which
run along its flank were closed off when the fountain was erected.

The 3 large openings of the loggia were in some way like the grotto doors. I would suggest this might indicate roughly equal widths. If we assume this, given about 1 1/2 feet for the piers, the flanking openings must be slightly less wide. This conforms with the given fact that the rectangular openings are smaller than the three round-headed ones ("a volto"). Thus each face of the loggia would resemble the scheme of loggia III at the Villa Giulia (at the rear of the Nymphaeum).

2) Staircases "con comodo sotto a mezzo, e sotto vi sono nei volti alcuni uccelieri" (my emphasis). This "sotto" is somewhat confusing. Can it mean that the landing has a roof or vault? Probably not. More likely "comodo" is to be associated with "uccelieri," and the staircases were entirely open, and under the landings were deep niches, screened in and containing song birds.

The text mentions that the uccelieri were like those under the corridore at the opposite end of the garden. However this corridore is destroyed, so no help regarding size can be gathered from that.

3) The inscription, according to my calculations, should be around the three faces as follows, two sections per face placed over the rectangular openings: HIERONYMVS GVALDVS / COM:ET PR:AP.P. / GENIO, ET LYMPHIS/CAMOENISQ:DICAVIT/ANNODOM:/MDXLVI. Probably it read from left (south) to right.

4) The size of the tondi? Probably their diameter is a ratio or fraction of the width of the round-headed arch, but we can only surmise as to how much. The masks were probably over life size, thus the tondi including frame might have been at least 1 1/2 Vicentine feet.

5) The form of the vault of the loggia from the exterior is something
of a problem. Since it merits description in the two major texts, one
is inclined to credit it with some visual importance. If it was
saucer-shaped as in plate 1 , which I think is most likely, it would
echo the form of the grotto as well as two additional free-standing
fountains with oval basins elsewhere in the garden also built by
Ammannati. This form would be the more usual form of vault t o
carry lead slabs.

As for the ground plan, knowing the size of the square (20 x 20 feet)
into which an oval must fit, with the help of the dimensions of the
basins, one can arrive at an idea of its shape. The circumference of
the basins (10 and 5 feet) is given and we can calculate their diameter:
3.18 feet for the large basin in the rear; 1.59 for the two smaller
basins in the entrance portal. It is possible however, that the basins
were oval, not circular.

If one allows for a ca. .75 feet on either side of the basin -
enough space for a niche - the entrance door would be perhaps 3 feet three
deep. The corresponding niche at the rear would probably have been
approximately the same depth. Thus it is possible to arrive at a short
diameter of ca. 14.6 feet. Apparently the side doors lacked niches
and their depth would have been shallower, and one could imagine a
long diameter of ca. 19 feet.

Serlio, in book I, 14 (published 1545) demonstrates how to construct
an oval plan the dimensions of which resemble the oval I arrived at
independently, based on the measurements provided by Gualdo.

The grotto was divided into 8 equal spaces, including the 3 doors
and the large niche in the rear. Thus, there probably were 4 niches
roughly the size of the rear niche between the 3 doors and rear niche.
Four benches (quattro bancheti) were distributed between the niches,
probably one to a niche.

The ground plan offered by the author is intended only as a rough
guideline. It is not clear how much decorative carving and stucco,
shells, stalagtites and tufa would have obscured the oval space.
The oval leitmotif was carried by Gualdo's escutcheon in the vault
and echoed with other smaller such forms ("mandole") on the walls, and
perhaps would have been stressed by the pattern of the paving stones.
Thus, perhaps the niches were half ovals. Were the vases oval also?
We don't know. Ammanati may have used the circular form as a contrast
to the frequent use of the oval; and these in turn would have echoed
the tondi on the exterior.

In the 1650 description Gualdo gives the height of the fountain
as "ca. piedi 36." In the more detailed earlier description of 1646
he gives it as "alta circa p. 50." In the reconstruction, we have
chosen the former figure, which requires some explanation. Although
the earlier description is more detailed it need not be assumed to be
always more accurate. Several things are left out of it which appear
in the later one, e.g., the stairwells. It should be observed that
the figure of 36 turns up in another context. In the earlier text at
the end of the description of Ammanati's large fountain, Gualdo moves
on to another part of the garden. He says "Partendoli da queste fonte

dalla parte verso mezzo giorno p. 36" one finds a base with an
inscription supporting a marble eagle. Could Gualdo have confused
the fountain's height for the length of the path when he described
the fountain four years later? Or did Ammanati lay out the garden
with three paths leading from the doors the length of which equalled
the fountain's height? Visually and structurally it is difficult to
envision a height of 50 feet for this work whose width is only 20
feet. Gualdo implies that the grotto level extends up to roughly
1/2 the height of the whole ("è fatta fino al mezzo di belli e grosse
pietre alla rustica"). Thus, if the whole were 50 feet high the grotto
would rise to a level of about 20 feet, making its height nearly the
size of its long diameter - a feature quite unusual. Rather, one
should imagine the height of the vaulted oval to be somewhat less than
the long diameter, e.g., as in the case of Ammanati's oval grotto at
the Pitti Palace where the vault height is about 2/3 of the long dia-
meter at its highest point.

 If we feel compelled to lower the height of the grotto, while
retaining a height of 50 feet for the whole fountain, we are left with
an embarrassingly disproportionate loggia whose height by far exceeds
its width.

 The proportions of a 36 foot fountain are more easily envisaged.
The grotto would rise to ca. 13 feet, the loggia (including roof) to
ca. 18 feet, and the vase the remaining five feet, making 36 in all.

 I have estimated that the arches are supported by piers ca. 1 1/2
feet wide, with stucco harpies attached to them. Assuming that the
width of the central arch is approximately the same as the grotto door,

which may be inferred from "tre gran finistrone, come le porte da
basso" (1646), the remainder of the space (eight feet) makes up the
width of the flanking openings. Given a width of ca. four feet,
their height could not greatly exceed nine or ten feet without
violating sixteenth-century proportions. Given a width of ca. six
feet for the central door one would not expect its height to exceed
ca. 14-15 feet.

APPENDIX 3

Handlist of Surviving Sculptures

Neptune, Padua, Palazzo Strozzi, ht. 195 cm. Date: before 1533;
 attribution: see p. 13 f.

Lunette of God the Father with Angels, Pisa, Duomo, for the altar of
 SS. Martiri, width 231 cm. Date: c. 1532-34; attribution: Borghini.
 See p. 20 ff.

Leda and the Swan, London, Victoria and Albert Museum, ht. 138.40 cm.
 Date: c. 1534-37; attribution: see p. 27 f. Preparatory sketch
 in Boston, Mus. of Fine Arts: p. 28 f., 31 f.

Sculpture for the Sannazzaro Tomb, Naples, Sta. Maria del Parto
 Apollo, ht. 158 cm.

 Minerva, ht. 153 cm.

 S. Nazaro, ht. 165 cm.

 Date: c. 1536-1540, attribution: Borghini. See p. 36 f.

The Nari Tomb, Florence, Bargello.

 Victory Group, 200 x 100 cm.

 Effigy of Mario Nari, 160 x 66 cm.

 Date: 1539-42 (p. 68-69); attribution: Borghini. See p. 65 f.

Eight Spandrel Figures, Venice, Library: 6 River Gods, 2 Winged
 Female Figures, approx. 2/3 life size.

 Date: 1541-43; attribution: Francesco Sansovino. See p. 87, 90 f.

Colossal Hercules, Padua, Pal. Benavides. Stone, ht. 713 cm. Date:
 1544-45 (see p. 110); see p. 121 f.

Benavides Tomb, Padua, Church of the Eremitani, 372 cm. wide. Seven
 statues and two putti in relief: stone allegories of Labor and Wisdom,
 (ht. 172 cm. Fame, Honor, Immortality; two youths (all approx. life size).
 Date: 1545-46, see p. 135 f.

<u>Sapienza</u>, Padua, Museo Archeologico dell'Universita di Padova. Stuccoforte

 <u>modello</u>, ht. 61 cm. See p. 135, n. 2; 147 f.

<u>Triumphal Arch</u>, Padua, Pal. Benavides.

 Stone statues of <u>Apollo</u>, (ht. 191.5 cm.), and <u>Jupiter</u> (ht. 196 cm.).

 Two stone <u>reliefs</u> (each 90 x 187 cm.; see p. 154 f. and 162 f.)

 Two <u>Victories</u> in spandrels, <u>two putti</u>.

 Date: 1545-47, see p. 151 f.

Small female <u>head</u>, Padua, Museo Archeologico dell'Università di Padova.

 Stucco, ht. 13.25 cm. Date: 1545-47, attr: Bettini. See p. 162, n. 12.

Handlist of Lost Sculptures

Tomb of Francesco Maria della Rovere, Urbino, Sta. Chiara. Date: c. 1538
and 1542-43, attribution: Vasari. See p. 50 f, and 62 f.

Stuccos for the Villa Imperiale, Pesaro, Villa Imperiale. Date: c. 1538,
attribution: Borghini. See p. 59 f.

Project for Court of Urbino involving three blocks of marble. Date: 1544,
source: document 1, p. 216. See p. 52 f.

Two Youths for the Nari Tomb, once in Florence, SS. Annunziata. Date:
1539-42, see p. 64.

Neptune for the balustrade of Sansovino's Library in Venice. Date:
c. 1541-43, see p. 83, 85.

Two Spandrel Figures, Venice, Library. Date: 1541-43, see p. 89 f.

Terracotta bust of Marco Mantova-Benavides. Source: Benavides Inventory,
date: 1543-46. See p. 140, n. 19.

Putto Relief in Terracotta. Source: Benavides Inventory. See p. 168, n. 2.

Terracotta Model of a Satyr. Source: Benavides Inventory. See p. 168.

Two Large Satyrs. Source: Benavides Inventory. See p. 167.

A small model of an amphitheater with statuettes of seven planetary deities.
Source: Benavides Inventory. See p. 168, n. 4, and p. 171, n. 10.

Reclining figure (River God?). Source: Portenari, see p. 169.

Theater sets for Giovannandrea dell'Anguillara. Date: 1545; source:
Riccardiana sketchbook. See p. 170 f.

Three Fountains for Giralamo Gualdo, Vicenza, former Pal. Gualdo. Date:
1545-46.

1) Large architectonic 2-story fountain (see p. 177 f.) containing

as sculptural decoration

a) three marine deities in the grotto

b) 12 stucco harpies attached to the piers of the loggia

c) an unknown quantity of sculptural embellishment

2) A free-standing fountain containing a statue of <u>Fame</u>, see p. 190 f.

3) A free-standing fountain containing a statue of <u>Time</u>, see p. 190 f.

Index of Erroneously Attributed Sculptures

Bassano, Museo Civico, <u>Bronze Portrait of Lazzaro Bonamico</u>. Attribution:
Ciardi-Dupré, see p. 108, n. 29.

Berlin, Staatliche Museum, <u>Terracotta relief of Madonna and Child</u>,
see p. 108, n. 29.

California, Huntington Library, <u>Bronze statuette of Hercules</u>. Attribution:
Pope-Hennessey, see p. 133, n. 26.

Detroit, Institute of Arts, <u>Two bronze statuettes of Mars and Neptune</u>.
Attribution: Ciardi-Dupré, see p. 108, n. 29.

New York, Metropolitan Museum, <u>Bronze statuette of a nude male youth</u>.
Attribution: Callegari, see p. 107, n. 29.

Padua, Church of the Carmine, <u>Monument to Giovanni Naldo</u>. Attribution:
Bettini, see p. 172, n. 11.

Padua, Museo Archeologico dell'Università di Padova, <u>Terracotta statuette
of a female figure</u>. Attribution: Bettini, see p. 168, n. 4.

<u>Ibid</u>., <u>Small terracotta head</u>, #85. Attribution: Bettini, see p. 172, n. 11,
#5.

<u>Ibid</u>., <u>Terracotta portrait of Michelangelo</u>. Attribution: Bettini, see p. 172,
n. 11, #4.

<u>Ibid</u>., <u>Small terracotta copy of Michelangelo's Aurora</u>, #239. Attribution:
Bettini, see p. 172, n. 11, #3.

Padua, Museo Civico, <u>Terracotta statue of a female figure</u>, #28.
Attribution: Gabbrielli, see p. 171, n. 11 #1

<u>Ibid</u>., <u>Bronze statuettes of Hercules and Omphale</u>. Attribution: Moschetti,
see p. 133, n. 26.

Padua, Pal. degli Specchi, <u>Stone Group of Hercules and Cerberus</u>. See p. 172,
#6.

Paris, Louvre, <u>Drawing of the Colossal Hercules</u>. Attribution: Vasari,

see p. 124 f, n. 9.

Pontecasale, Villa Garzoni, <u>Group of Pluto and Cerberus</u>. Attribution:

Callegari, see p. 106, n. 29.

<u>Ibid.</u>, <u>Two Male Caryatids</u>. Attribution: Venturi, see p. 107, n. 29.

Urbino, Sta. Chiara, <u>Relief Portrait of Francesco Maria della Rovere</u>,

see p. 53 f.

Vienna, Kunsthistorisches Museum, <u>Terracotta statuette of Apollo</u>.

Attribution: Ciardi-Dupré, see p. 168, n. 4.

Vienna, Castiglione Collection (formerly), <u>Bronze statuette of a satyr</u>.

Attribution: Gabbrielli, see p. 108, n. 29.

BIBLIOGRAPHY

Altamura, A., Jacopo Sannazzaro, Napoli, 1951.

Amsterdam, Rijksmuseum, Meesters van het bronz der italiaanse renaissance, 1962.

Anonymous, Selva Vicentina. Ms. Bibl. Marciana, Venice, It. IV, #5102.

Archivio di Stato di Firenze, Gesuiti XII and Convento 119.

Arslan, W. "Di alcune architetture toscane a Padova," Miscellanea di storia dell'arte in onore di I. B. Supino, Firenze, 1933, 518 ff.

Aru, C. "Gli Stagi," L'Arte, IX, 1906, 476 ff.

____, "Scultori della Versilia," ibid., XII, 1909, 269 ff.

Baldinucci, F. Opera, VII, Milano, 1811, 393 ff.

Barbieri, F., et al., Guida di Vicenza, Vicenza, 1956.

Bartoli, C. Ragionamenti accademici ... sopra alcuni luoghi difficili di Dante, Venice, 1567.

Basilio, N. Lettera. Ms. Bibl. Marciana, Venice, Libreria Gonzati, 23.11.5.

Bettini, S. "Note sui soggiorni veneti di Bartolomeo Ammannati," Le Arti, III, 1940, 20 ff.

Biagi, L. "Di Bartolomeo Ammannati e di alcune sue opere," L'Arte, XXVI, 1923, 49 ff.

Bocci, F. Sopra l'Imagine miracolosa della SS. Annunziata, Firenze, 1592.

Bocci, Franc., ed. Giov. Cinelli. Le Bellezze della città di Firenze ..., Firenze, 1677.

Borghini, R. Il Riposo, III, Milano, 1807, 164 ff.

Bottari, S. "Giovanni Angiolo Montorsoli a Messina," L'Arte, 1928, 234 ff.

Brandolesi, P. Pitture sculture architetture ed altre cose Notabili di Padova, Padova, 1795.

Callegari, A. "Il Palazzo Garzoni a Ponte Casale," Dedalo, Feb. 1926, 569 ff.

Calvesi, J. "Il sacro bosco di Bomarzo," Scritti di storia dell' arte in onore di L. Venturi, I, 1956, 369 ff.

Calvi, J. Biblioteca e storia degli scrittori di Vicenza, VI, Vicenza 1782.

Camesasca, E., ed. Lettere sull'arte di Pietro Aretino, Milano, n.d.

Candida, Bianca. I Calchi rinascimentali della collezione Mantova Benavides nel Museo del Liviano a Padova, Padova, 1967.

Celano, C. Notizie del bello dell'antico e del curioso della città di Napoli, V, Napoli, 1860.

Cessi, F. "Luca Ferrari da Reggio stimatore dei beni d'arte di casa Mantova," Padova, IX, 1963, n. 7-8, 11-12.

Cevese, R. Le Ville Vicentine, Treviso, 1953.

Checchi, M., et al. Padova, Venezia, 1961.

Chiodi, Luigi, ed. Lettere inedite di Lorenzo lotto, Bergamo, 1962.

Ciardi - Dupré, M. G. "La Prima attività dell'Ammannati Scultore," Paragone, n. 135, 1961, 3 ff.

_____, "Bronzi di Bartolomeo Ammannatti" and "Brevi note sui bronzetti italiani del Rinascimento esposti a Londra-Amsterdam-Firenze," Paragone, n. 151, 1962. 57 ff.and 64 ff.

Colangelo, F. Vita di Giacomo Sannazzaro, Napoli, 1819.

Colasanti, A. "Il memoriale di Baccio Bandinelli," Repertorium für Kunstwissenschaft, XXVIII, 1905, 434.

Croce, B. "La Tomba di Jacopo Sannazzarro e la Chiesa di Sta. Maria del Parto," Napoli Nobilissima, I, 1892, 73 ff.

Da Schio. Memorabili. Ms. Bibl. Civica Oliveriana, Vicenza.

De Stefano, P. Descrittione dei luoghi sacri della città di Napoli, Napoli, 1560.

Del Migliore, F. L. Firenze città nobilissima illustrata, Firenze, 1684.

Fiocco, G. "La casa di Palla Strozzi," Atti della Accademia Nazionale dei Lincei, CCCLI, 1954, ser. VIII, vol. V, fasc. 7.

Formenton, F. Memorie storiche della città di Vicenza, Vicenza, 1867.

Fossi, M. Bartolommeo Ammanati Architetto, n.d. (1968).

_____, ed. Bartolommeo Ammanati, La Città, Roma, 1970.

Frey, K. Der literarische Nachlass Giorgio Vasaris, I, Munich, 1923.

Gabbrielli, A. "Su Bartolomeo Ammannati," Critica d'arte, II, 1937, 89 ff.

Gay, Gio. Carteggio inedito d'artisti dei secoli XIV, XV, XVI, 1839-40.

Gherardi, P and E. Guida di Urbino, Urbino, 1890.

Gronau, G. Documenti artistici urbinati, Firenze, 1936.

Gualdo, G. (the Elder). Rime. Venezia, 1569.

Gualdo, G. (the Younger). "Giardino da chà Gualdo, cioè raccolta de Pittori, scultori, archititti, celatori, miniatori, e altri artefici Illustri, nella Galeria sopradetto, nella contra di Pusterla, qui dell anno 1650. consacrato, et al nome del vir-tuosissimo, et erudissimo Sig.r Carlo Ridolfi Cavaliero di S. Marco, Diccato dal Co: Girolamo Gualdo Vicentino ..." Ms. Marciana It. IV, 127 (n° 5102, 3).

_____. "Raccolta delle inscritioni cossi antiche come moderne, quadri e pitture, statue, bronzi, marmi, medaglie, gemme, minere, animali, petriti, libri, instrumenti mathematiche, si trovano in Pusterla nella casa, et Horti, chi sono di me Girolamo de Gualdo Emilio D.v che h'vuq anco per Inventario, MDCXLIII, nel mese di Dicembre 27," Bibl. Marciana, Venice, Cl. It. #5103, p. 10 ff. and p. 16 ff.

Guazzo, M. Historia, Venice, 1546.

Heikamp, D. "Ein Madonnenrelief von Francesco da San Gallo," Berliner Museen Berichte, n. F. VIII, Nov. 1958, 34 ff.

Ivanoff, N. "Ignote primizie veneziane di Alessandro Vittoria," Emporium, June 1961, 243 ff.

_____. "La Libreria Marciana, Arte e Iconologia," in Saggi e Memorie di Storia dell'arte, 6, 1968, 35 ff.

Keutner, H. "Die Bronzevenus des Bartolomeo Ammanati," Münchner Jahrbuch der Bildenden Kunst, 1963, 79 ff.

_____. "The Palazzo Pitti Venus and other works by Vincenzo Danti," Burlington Magazine, 100, 1958, 431 ff.

Kriegbaum, F. "Ein Verschóllenes Brunnenwerk des Bartolomeo
Ammanati," Mitteilungen des Kunsthistorischen Instituts in
Florenz, III, 1929, 71 ff.

Lauts, J. "Zwei Kaminbocke des Francesco Segalo im Berliner
Schlossmuseum," Berliner Museen Berichte, LVII, 1936, Heft 4,
69 ff.

Lorenzetti, G. "Il Campanile di San Marco reedificato," L'Arte,
XIII, 1910, 104 ff.

_____ "La Libreria Sansoviniana di Venezia," Accademie e
Biblioteche d'Italia, III, pts. I and II, 1928-29, 73 ff.,
1929-30, 22 ff.

Magni. 'Ammanati,' Thieme-Becker Kunstlerlexikon, I, Leipzig, 1907.

Magrini, Ant. Notizie di Girolamo Gualdo. Vicenza, 1865.

Manara, C. L'Opera di Giovanni Angelo Montorsoli a Genova. Genova,
1959.

Mantova - Benavides, A. Inventario [of the Museo Mantova - Benavides].
1695. Ms. Biblioteca Civica, Padova, #5018.

Mantova - Benavides, M. Analysis Variones Questionis. Venice, 1568.

_____ Di lettere familiari diverse. Padova, 1578.

_____ Enchiridii Rerum Singularum. Venice, 1551.

"Lettere di diversi scritte al celebre professore di Padova
Marco Mantova," Cod. DCXIX, 6. Padova, Seminario.

[Documents and letters pertaining to Marco Mantova Benavides]
Cod. 1349, Biblioteca Civico Correr, Venezia.

Marzari, G. La Historia di Vicenza. Venice, 1590.

Middeldorf, U. Giovanni Bandini detto Giovanni dell'Opera," Rivista
d'arte, XI, 1929, 481 ff.

_____ "Perino da Vinci," Old Master Drawings, XIII, June 1938,
10.

Milanesi, G. Le Lettere di Michelangelo Buonarotti. Florence, 1875.

Morelli, J. Notizia d'opera di disegno. Bassano, 1800.

Moreni, D. Descrizione della Chiesa SS. Annunziata di Firenze. Firenze, 1791.

Morisiani, O. "Una statua del Montorsoli e una dell'Ammannati a Napolis" Rivista d'arte, XXIII, 1941.

Moroni, Gaetano. Dizionario di erudizione storico-ecclesiastica. Venezia, 1840-79.

Morsolin, B. Le collezioni di cose d'arte nel secolo decimo sesto in Vicenza. Vicenza, 1881.

_____ Il Museo Gualdo in Vicenza, 1894.

Moschetti, A. Il Museo Civico di Padova. Padova, 1938.

Moschini, G. Guida per la città di Padova. Venezia, 1817.

Nagler, G. K. "Bartolomeo Ammanati," Neues allgemeines Kunstler-lexicon, I. Munich, 1835.

Paatz, W. and E. Die Kirchen von Florenz, I. Leipzig, 1940.

Papadopoli, N. C. Historia Gymnasii Patavini, I. Venice, 1726, 256 ff.

Papini, Pisa, I. 1912.

Pastor, L. v. Storia dei Papi, XIII, Roma, 1932.

Patzak, B. Die Villa Imperiale in Pesaro, Leipzig, 1908.

Perkins, C. Tuscan Sculptors, II. London, 1864.

Pinelli, C. and Rossi, O. Genga Architetto. n.d. (1971), 289 ff.

Pittoni, L. Jacopo Sansovino Scultore. Venezia, 1909.

Planiscig, L. Venezianische Bildhauer der Renaissance. Wien, 1921.

Polacco, L. "Il Museo di Marco Mantova Benavides e la sua formazione," Arte in Europa, Scritti di Storia dell'arte in onore di Edoardo Arslan, I, 1967, 665 ff.

_____. "Il Museo di scienze archeologiche e d'arte dell'Università di Padova. I. Storia e Ordinamenti," Atti dell'Istituto Veneto di Scienze, Lettere, ed Arte, CXXV, 1966-67, 421 ff.

Pope - Hennessey, J. Essays on Italian Renaissance Sculpture. London, 1968.

_____. High Renaissance and Baroque Sculpture, III.
London, 1963, 73.

_____. "A Relief by Sansovino," Burlington Magazine,
101, 1959, 4 ff.

Portenari, A. Della Felicità di Padova. Padova, 1623.

Riccoboni, A. Oratio in obitu Marci Mantova-Benavides. Patavii,
1582.

Richa, G. Notizie istoriche delle chiesa fiorentine ... VIII.
Firenze, 1759.

Ripa, C. Iconologia. Ed. C. Orlandi, Perugia, 1764, 5 vols.

Rossetti, G. Descrizione della pittura, scultura ed architettura di
Padova. Padova, 1776.

Rotondi, P. "Contributi all'attività urbinate di Giovanni Bandini
detto dell'Opera," Urbinum, XVII, 1942, 8 ff.

_____. Studi urbinati artistici. Urbino, 1949.

Sanpaolesi, P. "La vita vasariana del Sansovino e l'Ammannati,"
Studi Vasariani. Firenze, 1950, 134 ff.

Sansovino, F. Delle cose notabili che sono in Venetia. Venetia,
1561, 23r.

_____. Venetia città nobilissima. Ed. G. Martinioni, Venezia,
1663.

Semenzato, C. "Alcune opere della Raccolta Benavides al Liviano,"
Bollettino del Museo Civico di Padova, XLV, 1956, 90 ff.

Serra, L. Catalogo delle cose d'arte di Urbino. Roma, 1932.

_____. "La Provincia di Pesaro-Urbino," ed. O.T. Locchi. Roma,
1934.

Supino, I. "I pittori e gli scultori del Rinascimento nella
Primariale di Pisa," Archivio storico dell'arte, VI, 1893,
419 ff.

Tanfani Centofanti, L. Notizie di artisti tratte di documenti
pisani. 1897.

Temanza, T. Vita di Jacopo Sansovino. Venezia, 1752.

_____. Vita dei più celebri ... Venezia, 1778.

Tolnay, C. de. Michelangelo, IV. Princeton, 1954.

Tomasini, J. P. Elogia dei uomini illustri di Padova. Padova, 1630.

Tonini, P. Il santuario della Santissima Annunziata di Firenze.
 Firenze, 1876.

Ursato, S. Monumenta Patavina. Patavii, 1652.

Valeriano, P. Hieroglyphica. Basel, 1575.

Valsecchi, A. Elogio di Marco Mantova-Benavides. Padova, 1839.

Vasari, G. Le Vite ... ed. G. Milanesi, VII, 227.

Venturi, A. Storia dell'arte italiana, X, pt. II, Milano, 1936.

Vodoz, E. "Studien zum architektonische Werke des Bartolomeo
 Ammanati," Mitteilungen des Kunsthistorischen Instituts in
 Florenz, VI, 1941, 1 ff.

Weinberger, M. Michelangelo the Sculptor. New York, 1967.

Wittkower, R. "Nanni di Baccio Bigio and Michelangelo," in
 Festschrift Ulrich Middeldorf. Berlin, 1968, 248 ff.

Zampetti, P., ed. Lorenzo Lotto, Il Libro di spese diverse. Roma,
 n.d. (1969).

ILLUSTRATIONS

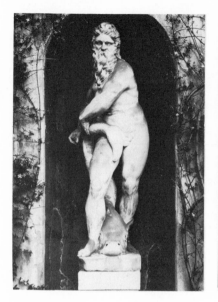

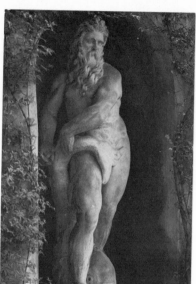

Fig. 2

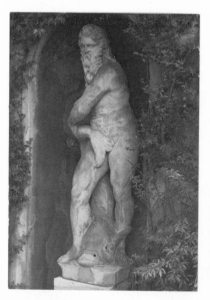

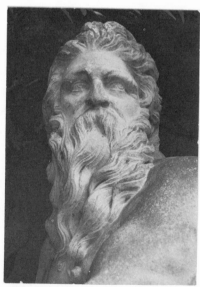

Fig. 3

Fig. 4

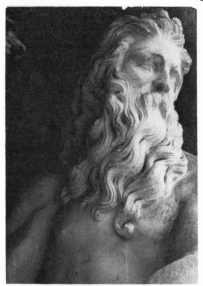

Fig. 5

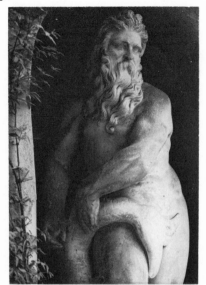

Fig. 6

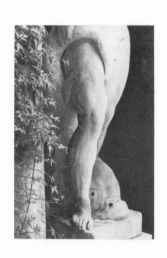

Fig. 7

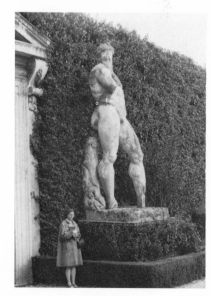

Fig. 8

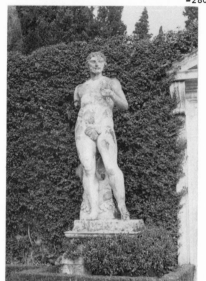

Fig. 9

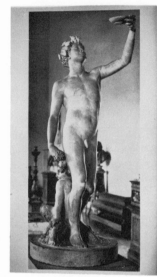

Fig. 10

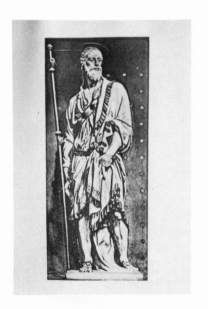

Fig. 11

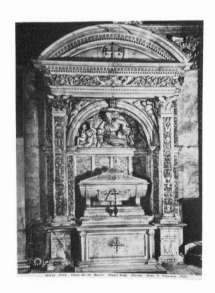

Fig. 12

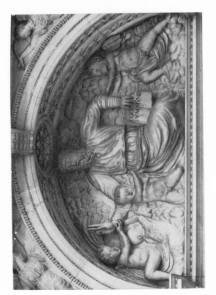

Fig. 13

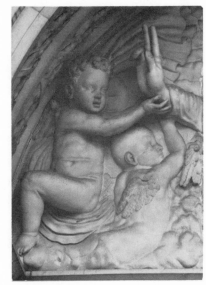

Fig. 14

Fig. 15

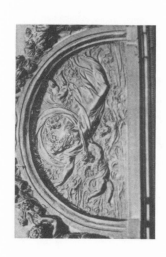

Fig. 16

Fig. 17

Fig. 18

Fig. 19

Fig. 20

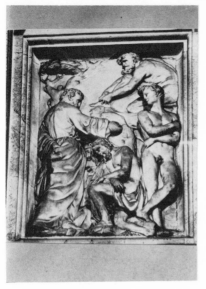

Fig. 21

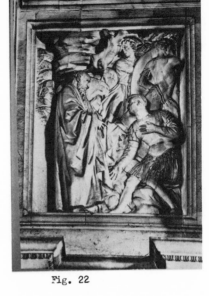

Fig. 22

Fig. 23

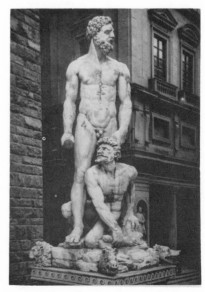

Fig. 23a

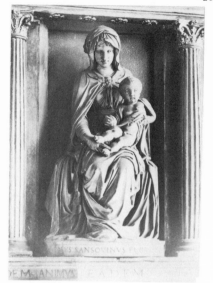

Fig. 24

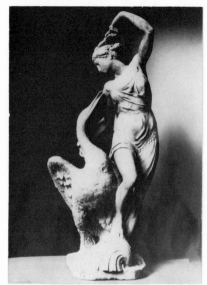

Fig. 25

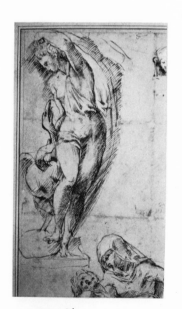

Fig. 26

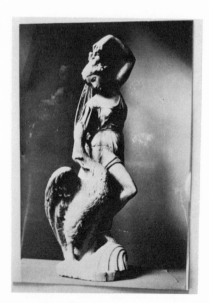

Fig. 27

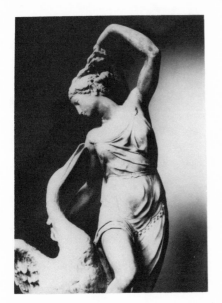

Fig. 27a

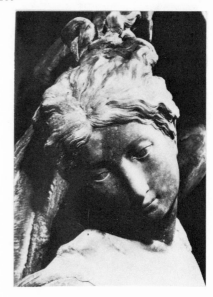

Fig. 28

Fig. 29

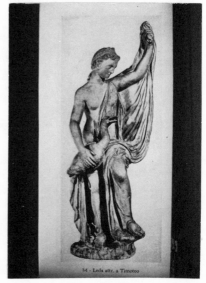

Fig. 30

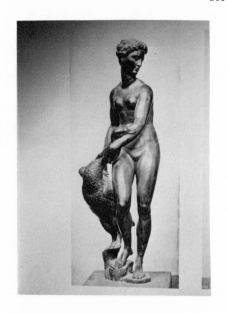

Fig. 31

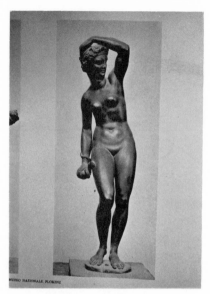

Fig. 32

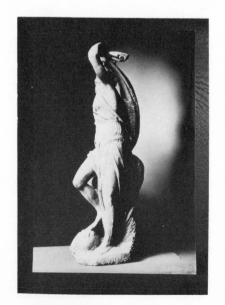

Fig. 33

Fig. 34

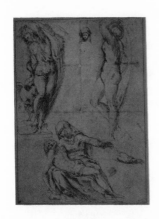

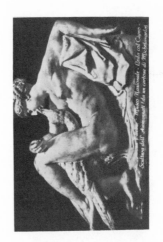

Fig. 35

Fig. 36

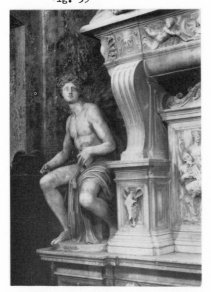

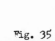

Fig. 38

Fig. 37

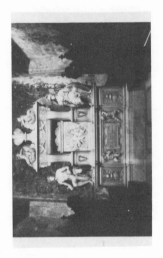

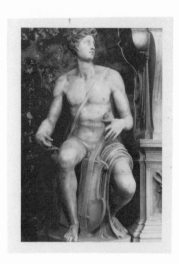

Fig. 39 Fig. 40

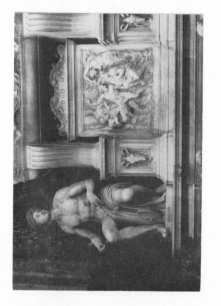

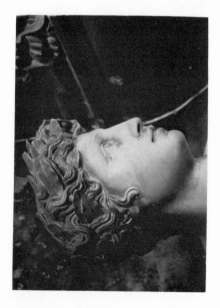

Fig. 41 Fig. 42

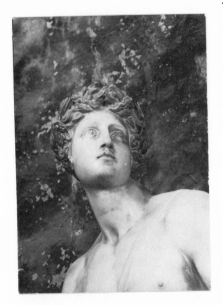

Fig. 43

Fig. 44

Fig. 45

Fig. 46

Fig. 46a

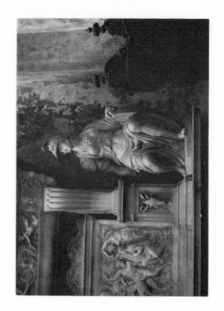

Fig. 47

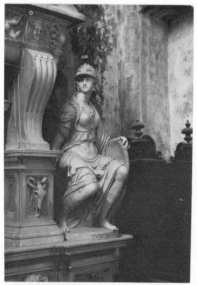

Fig. 48

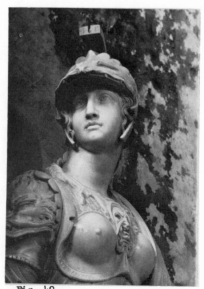

Fig. 49

Fig. 50

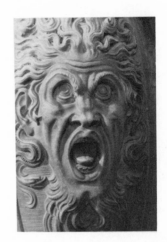

Fig. 51

Fig. 52

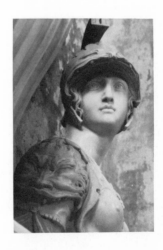

Fig. 53

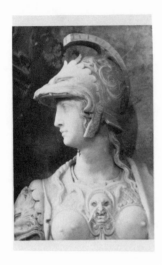

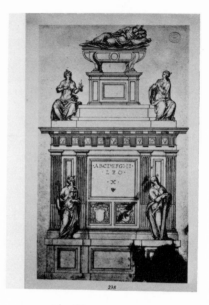

Fig. 54

Fig. 55

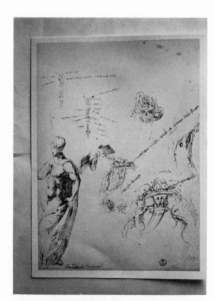

Fig. 56

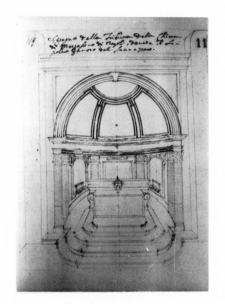

Fig. 56a

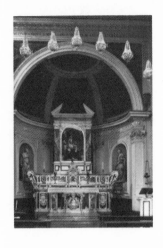

Fig. 56b

Fig. 57

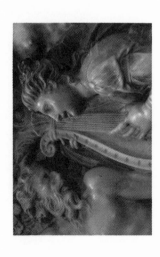

Fig. 58

Fig. 59

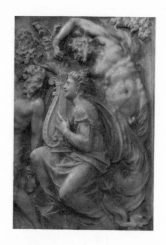

Fig. 60

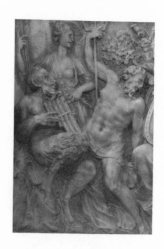

Fig. 61

Fig. 62

Fig. 63

Fig. 64

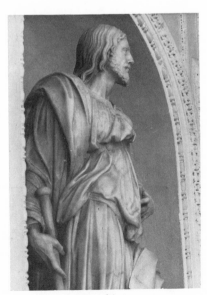

Fig. 65

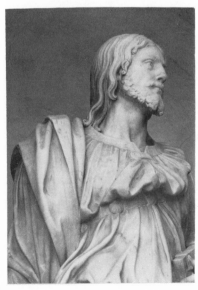

Fig. 66

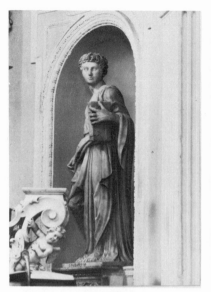

Fig. 67

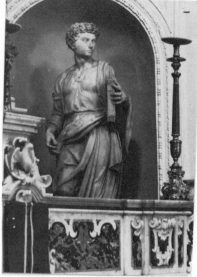

Fig. 68

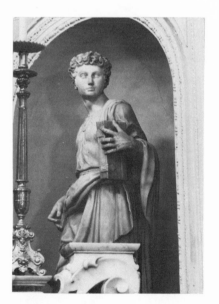

Fig. 69

Fig. 70

Fig. 71

Fig. 72

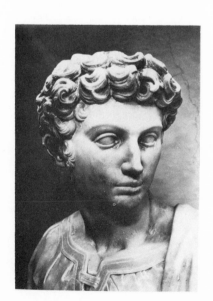

Fig. 73

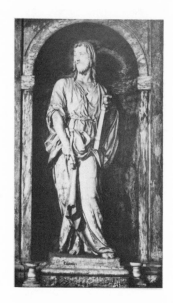

Fig. 74

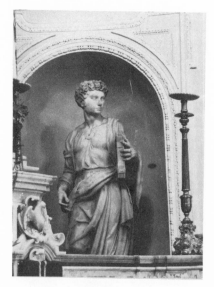

Fig. 75

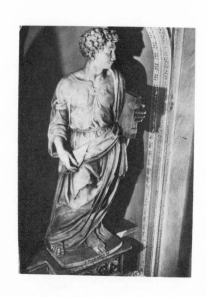

Fig. 76

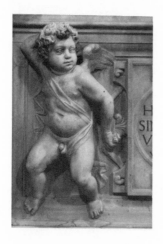

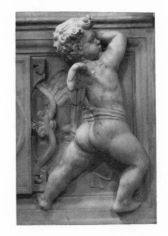

Fig. 77

Fig. 78

Fig. 78a

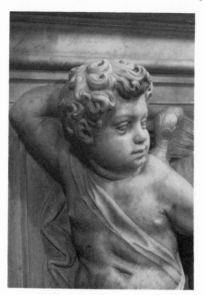

Fig. 79

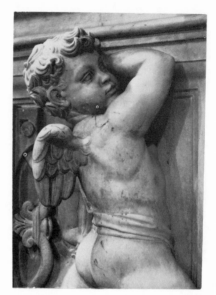

Fig. 80

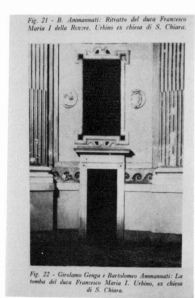

Fig. 21 - B. Ammannati: Ritratto del duca Francesco Maria I della Rovere. Urbino ex chiesa di S. Chiara.

Fig. 22 - Girolamo Genga e Bartolomeo Ammannati: La tomba del duca Francesco Maria I. Urbino, ex chiesa di S. Chiara.

Fig. 80a

Fig. 81

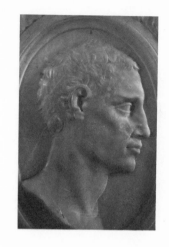

Fig. 82

Fig. 83

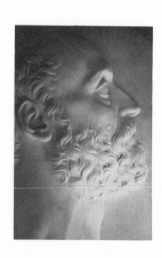

Fig. 84

Fig. 85

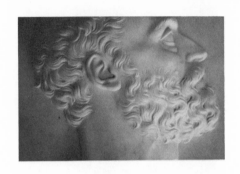

Fig. 86

Fig. 87

Fig. 87a

Fig. 88

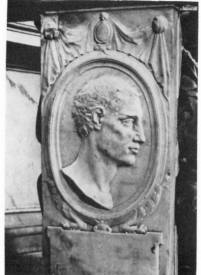

Fig. 88a

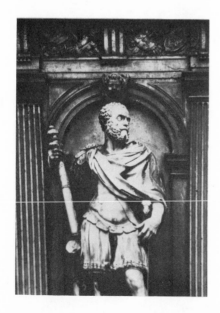

Fig. 89

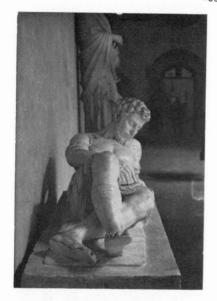

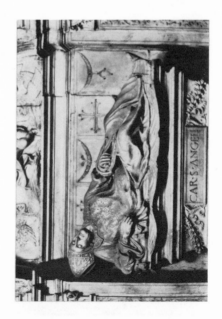

Fig. 90

Fig. 91

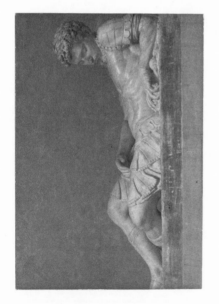

Fig. 92

Fig. 93

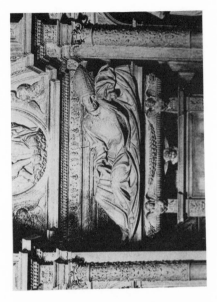

Fig. 94

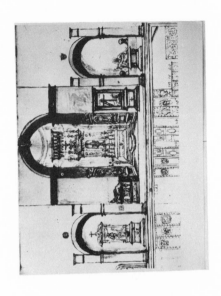

Fig. 95

Fig. 96

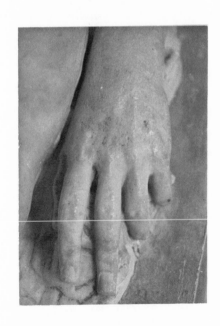

Fig. 97

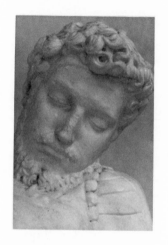

Fig. 98

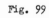

Fig. 99

Fig. 100

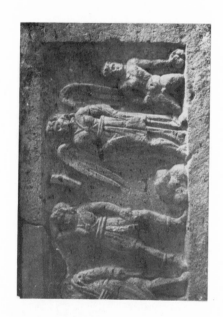

Fig. 101

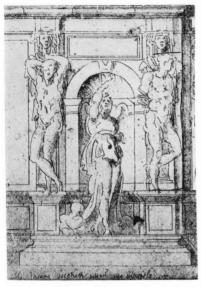

Fig. 102

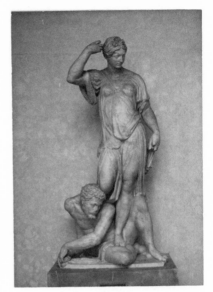

Fig. 103

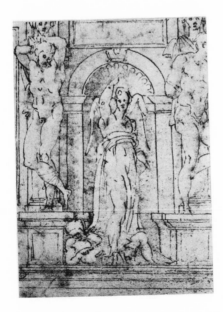

Fig. 104

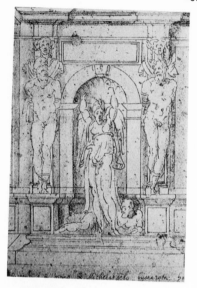

Fig. 105

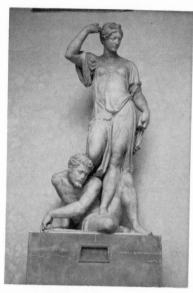

Fig. 106

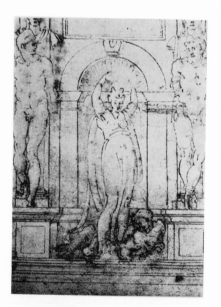

Fig. 107

Fig. 108

Fig. 109

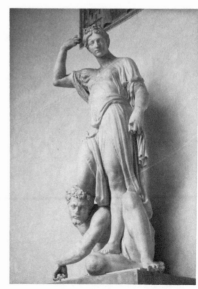

Fig. 110

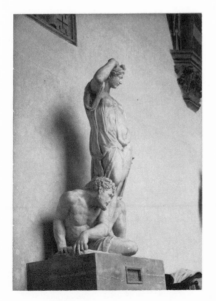

Fig. 111

Fig. 112

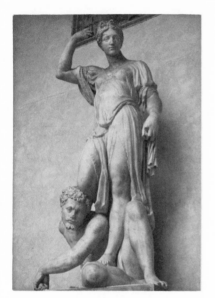

Fig. 113

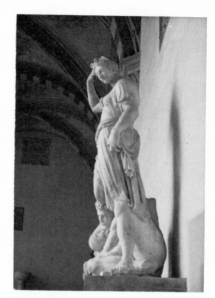

Fig. 114

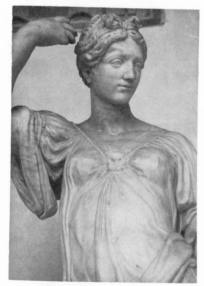

Fig. 115

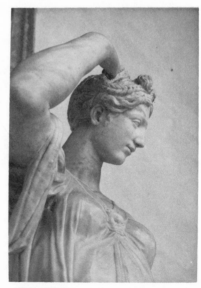

Fig. 116

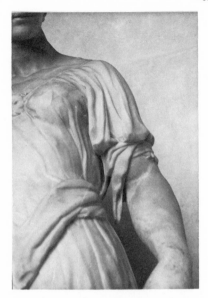

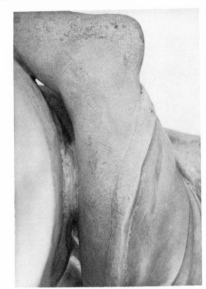

Fig. 116a Fig. 117

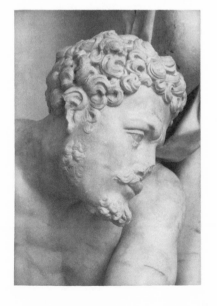

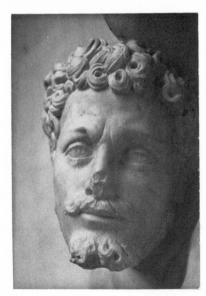

Fig. 118 Fig. 119

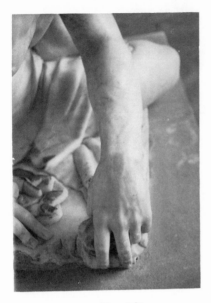 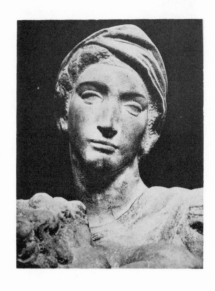

Fig. 120 Fig. 121

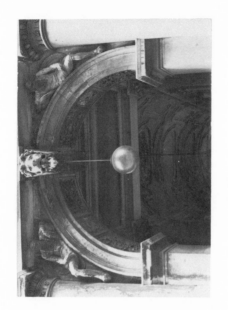

Fig. 122

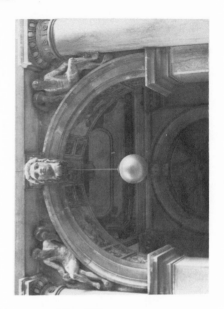

Fig. 123

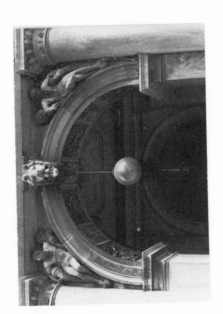

Fig. 124

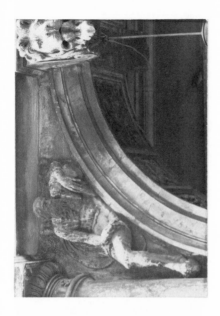
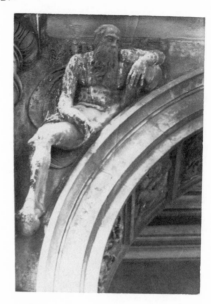

Fig. 125　River God A　　　Fig. 126

Fig. 127　　　　　　　Fig. 128

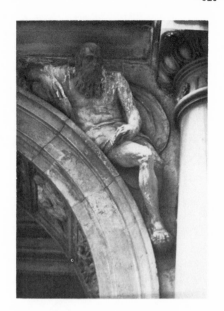
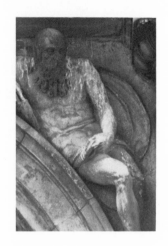

Fig. 129 River God B Fig. 130

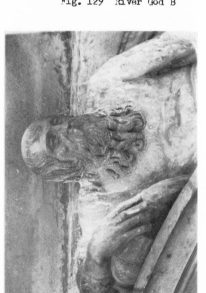
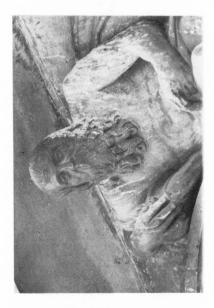

Fig. 131 Fig. 132

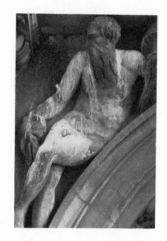

Fig. 133 River God C Fig. 134

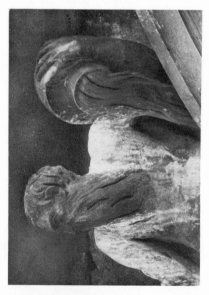

Fig. 135 Fig. 136

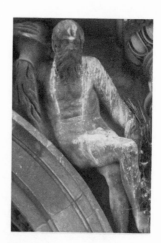

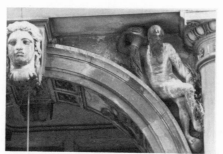

Fig. 137 River God D Fig. 138

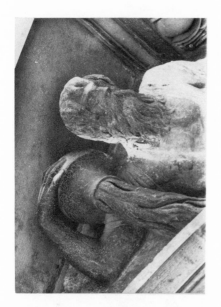

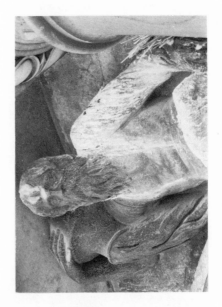

Fig. 139 Fig. 140

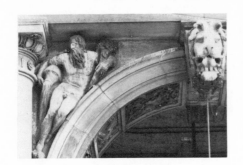

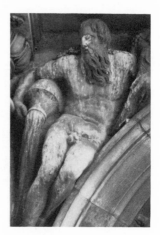

Fig. 141 River God E Fig. 142

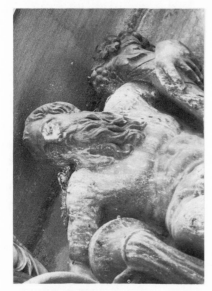

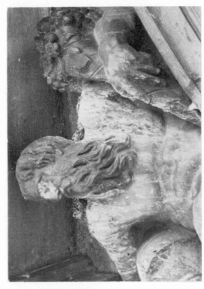

Fig. 143 Fig. 144

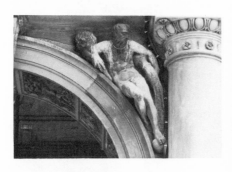

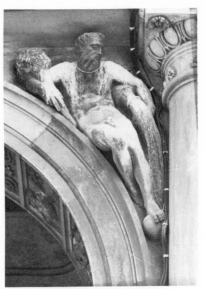

Fig. 145 River God F Fig. 146

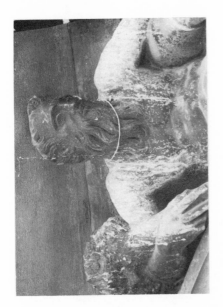

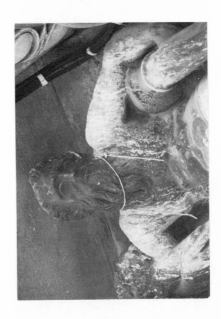

Fig. 147 Fig. 148

Fig. 149

Fig. 150

Fig. 151

Fig. 152

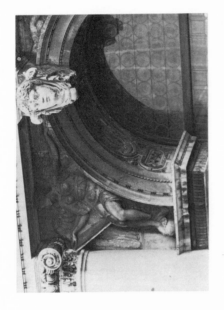
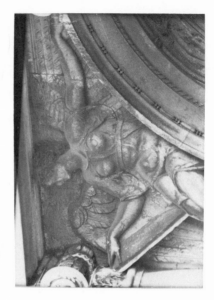

Fig. 153 Victory A Fig. 154
 After Ammannati

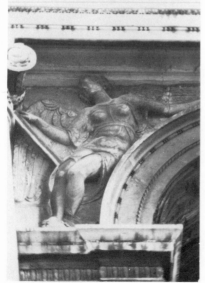

Fig. 155

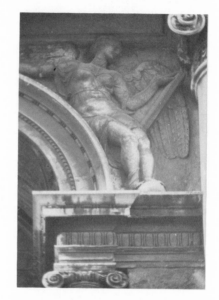

Fig. 156 Victory B Fig. 157
 Ammannati

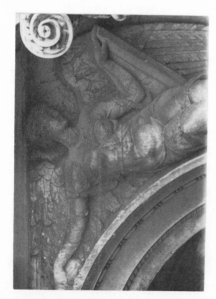

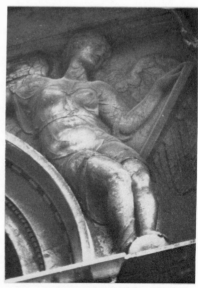

Fig. 158 Fig. 159

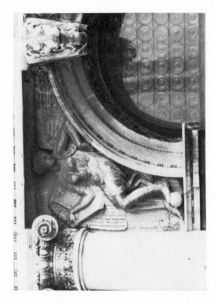

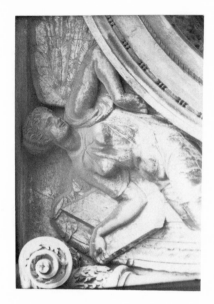

Fig. 160 Victory C
 After Ammannati

Fig. 161

Fig. 162

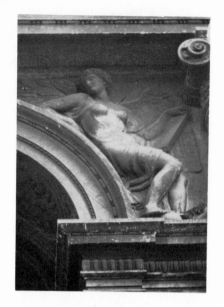

Fig. 163 Victory D
Ammannati

Fig. 164

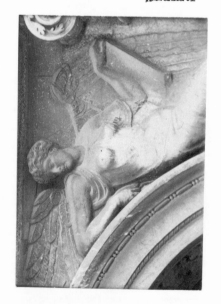

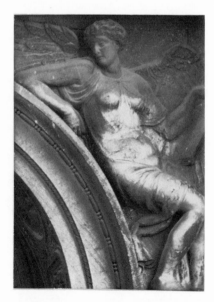

Fig. 165

Fig. 166

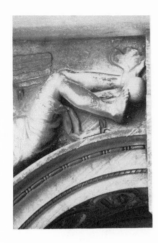

Fig. 167

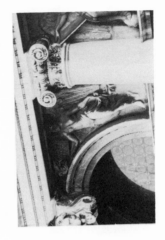

Fig. 168

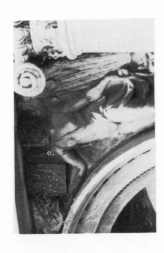

Fig. 169

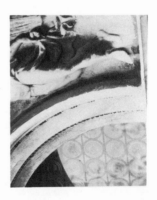

Fig. 170

Fig. 171

Fig. 172

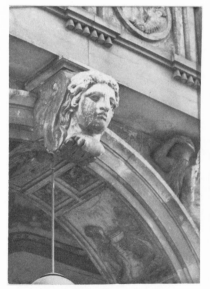

Fig. 173

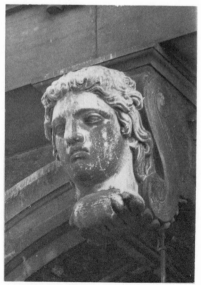

Fig. 174

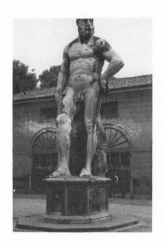

Fig. 175

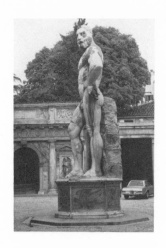

Fig. 176

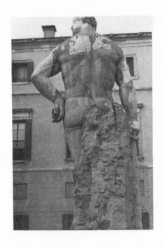

Fig. 177

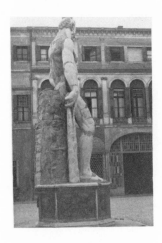

Fig. 178

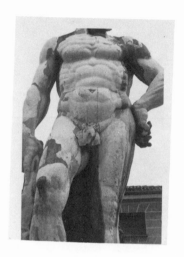

Fig. 179

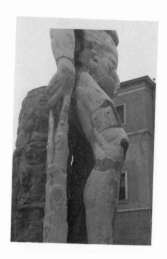

Fig. 180

Fig. 181

Fig. 182

Fig. 183

Fig. 184

Fig. 185

Fig. 186

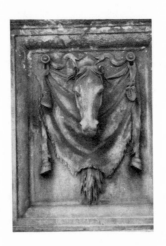

Fig. 187

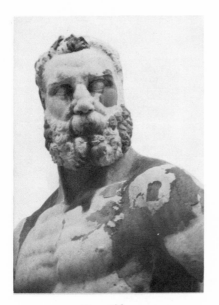

Fig. 188

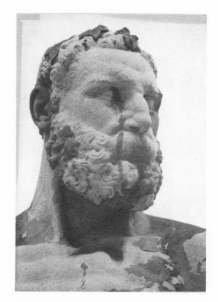

Fig. 189

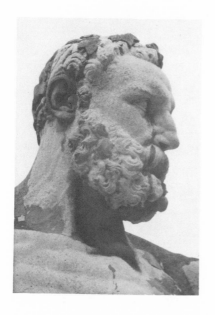

Fig.190

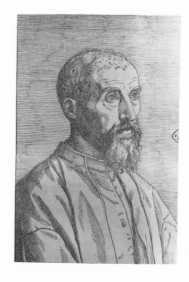

Fig. 191

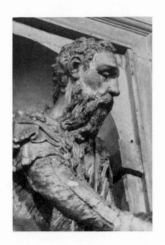

Fig. 192

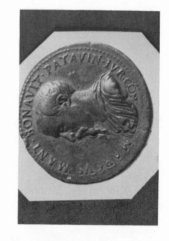

Fig. 193

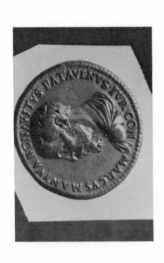

Fig. 194

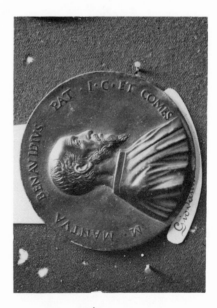

Fig. 195

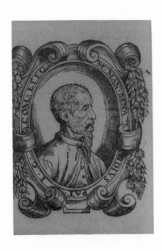

Fig. 195a

Fig. 196

Fig. 197

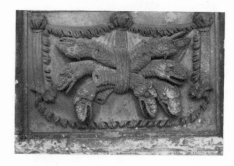

Fig. 198

Fig. 199

Fig. 200

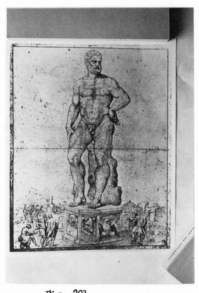

Fig. 201

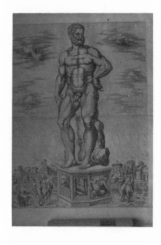

Fig. 202

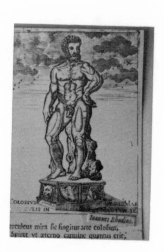

Fig. 203

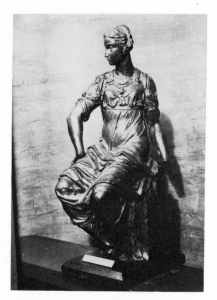

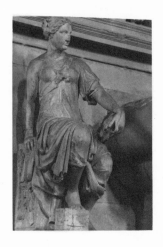

Fig. 204

Fig. 205

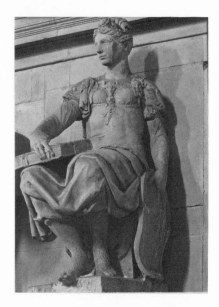

Fig. 206

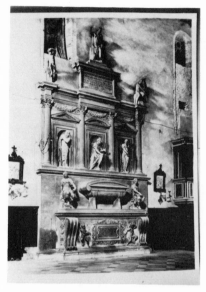

Fig. 207

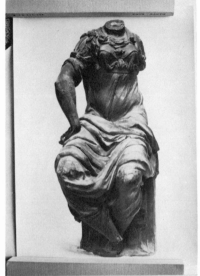

Fig. 208

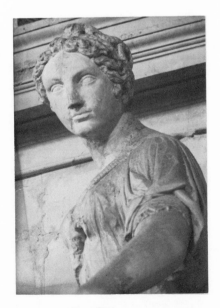

Fig. 209

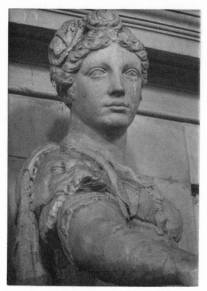

Fig. 210

Fig. 211

Fig.212

Fig. 213

Fig. 214

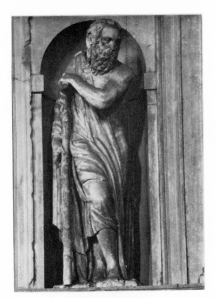

Fig. 215

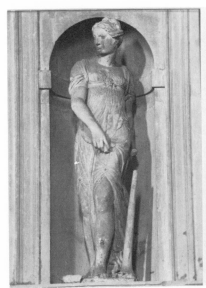

Fig. 216

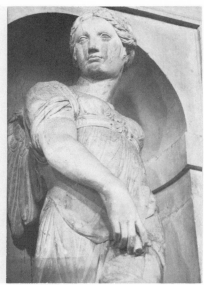

Fig. 217

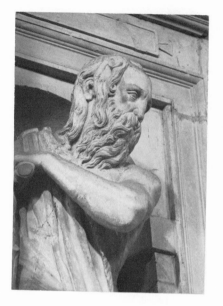

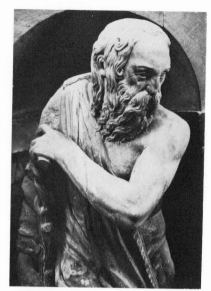

Fig. 219 Fig. 220

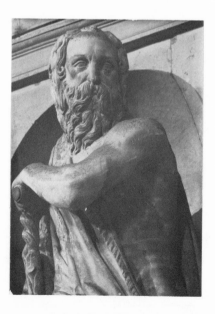

Fig. 221

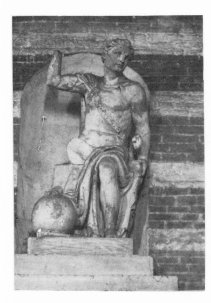

Fig. 222

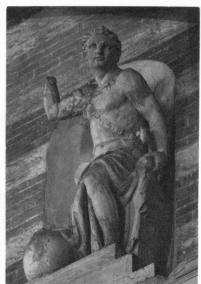

Fig. 223

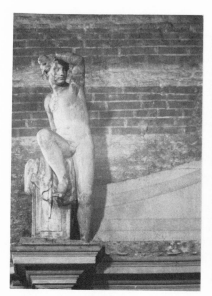

Fig. 224

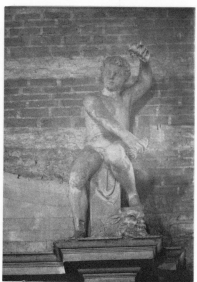

Fig. 225

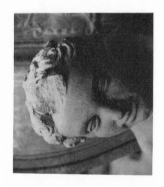

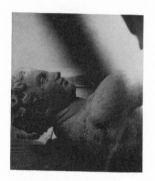

Fig. 226 Fig. 227

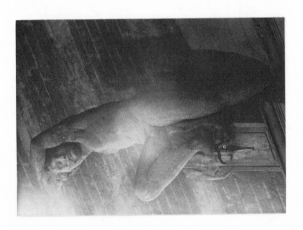

Fig. 228

Fig. 229

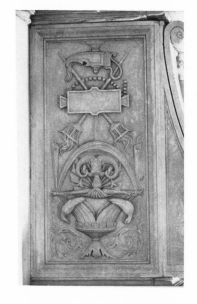

Fig. 230

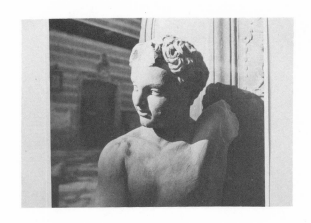

Fig. 231

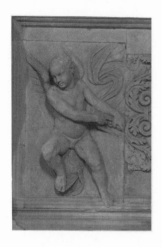

Fig. 232

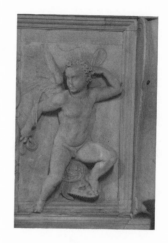

Fig. 233

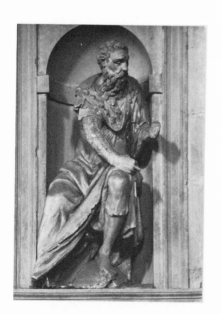

Fig. 234

Fig. 235

Fig. 236

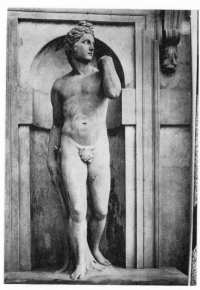

Fig. 237

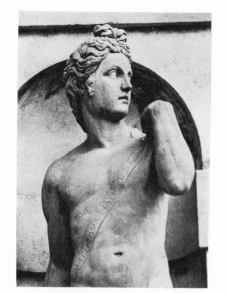

Fig. 238

Fig. 239

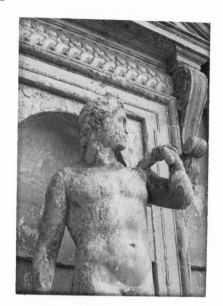

Fig. 240 Fig. 241

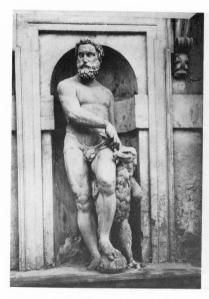

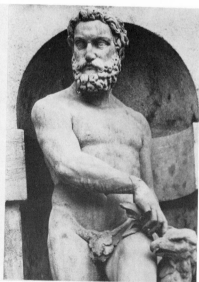

Fig. 242 Fig. 242a

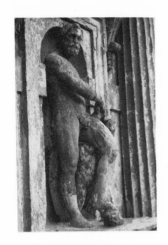

Fig. 243

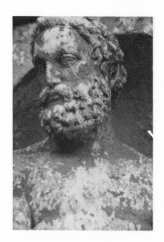

Fig. 244

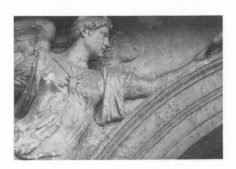

Fig. 245

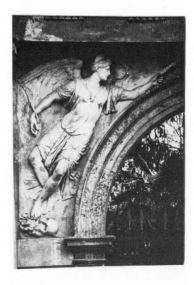

Fig. 246

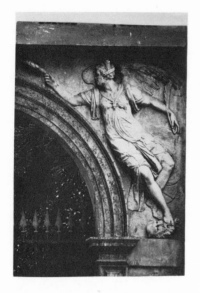

Fig. 247

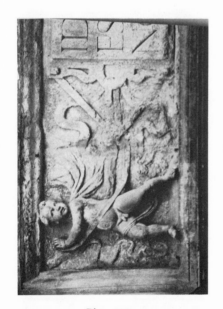

Fig. 248

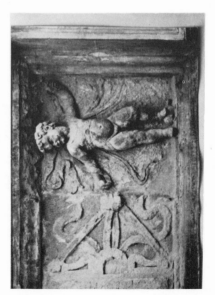

Fig. 249

Fig. 250

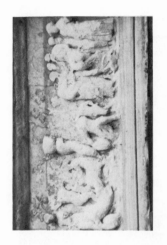

Fig. 251

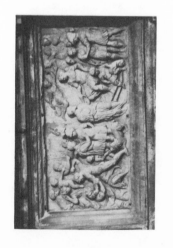

Fig. 252

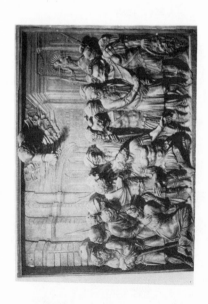

Fig. 253

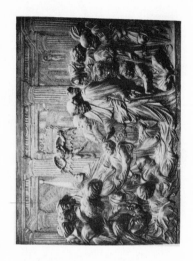

Fig. 254

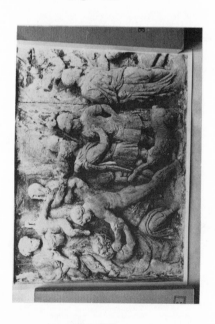

Fig. 255 Fig. 256

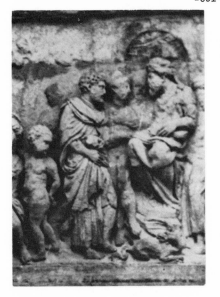

Fig. 257

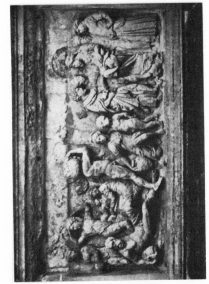

Fig. 258

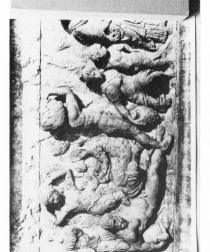

Fig. 259

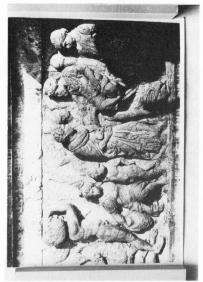

Fig. 260

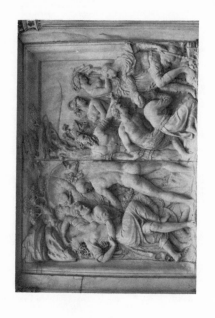

Fig. 261

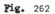

Fig. 262

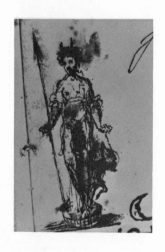

Fig. 263

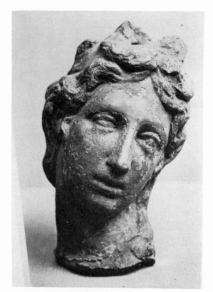

Fig. 264

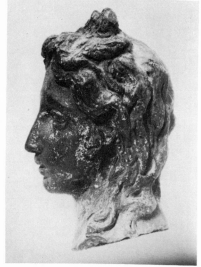

Fig. 265

Fig. 266

Fig. 267

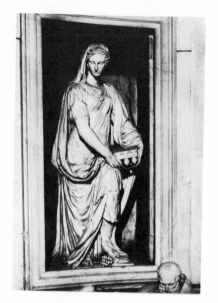

Fig. 268

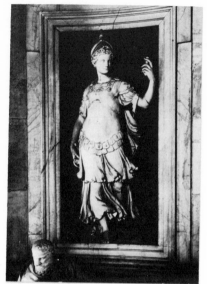

Fig. 269

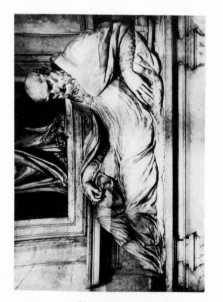

Fig. 270

Fig. 271

Plate 1

VICENZA FOUNTAIN BY B. AMMANNATI -- THEORETICAL RECONSTRUCTION -- EAST ELEVATION

SCALE 1 CM. = 5 VIC. FT.

Plate 2

Church

W

S ———|——— N

E

VICENZA FOUNTAIN -- GROUND PLAN OF THE GROTTO -- SCALE 1 CM. = 2 VIC. FT.

LENGTH OF EACH SIDE -- 20 VIC. FT.

DOOR WIDTH -- 6 VIC. FT.

A (LARGE FOUNTAIN BASIN) -- CIRCUMFERENCE 10 VIC. FT. -- DIAMETER 3.2 VIC. FT.

B (SMALL FOUNTAIN BASIN) -- CIRCUMFERENCE 5 VIC. FT. -- DIAMETER 1.6 VIC. FT.

PLAN BY PETER KINNEY